ABANDONED

HAUNTINGLY BEAUTIFUL DESERTED THEME PARKS

SEPH LAWLESS

Skyhorse Publishing

Skyhorse Publishing books may be purchased in bulk at special discounts for sales promotion, cor-porate gifts, fund-raising, or educational purposes. Special editions can also be created to specifications. For details, contact the Special Sales Department, Skyhorse Publishing, 307 West 36th Street, 11th Floor, New York, NY 10018 or info@skyhorsepublishing.com.

Skyhorse® and Skyhorse Publishing® are registered trademarks of Skyhorse Publishing, Inc.®, a Delaware corporation.

Visit our website at www.skyhorsepublishing.com.

10 9 8 7 6 5 4 3 2

Library of Congress Cataloging-in-Publication Data is available on file.

Cover and interior photography by Seph Lawless

ISBN: 978-1-5107-2335-1
eISBN: 978-1-5107-2338-2

Printed in China

CONTENTS

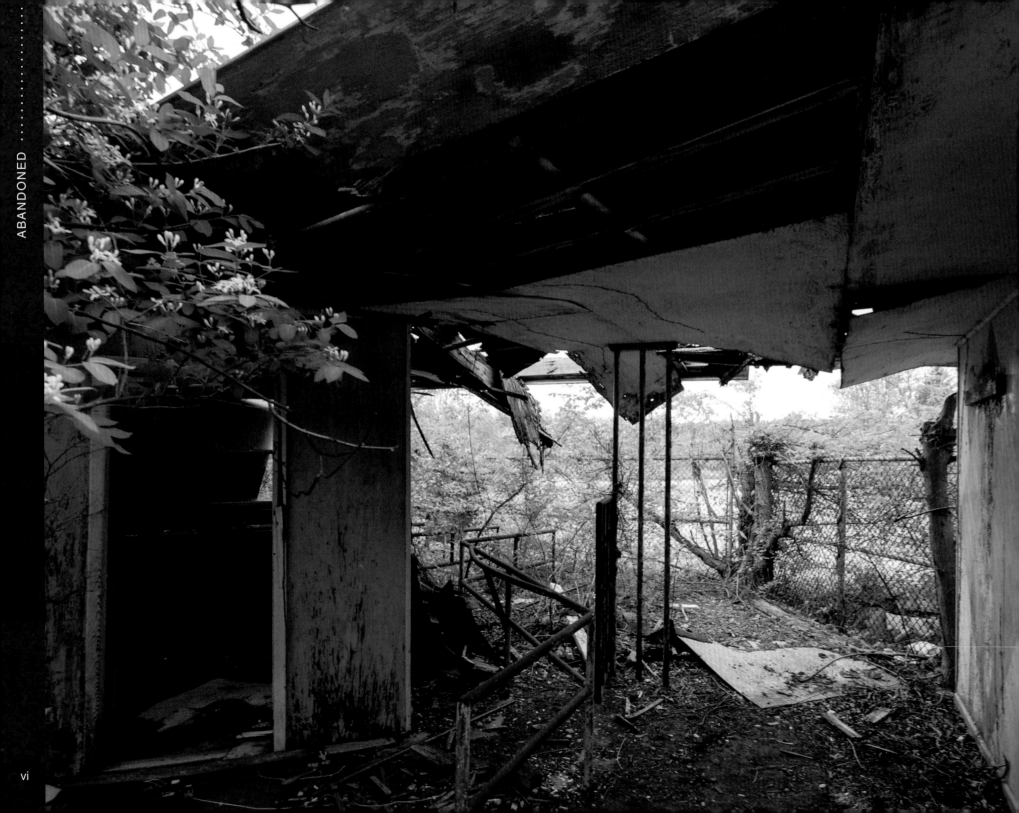

FOREWORD

"America is not a young land." William Burroughs once said that, and he was right. America has been here for a long time. Not just the Natives who hunted mammoths across the land bridge. I'm talking about you and me, the Americans born in the twentieth century who are still here in the twenty-first. Our America has been here long enough to leave ruins behind.

Have you ever been to Detroit? You don't even have to go to all the way to Eight Mile to see abandoned spray-painted middle-class houses stuffed with garbage bags and cast-off Christmas trees intersected with inhabited homes that have shiny mini-vans in the driveway and fresh-faced kids staring at you through the window.

America in decline.

Seph Lawless, urban explorer and photographer extraordinaire, is intimately familiar with the America that we have left behind. Maybe you've seen the ruins of our former selves, or maybe you've only seen it through his photos, but here they are. He started with the profoundly titled *Autopsy of America*, an exquisite book of photos of abandoned shopping malls. With artistic intuition and masterly technique, this Gonzo photographer penetrated places that we didn't even know were there.

Lawless grew up going to his local shopping mall in Cleveland. Remember when we used to see shopping malls as permanent staples of American consumer culture? We took them for granted. Or, if you were an eighties metalhead like me, we rejected them as vacuous end-products of human evolution. George Romero understood this when he used a shopping mall as the setting for his 1978 zombie apocalypse masterpiece, *Dawn of the Dead*.

"What are they doing here?" says one survivor, while looking from the terrace of the Monroeville Mall in Pennsylvania choked with zonked-out zombies in disco-era shopping attire. "Why do they come here?"

"Some kind of instinct," says another survivor in SWAT gear. "Memory of what they used to do. This was an important place in their lives."

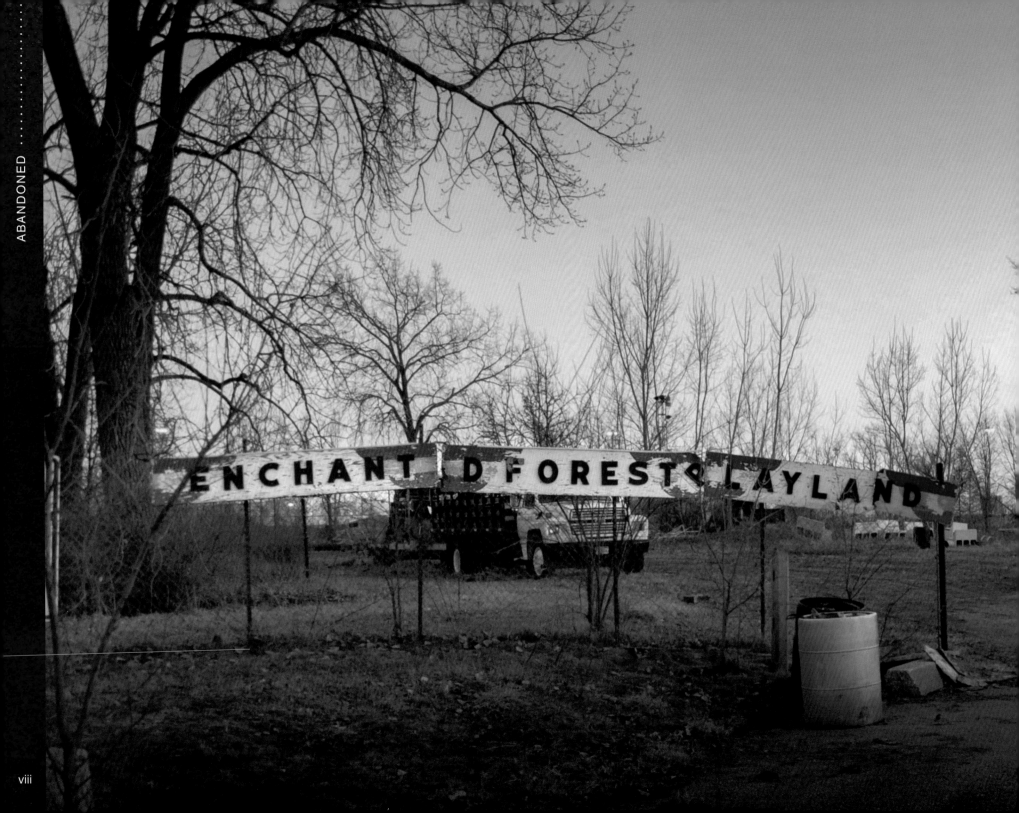

Lawless conveys in his photos not just an invitation to a post-apocalyptic place we haven't been to, but a window into a place we used to go and left behind. And we didn't know, when we walked away, that it would ever turn into America in decline.

Which bring us to Lawless's next book. What's the subject this time? Abandoned amusement parks fallen into ruins, leaving behind the skeletons of roller coasters and grinning clowns perched on giant tea cups in the middle of the forest. As a former barker, vendor, and roustabout for Ringling Brothers and the Big Apple Circus, I find this fascinating.

I met Lawless while I was reporting for CNNMoney and working on my own book, *Circus Jerks*. I must say, he beat me at my own game. Where does he find these weed-choked wonder rides in the middle of nowhere? That's his talent.

Of all the phantasmagoric freak house bizarrities that Lawless captured with his camera, my personal favorite is the Land of Oz. As an Appalachian Trail thru-hiker, I spent a lot of time wandering the hills of North Carolina. But never did I ever stumble across a sunset-dappled hilltop with a meandering yellow brick road bordered by goblin-faced trees that looked like they could "pick something off of you," as that angry tree said to Dorothy when, you know, she picked his apple.

I would like to go to that place. But is it still there? We'll have to ask Seph Lawless. Only he knows where to find these abandoned bits of Americana.

And they are fleeting.

Aaron Smith
CNN Journalist
February 2017

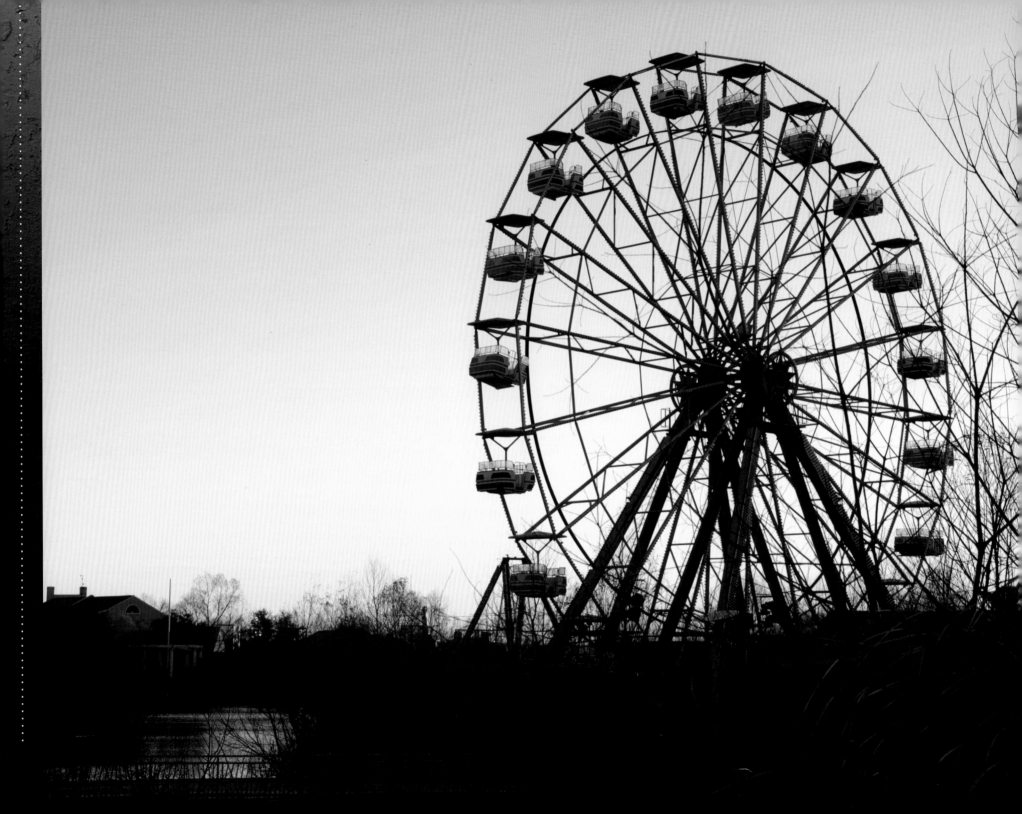

SIX FLAGS AMUSEMENT PARK

NEW ORLEANS, LOUISIANA
2003–2005

Six Flags in New Orleans, formerly known as Jazzland, unfortunately operated for only a few years before a life-changing event that sent shockwaves across a nation and devastated the landscape of New Orleans forever, a catastrophic hurricane named Katrina.

I first entered New Orleans in 2015 after being hired by the *Guardian* newspaper to document the tenth anniversary of Hurricane Katrina. I worked alongside the original FEMA responders for that project and met many survivors of that horrific storm. I was hired to document the hardest-hit areas of New Orleans, which was the Lower Ninth Ward. I also thought documenting the abandoned Six Flags amusement park would be a dramatic way to further show the amount of devastation of the area, and it worked. My images of the abandoned park went viral and fueled the other images that I took of the Lower Ninth Ward, as it cast awareness on all that still needed to be done in New Orleans since the floodwaters of Hurricane Katrina ravaged the city.

Perhaps at no other time in modern history has the US government been criticized so harshly at local, state, and even federal levels. The complete incompetence of the state and federal government to handle the storm before and during Hurricane Katrina reached enormous proportions, even compelling rap artist Kanye West to infamously lash out on a live television fundraising event that the current president at the time, George W. Bush, didn't care about black people.

I realized my images of New Orleans and the abandoned Six Flags park would test America's resilience once again by opening up old wounds, and my images did just that. After the images went viral, I did several television news appearances where I talked about the issues still facing New Orleans a decade after most Americans had forgotten about it.

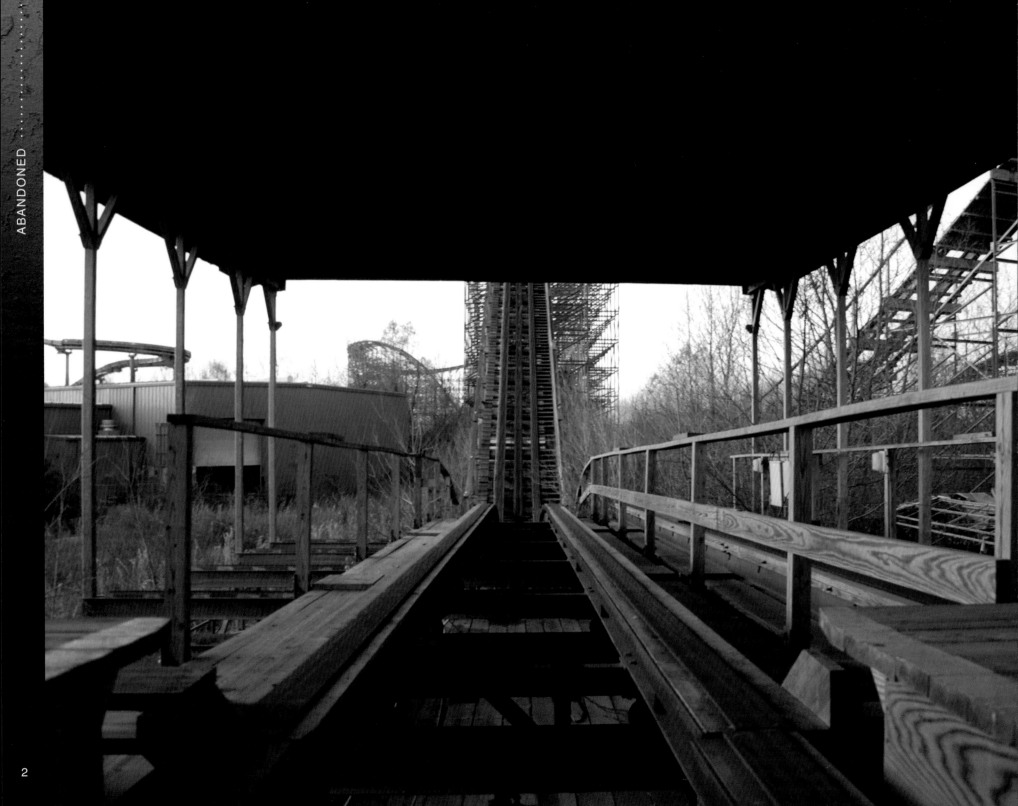

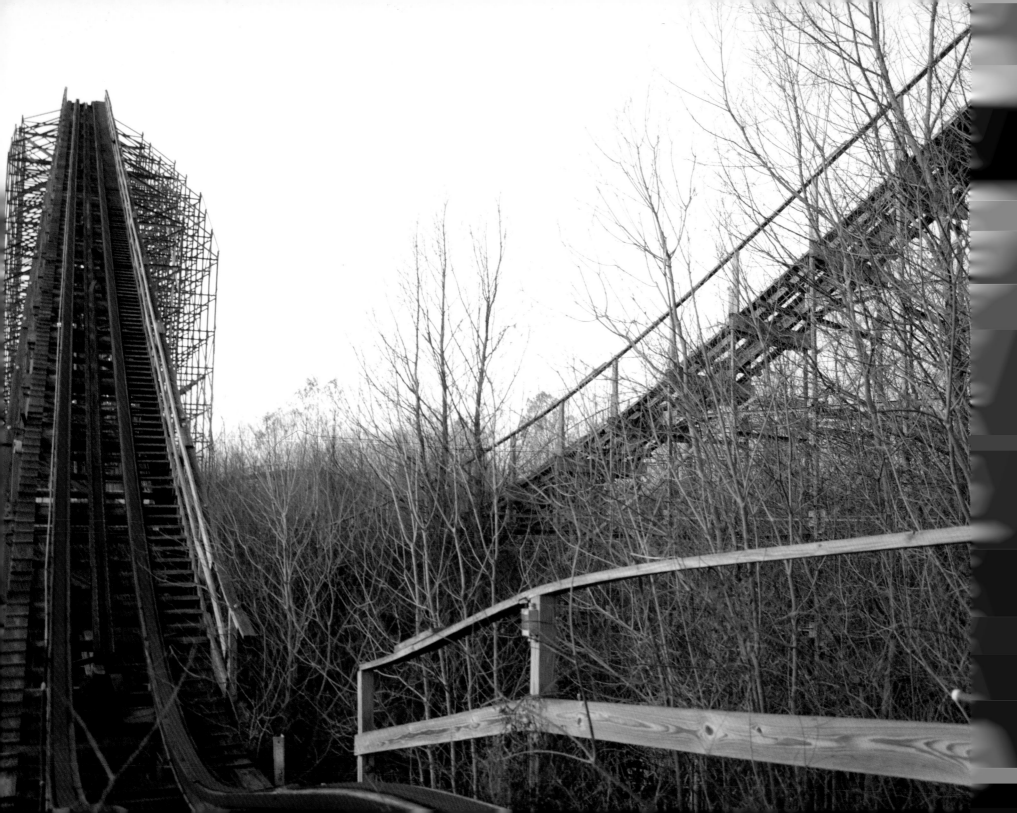

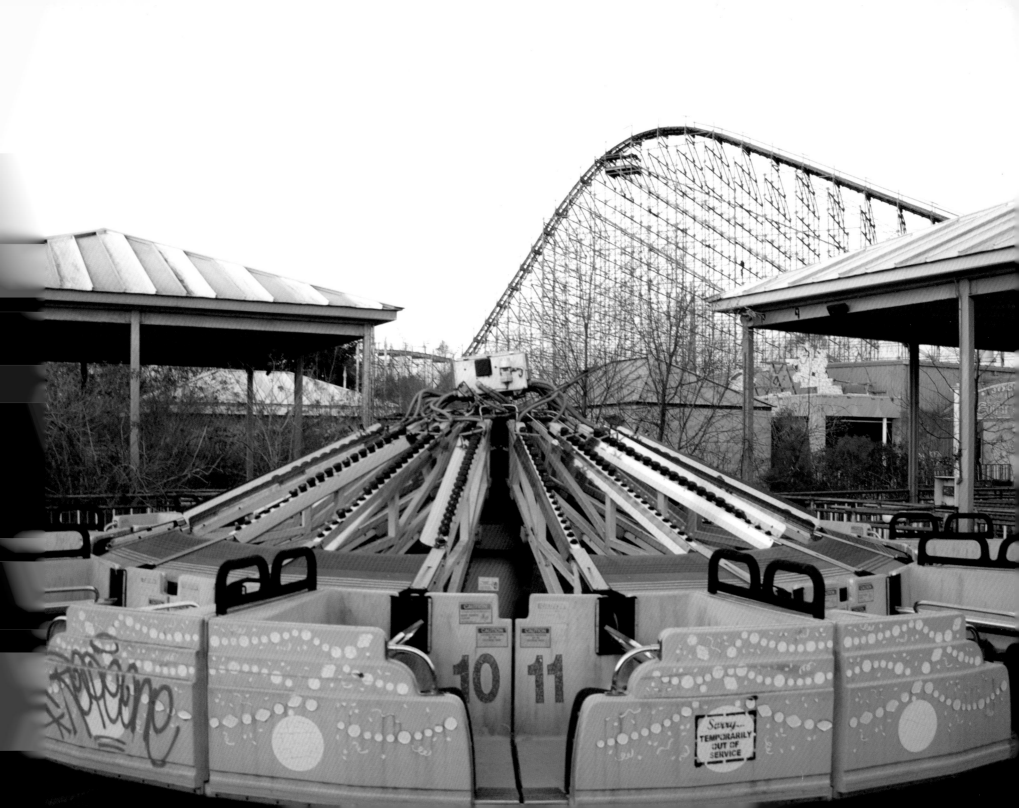

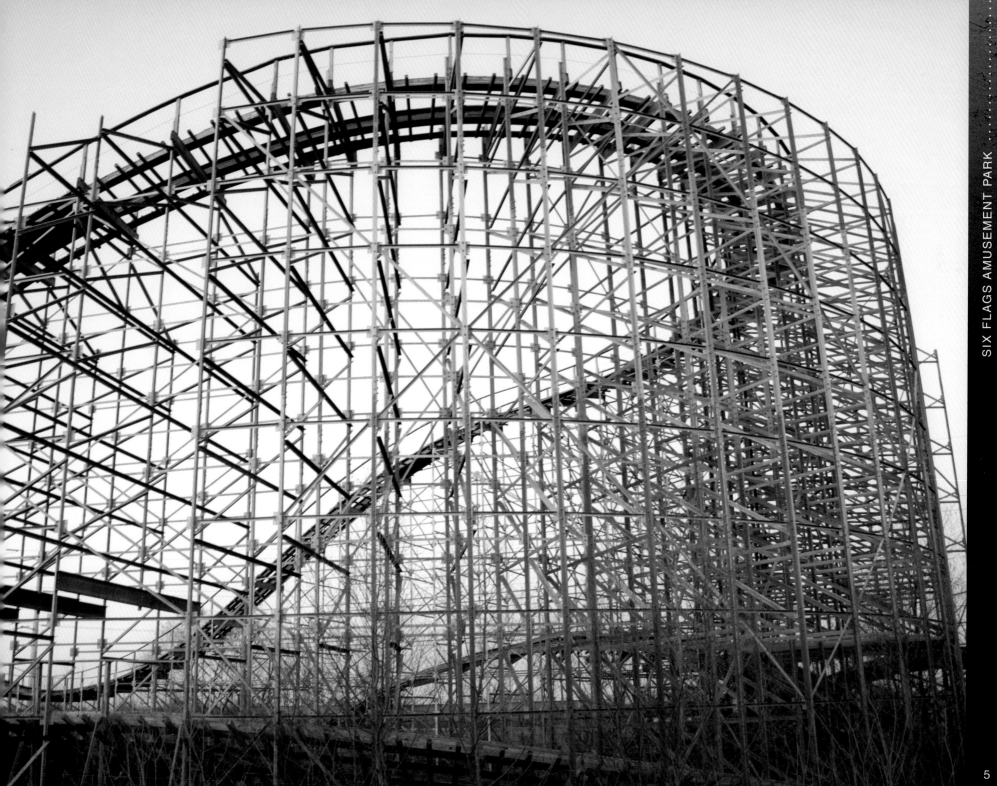

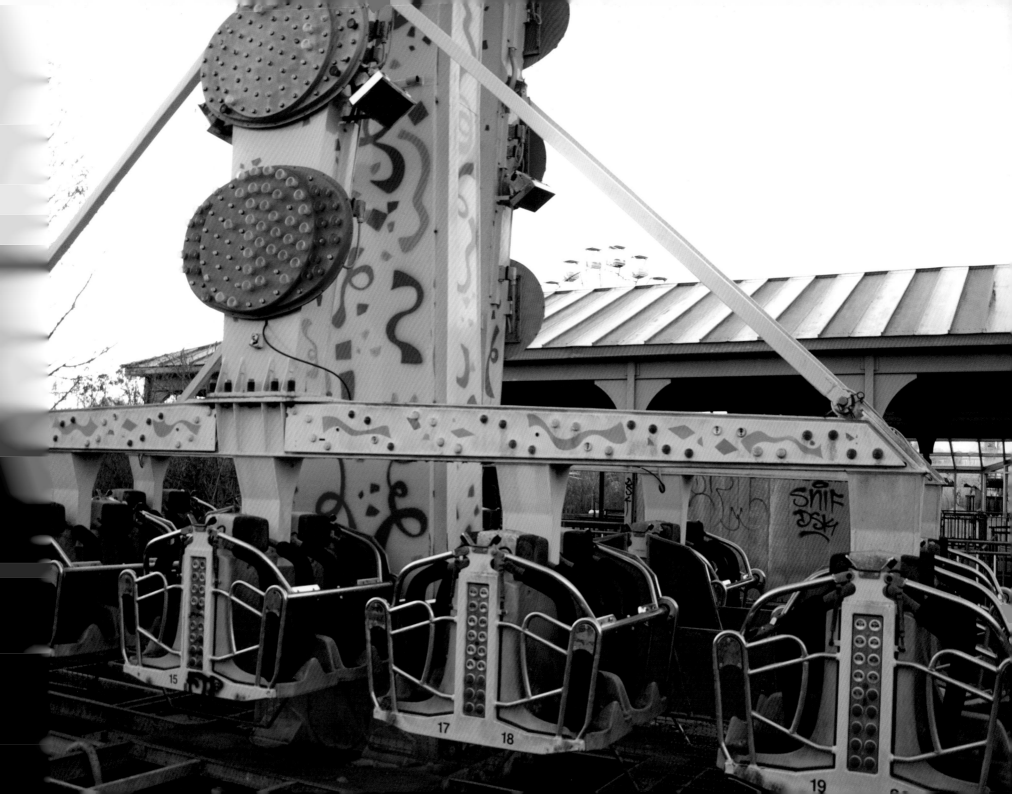

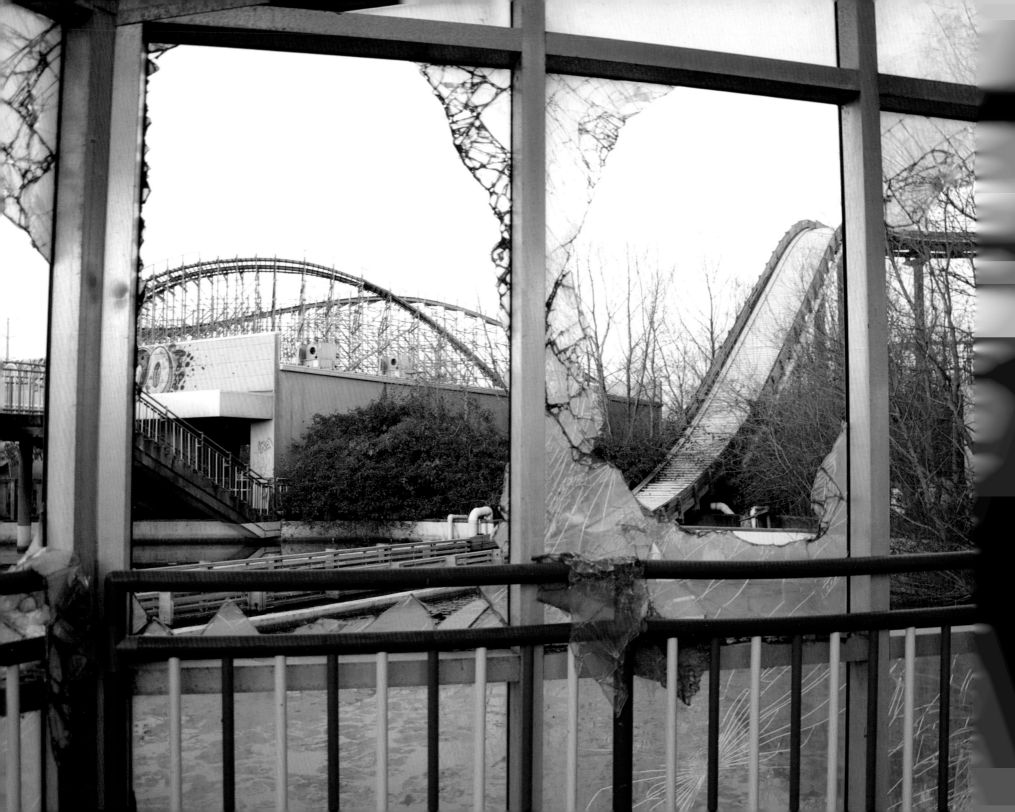

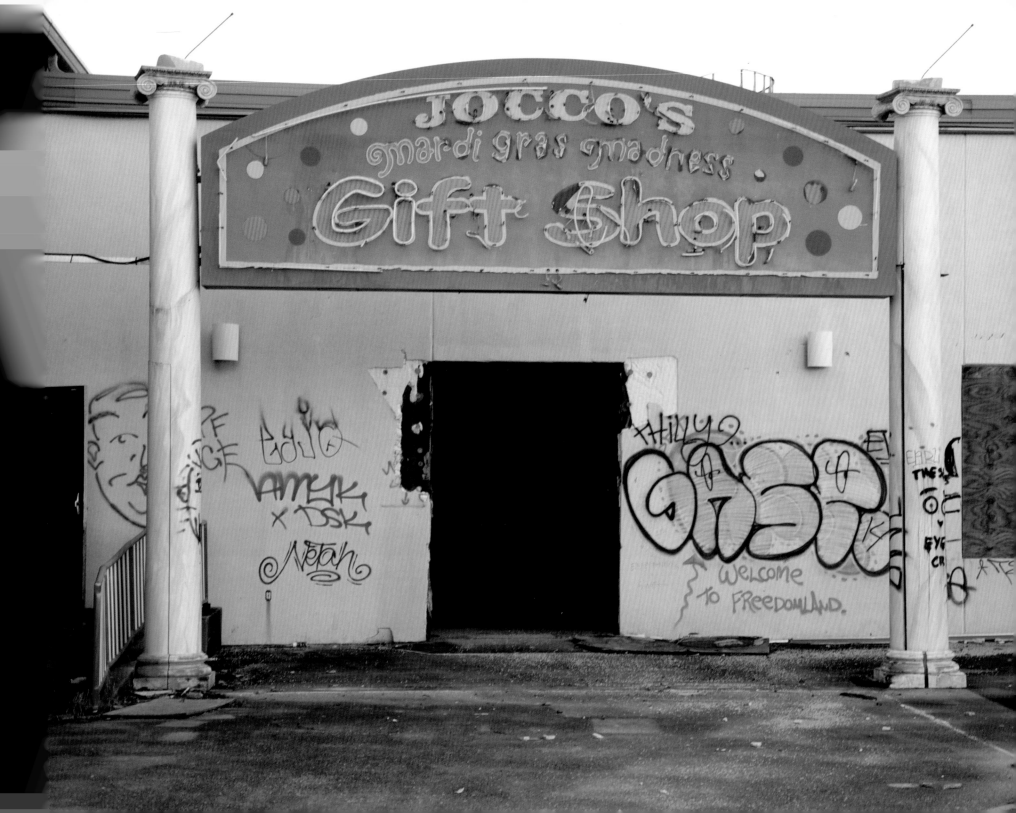

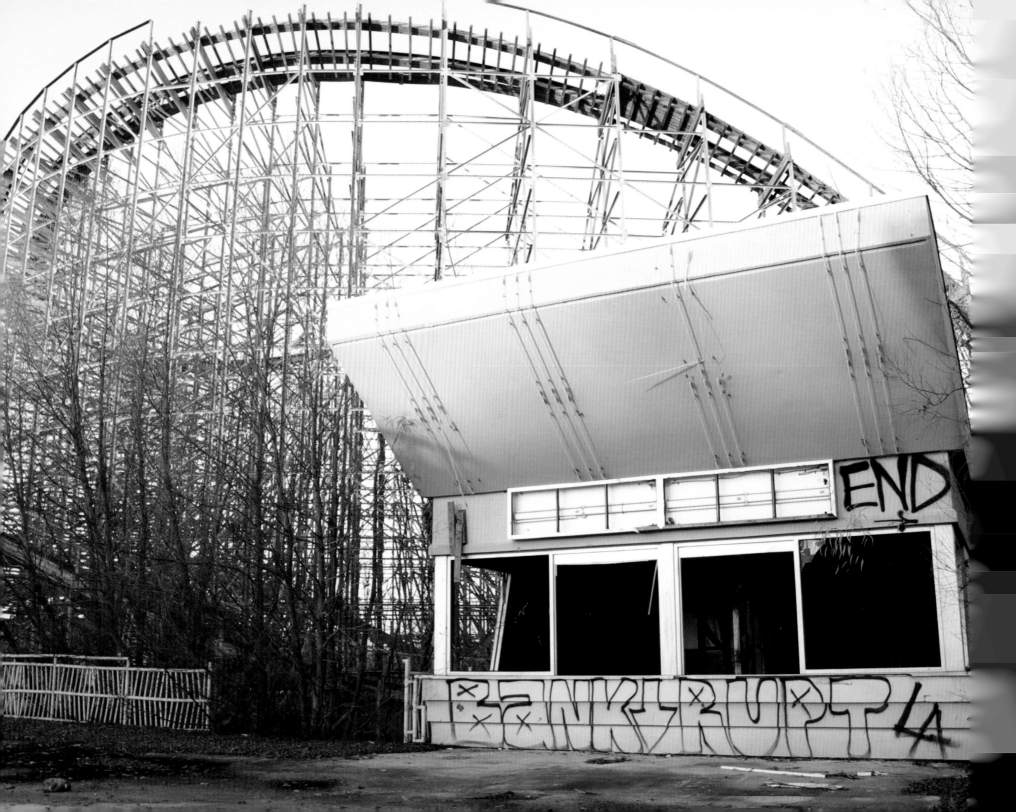

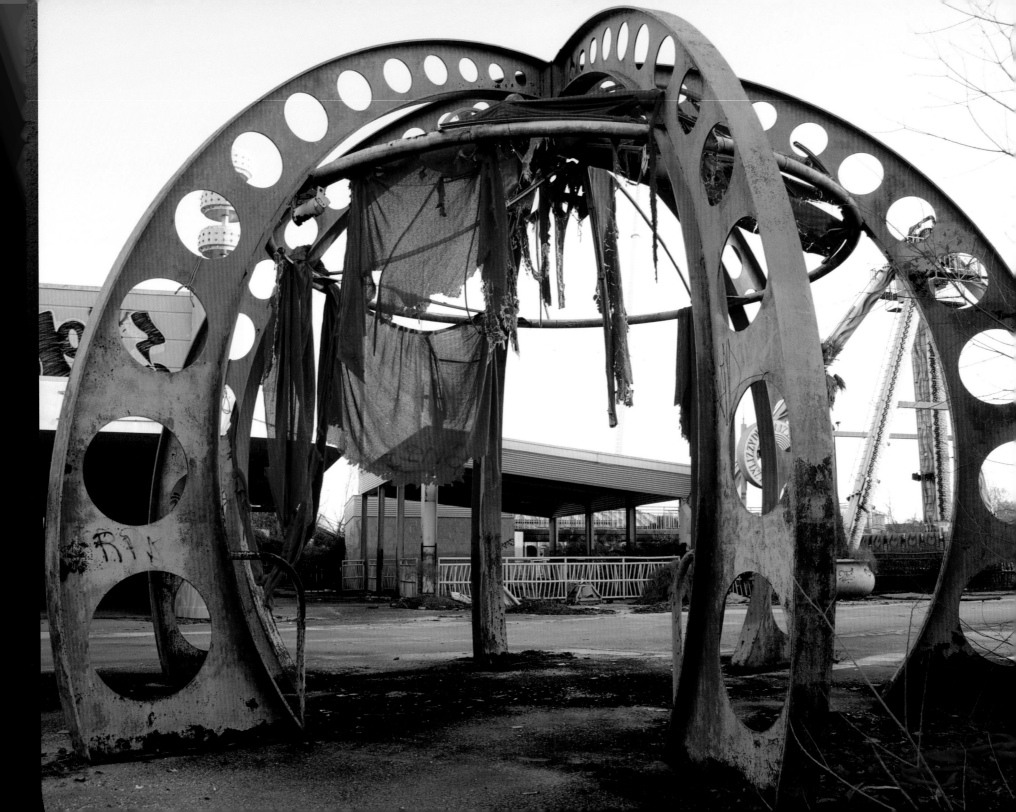

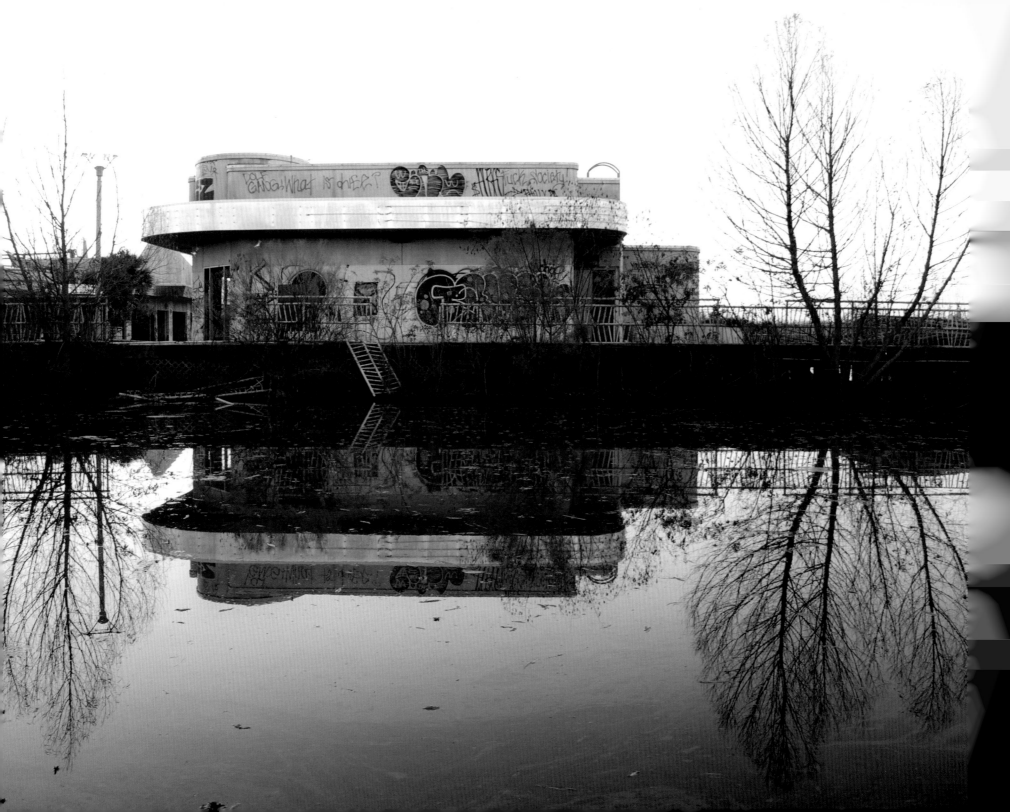

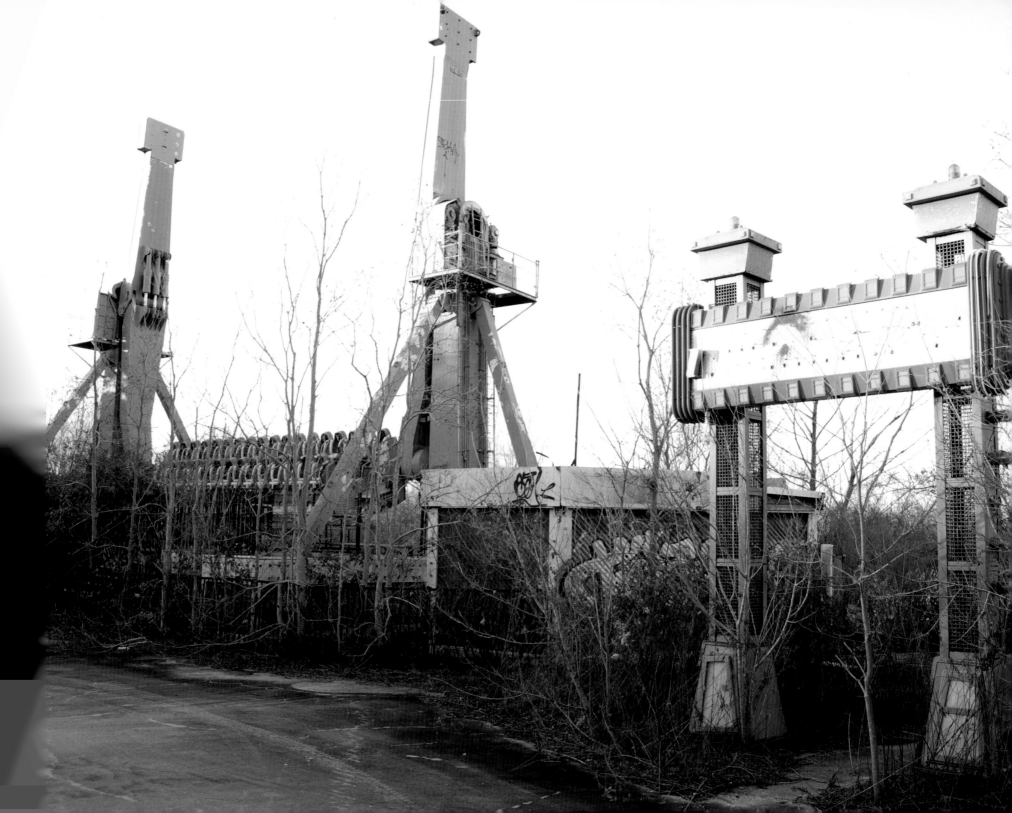

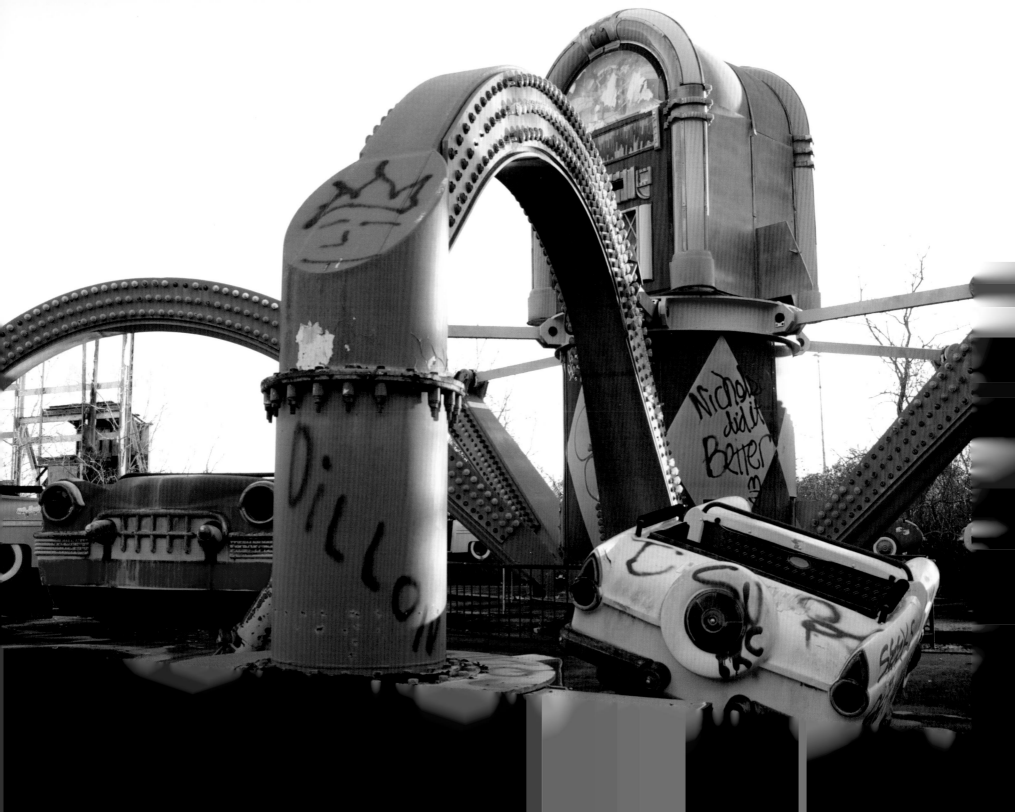

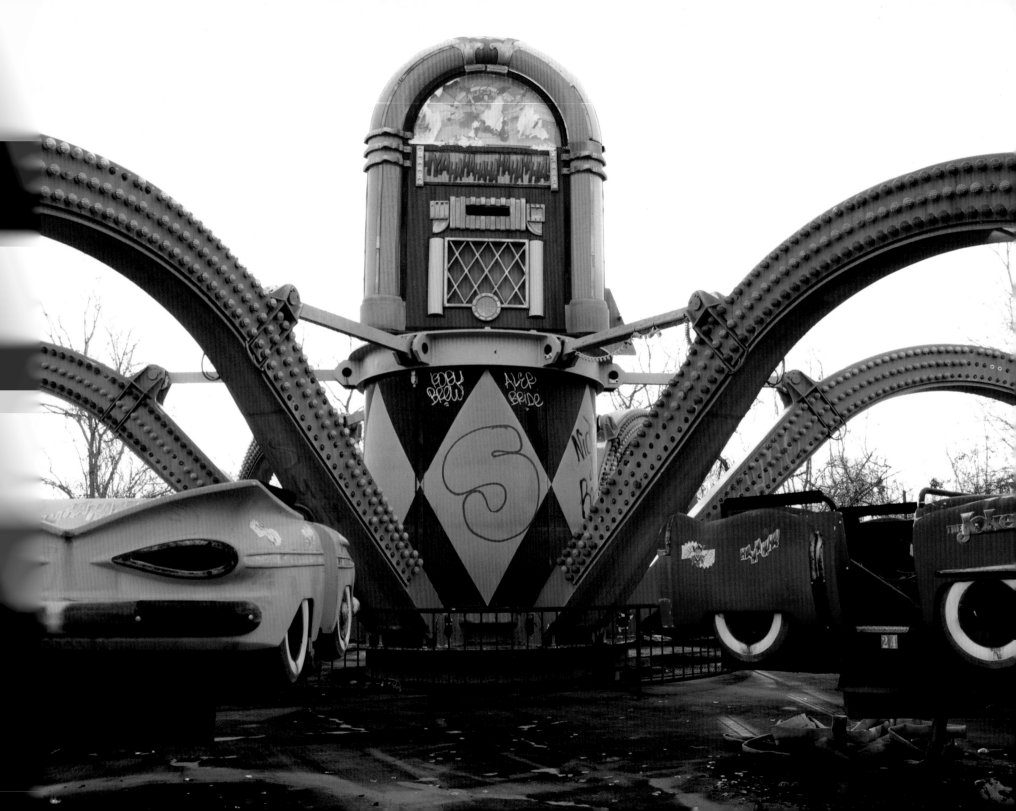

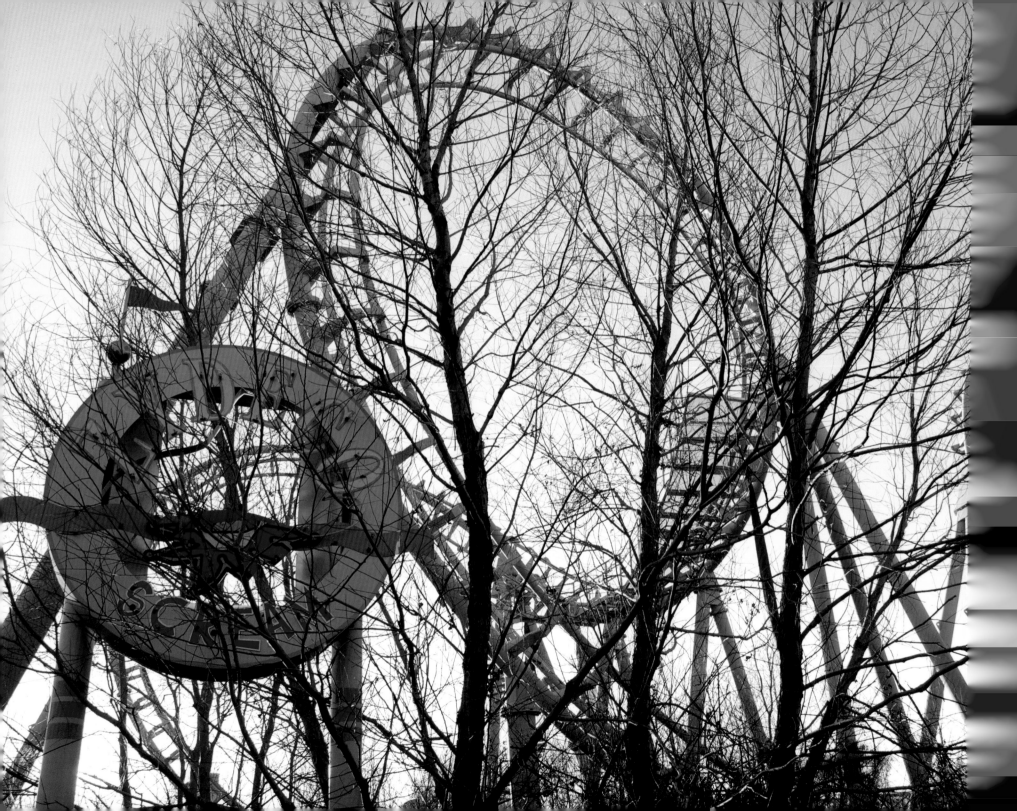

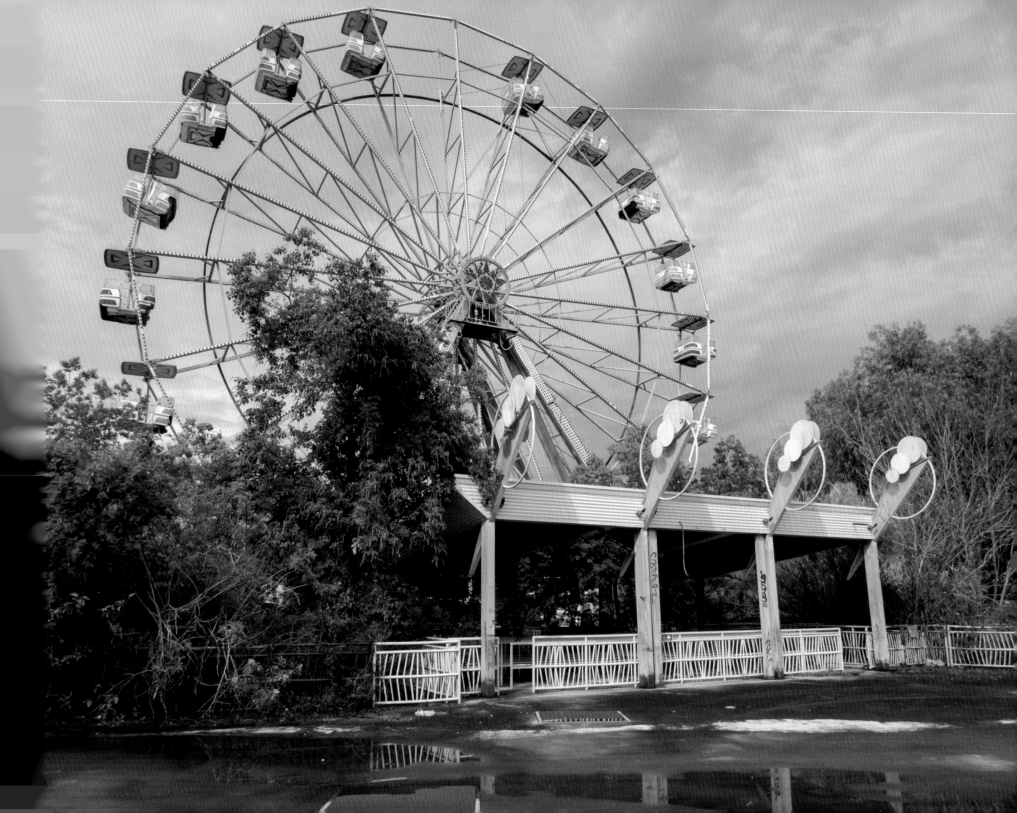

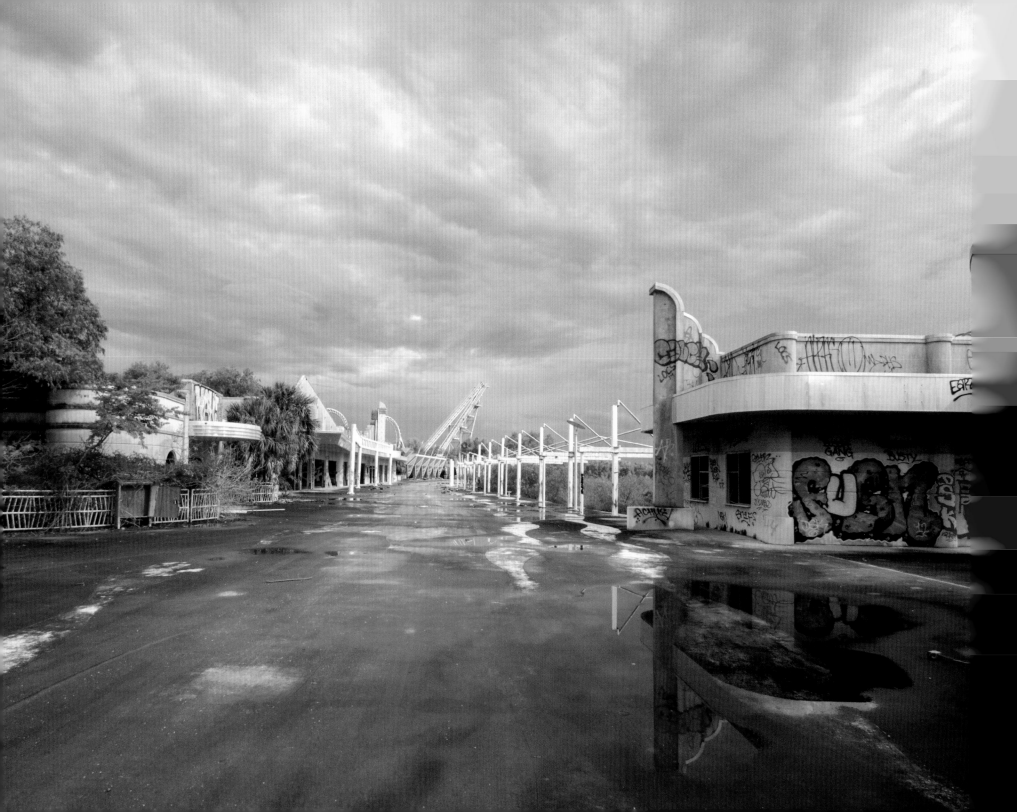

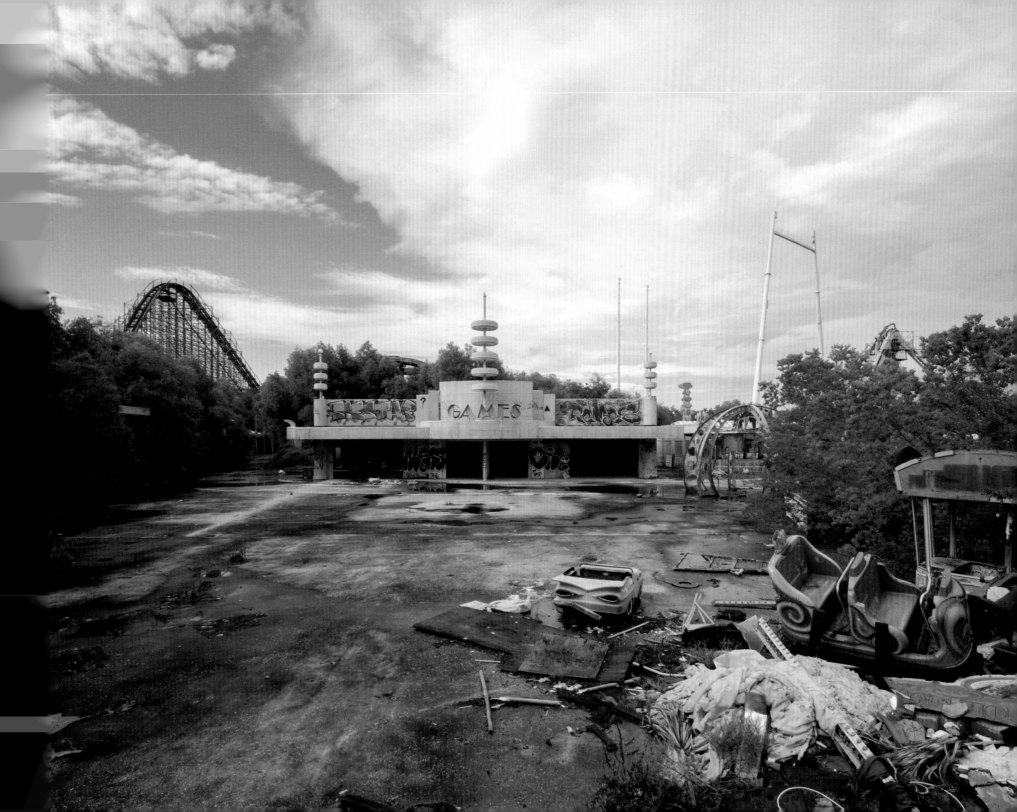

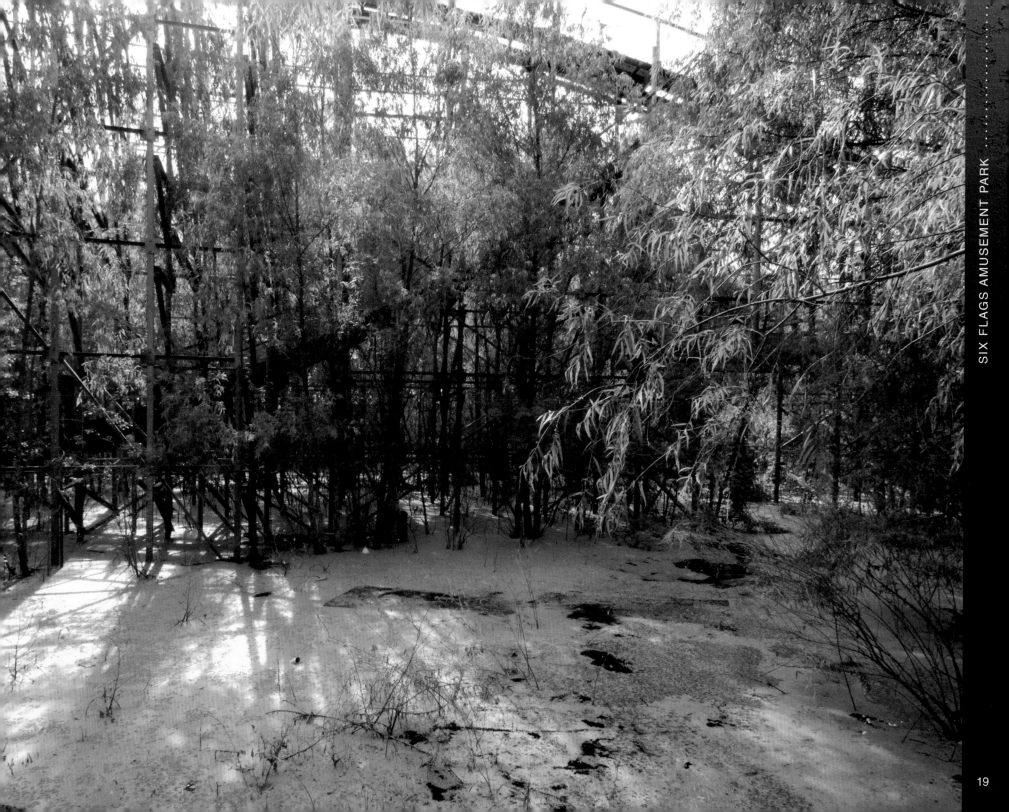

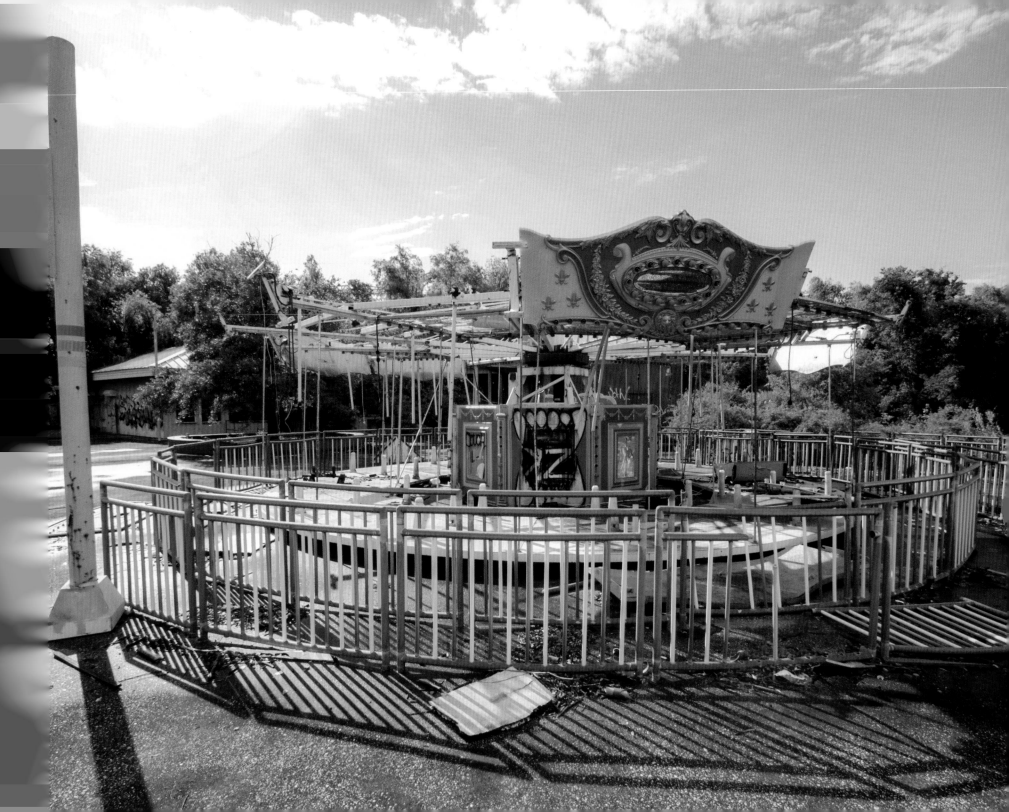

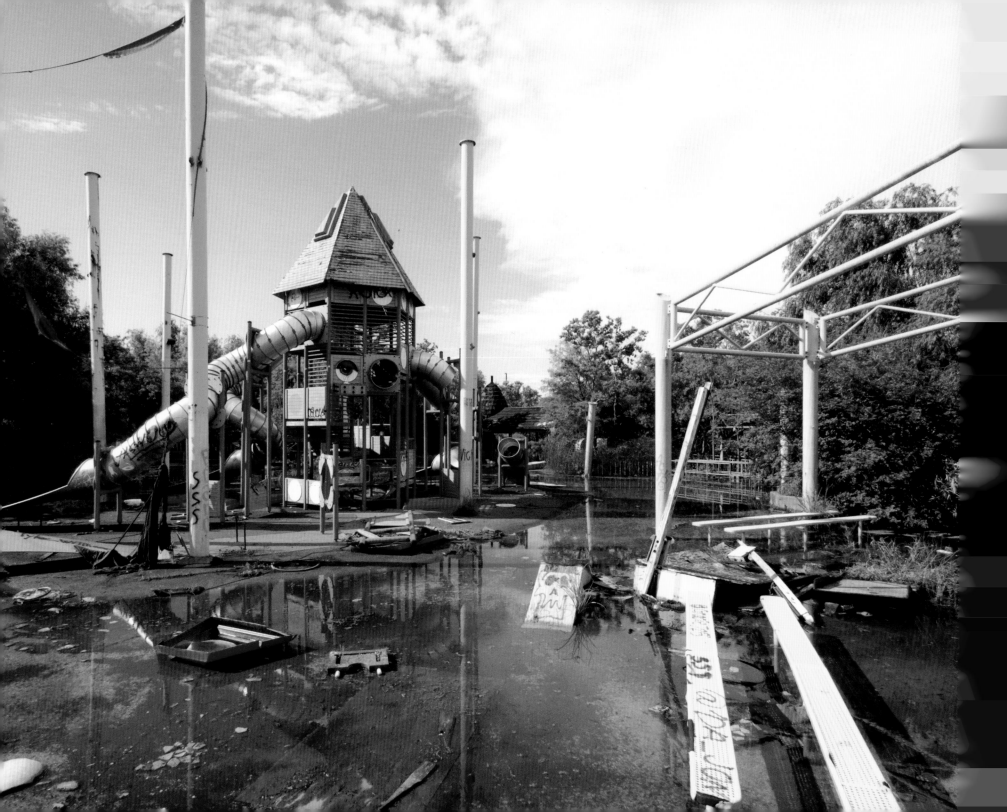

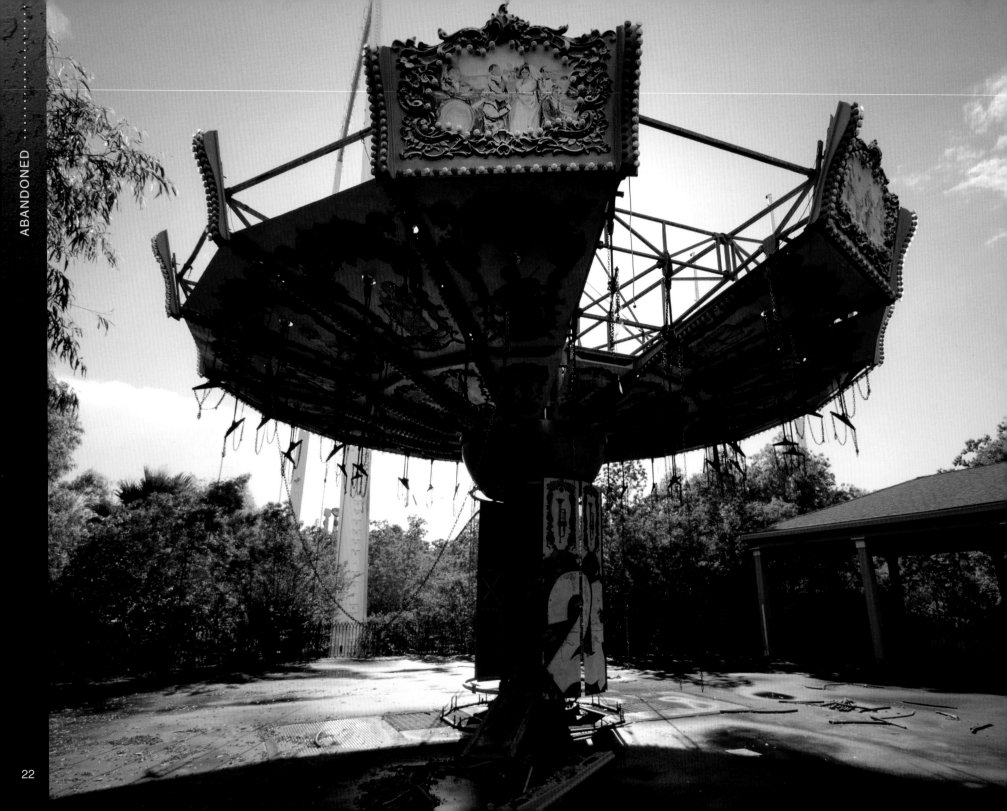

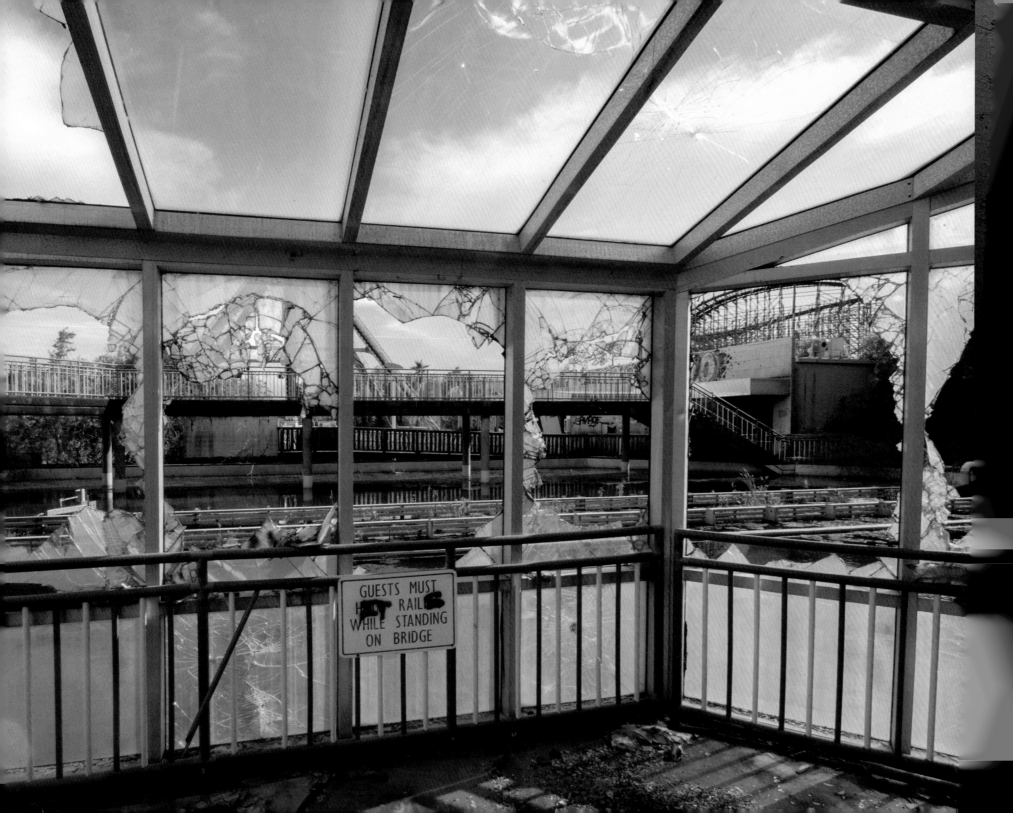

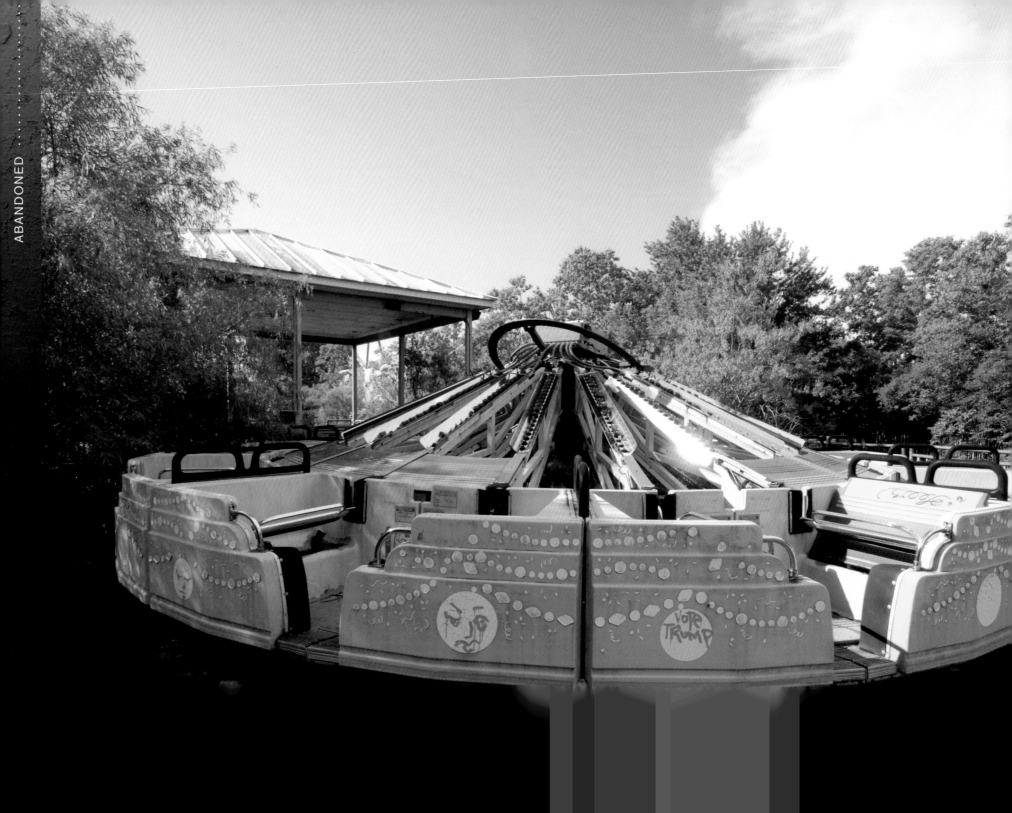

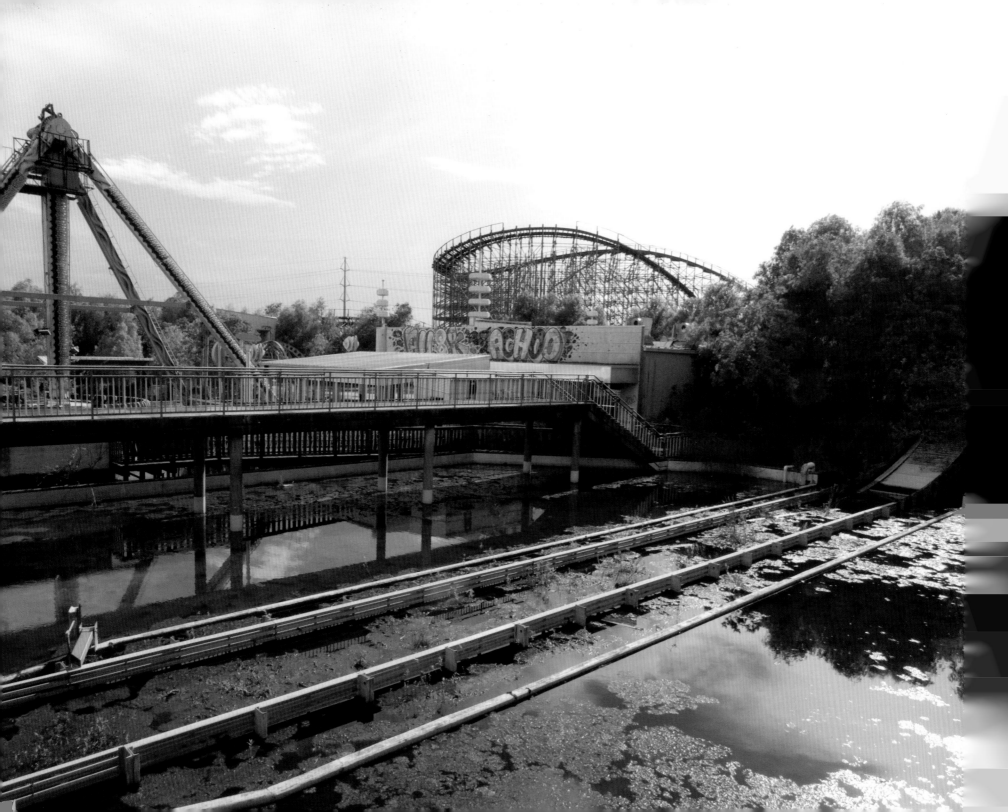

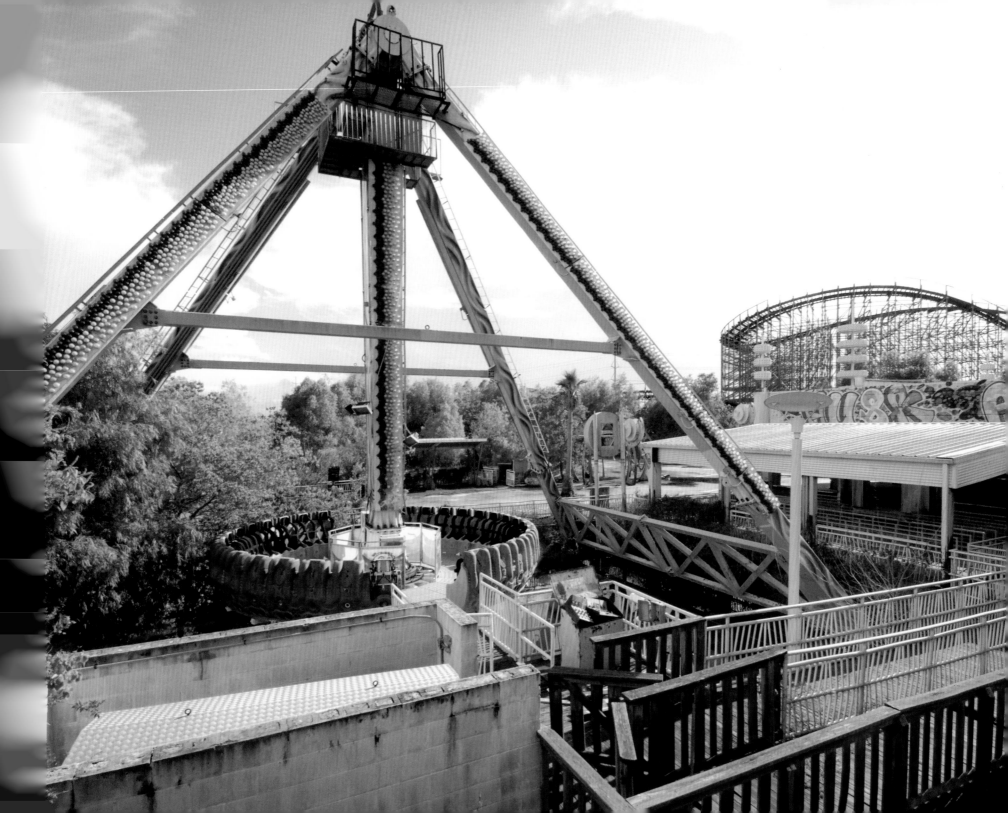

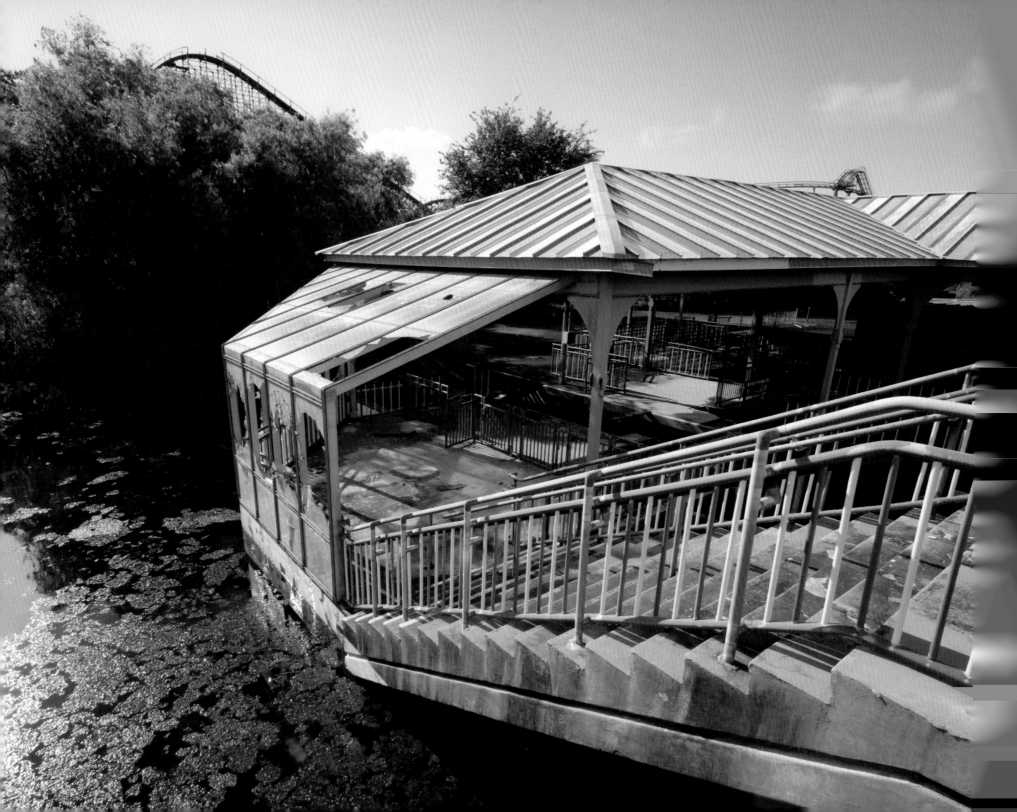

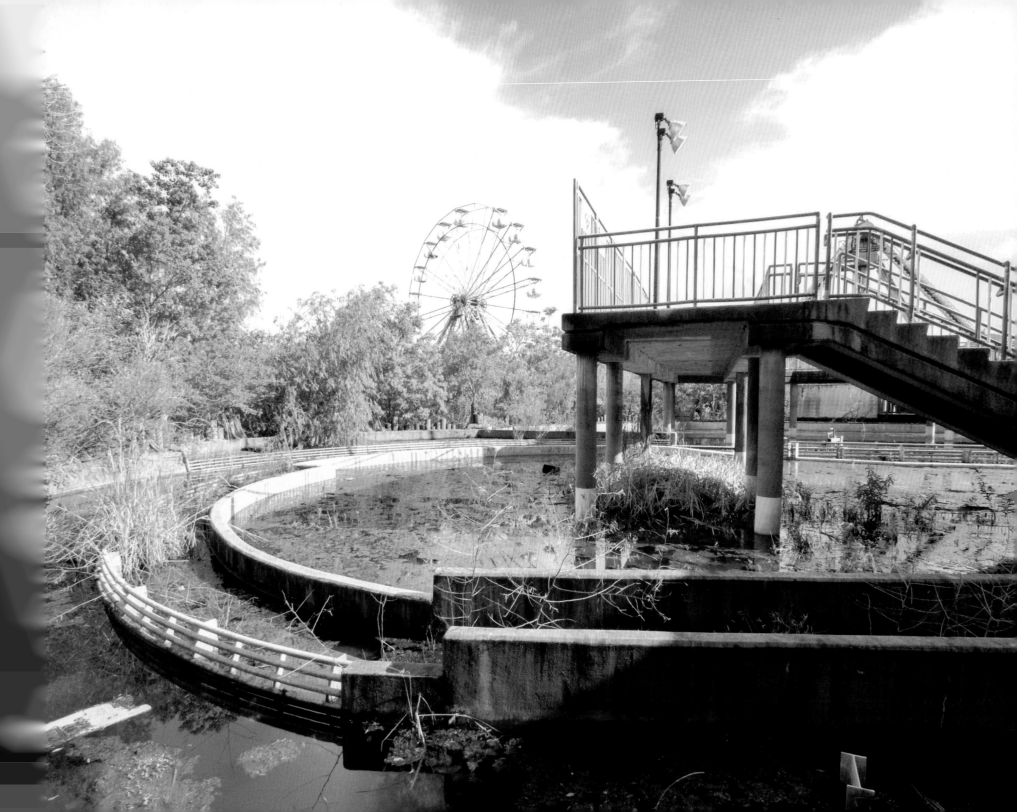

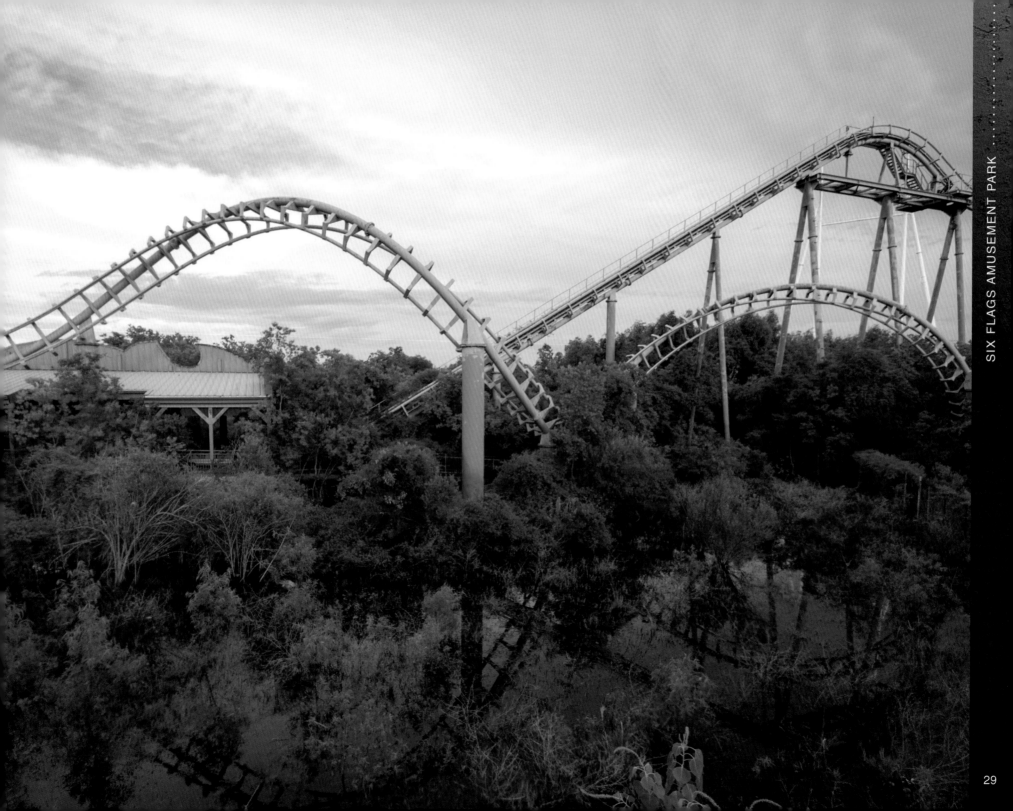

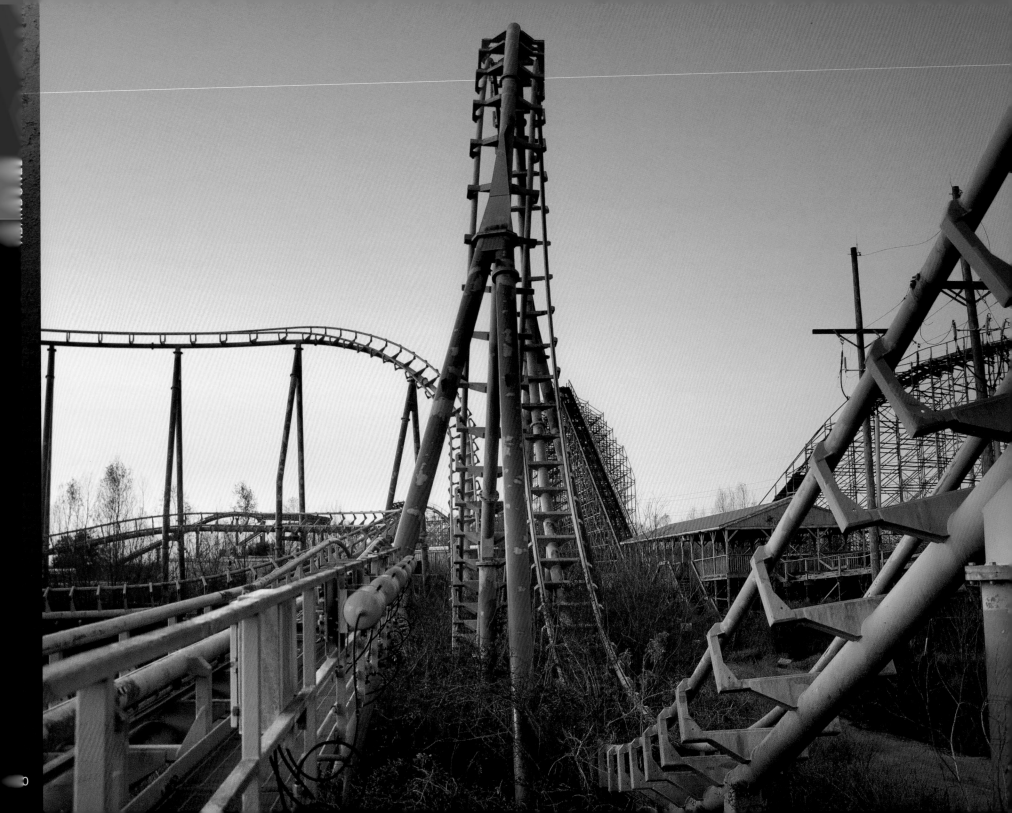

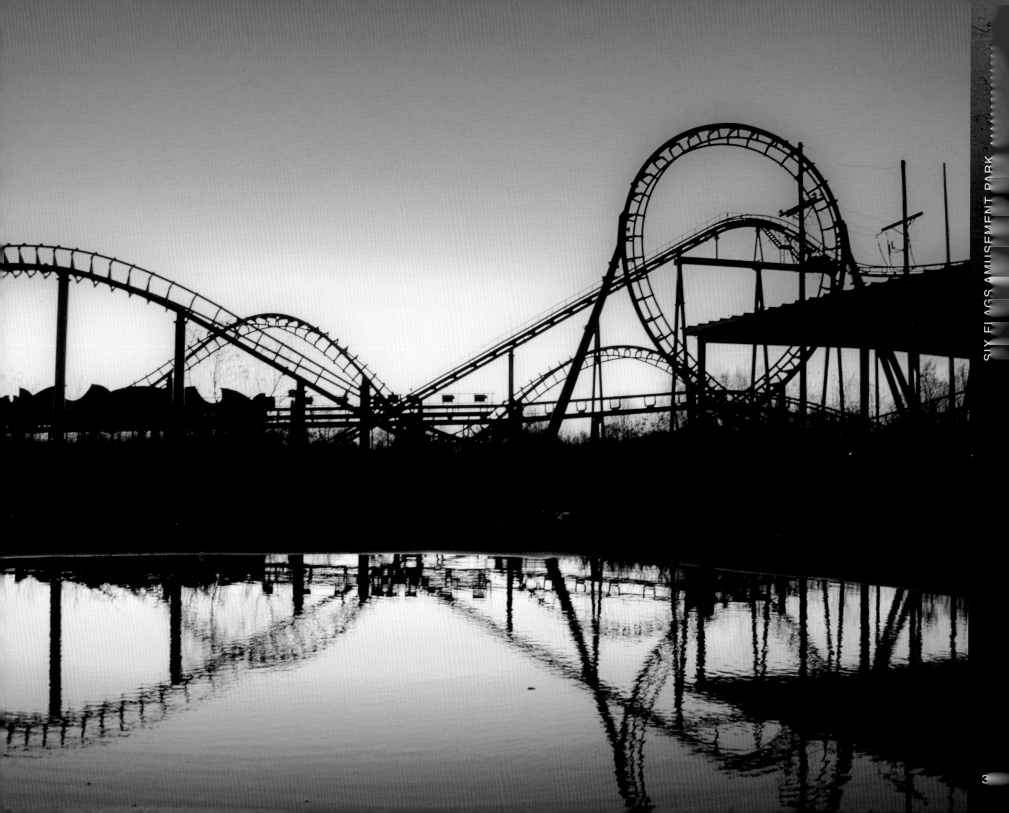

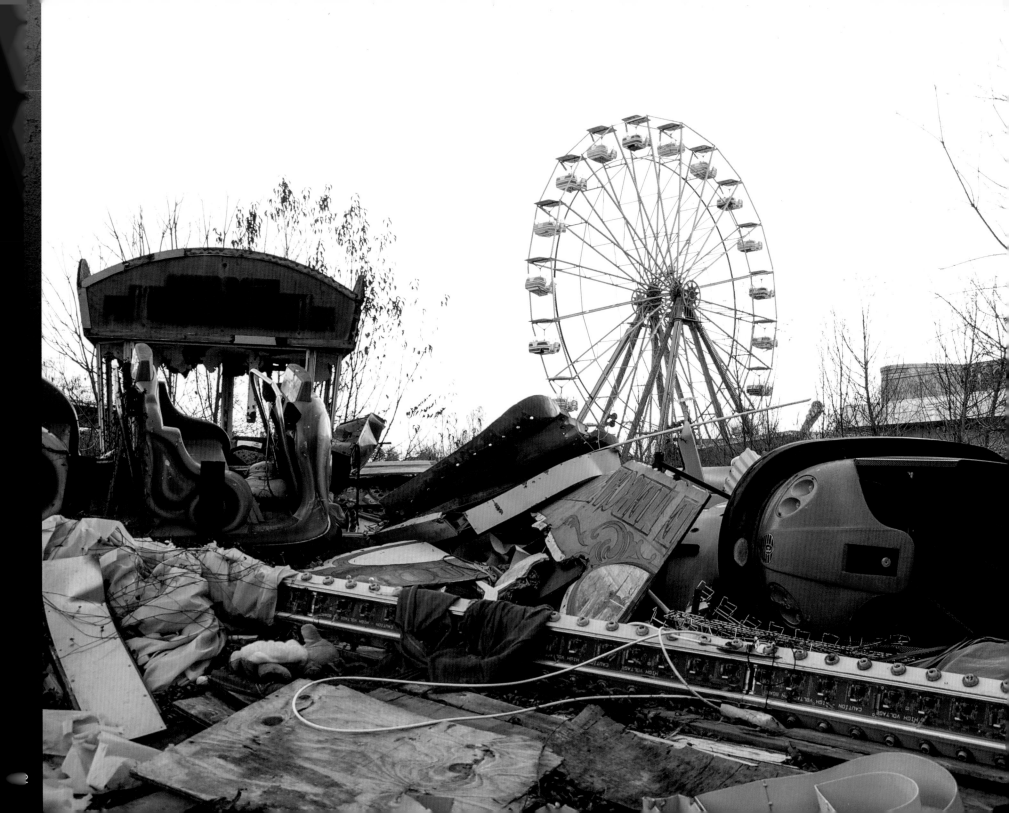

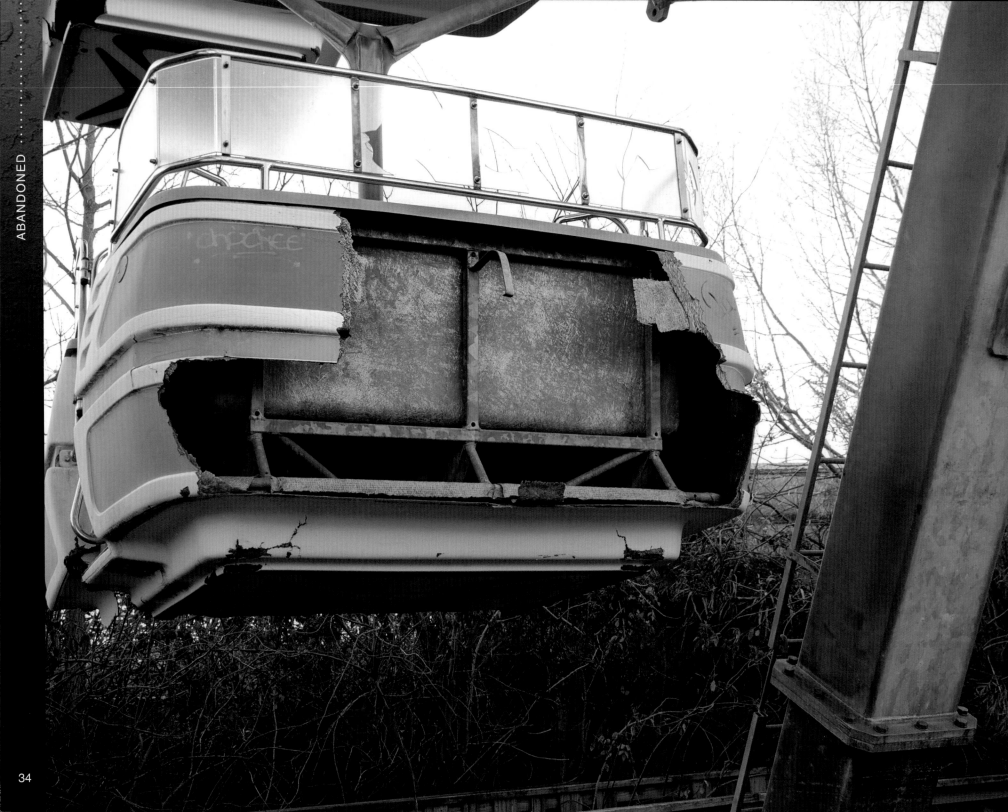

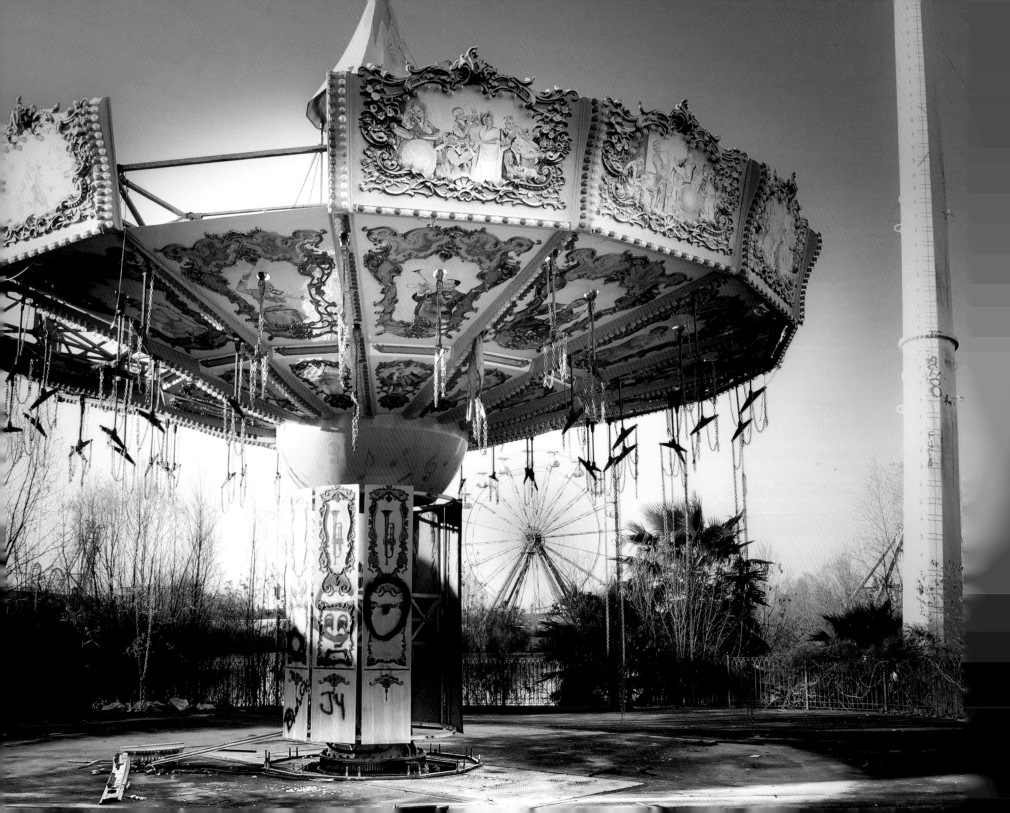

DISNEY WORLD'S DISCOVERY ISLAND AND RIVER COUNTRY

1974–1999 AND 1976–2001, RESPECTIVELY
ORLANDO, FLORIDA

Unbeknownst to most people, Walt Disney World in Orlando, Florida, has two abandoned sections of their kingdom that have been long forgotten and slowly decaying for years. One is Discovery Island, and the other, Disney's River Country. It shouldn't come as a surprise that most people don't know about the abandoned, decaying parts of the happiest place on Earth, but I learned fairly quickly why that was the case. Disney has taken great steps to ensure these two parts of Disney World are unseen and even hidden from tourists by erecting a large twenty-foot blackout fence around River Country. Disney doesn't permit anyone to step foot on Discovery Island. So, when my photos of the park went viral in 2016, most people were shocked to see that Disney had left these former areas to simply crumble, with no attempts to use the land for anything else or even clean up the mess left behind.

I challenged the Disney Corporation in interviews with the BBC News and other media outlets, stirring up controversy when I was quoted saying, "No billion-dollar company should be powerful enough not to clean up their own mess." Disney refused to comment on the viral photographs, but took notice after two separate events occurred just weeks after my photos went viral.

The first event was triggered after Florida's governor feared the possibility that the Zika virus could potentially spread to Florida, which emphasized the importance of removing standing water, especially around large populations. Days later, Disney entered the abandoned River Country and drained the pool inside the park that can be seen in my images filled with murky, dirty water. After Disney drained the pool, they filled it with cement. Several people said that might not have happened if it wasn't for my images going viral just weeks before that event.

The second was the tragic death of a two-year-old toddler who was literally snatched from his parent's hands by an alligator off a Disney Resorts beach and killed. I appeared on several television shows days later discussing the possibility that the abandoned, neglected sections of Disney could be a breeding ground for alligators to thrive undetected. This would be the second time that my abandoned Disney images would be part of a national discussion.

Disney refused to ever speak publicly about my images or the abandoned sections of Disney World. One BBC News journalist made five attempts to reach out to the Disney Corporation to comment and said he has never seen more blatant disregard than Disney's outright refusal to answer questions concerning the abandoned parts of Disney World.

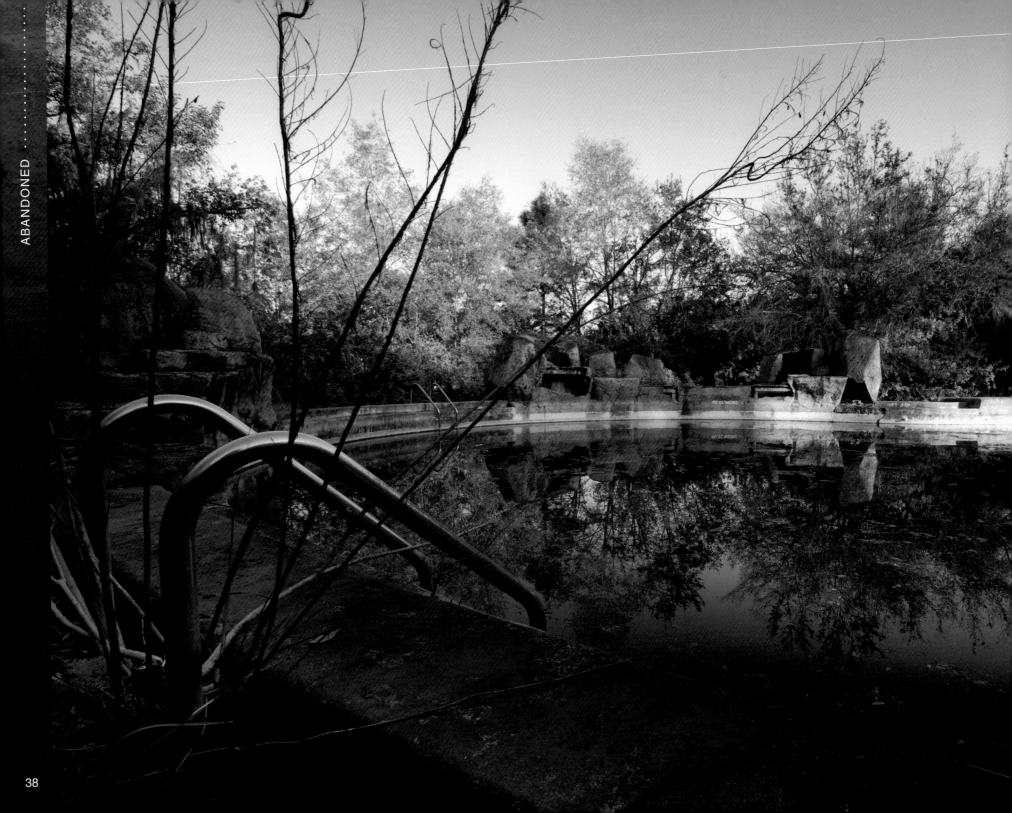

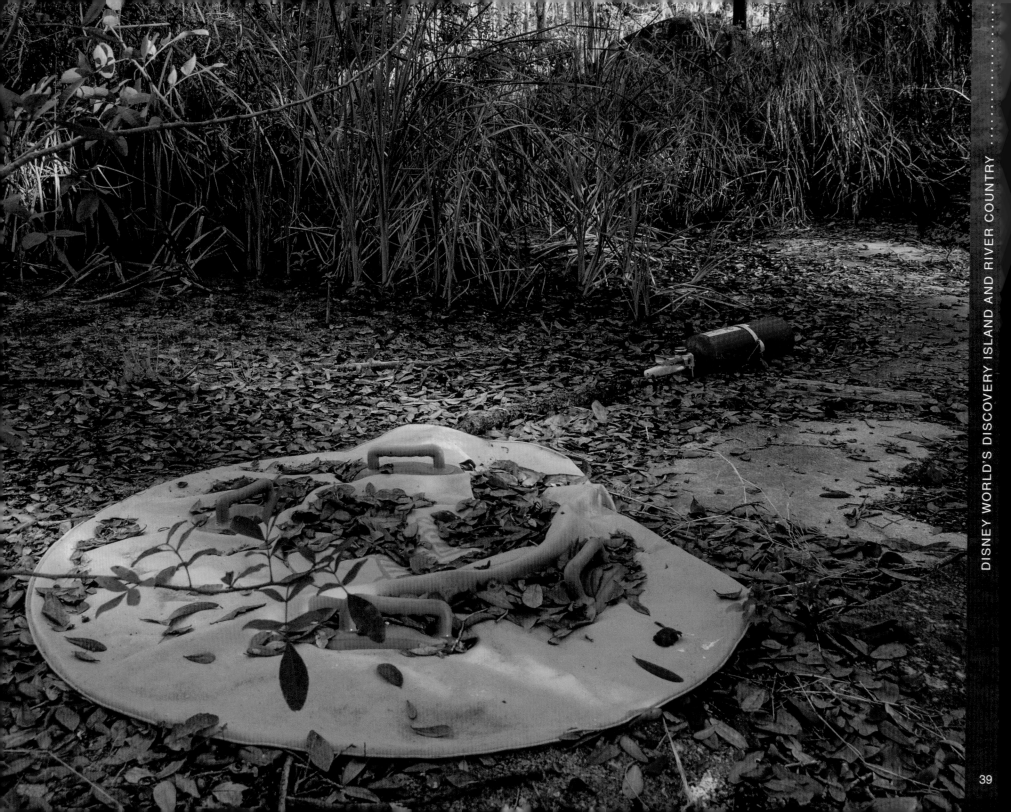

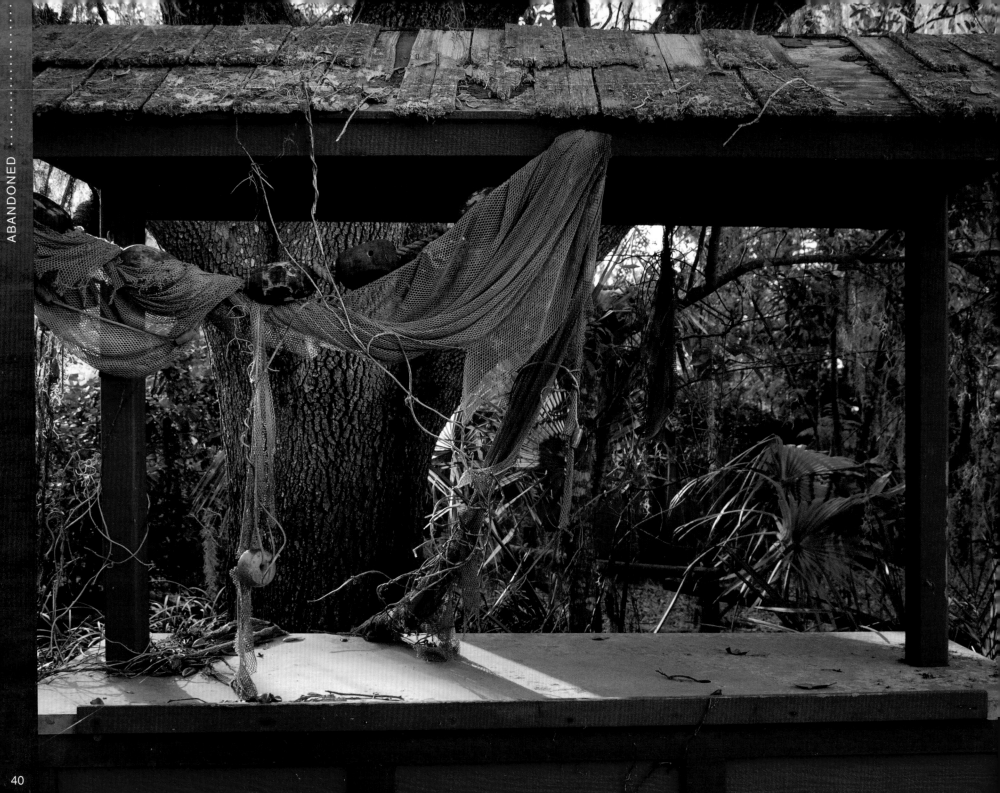

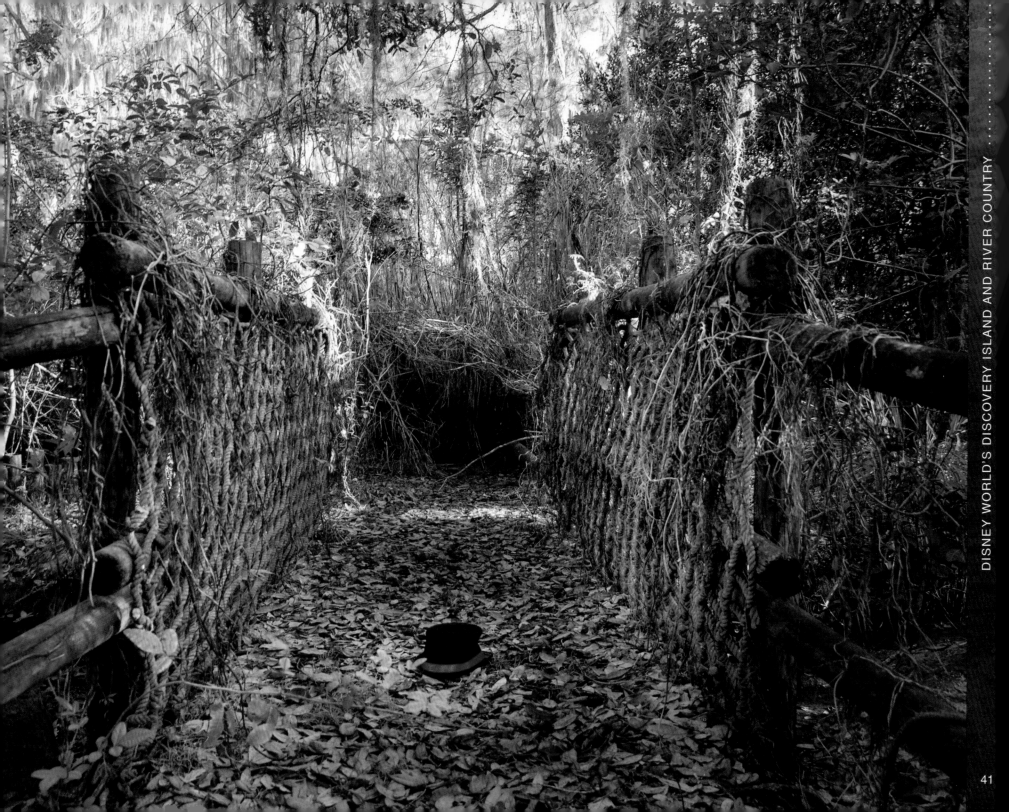

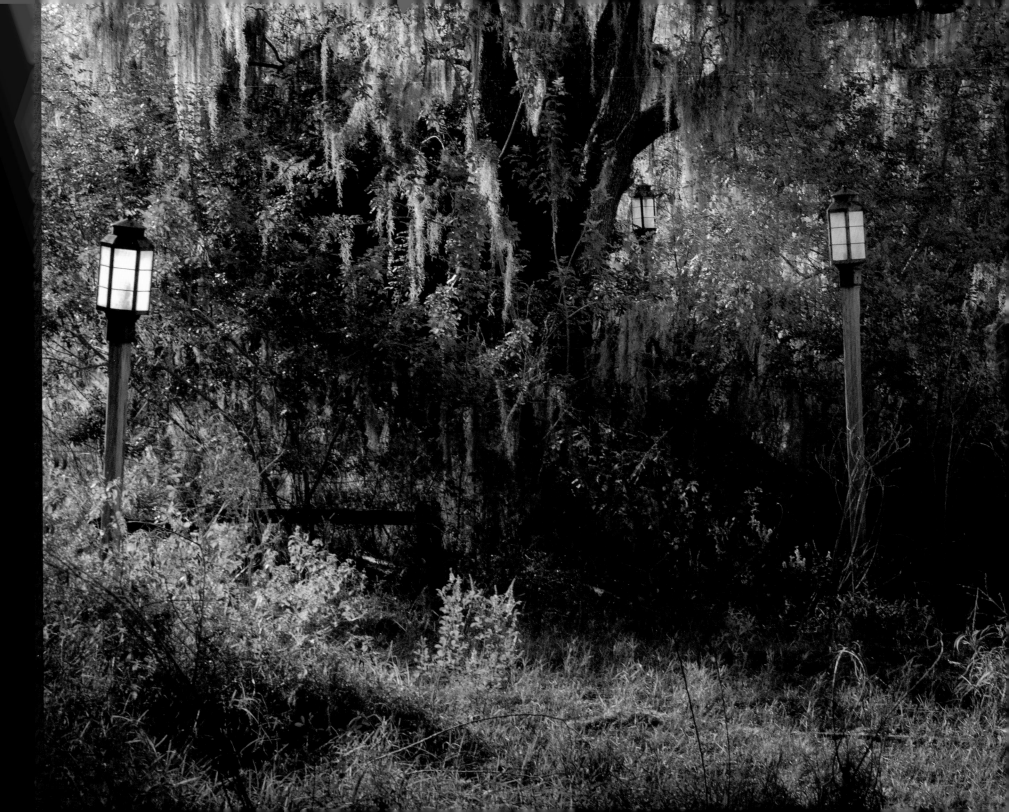

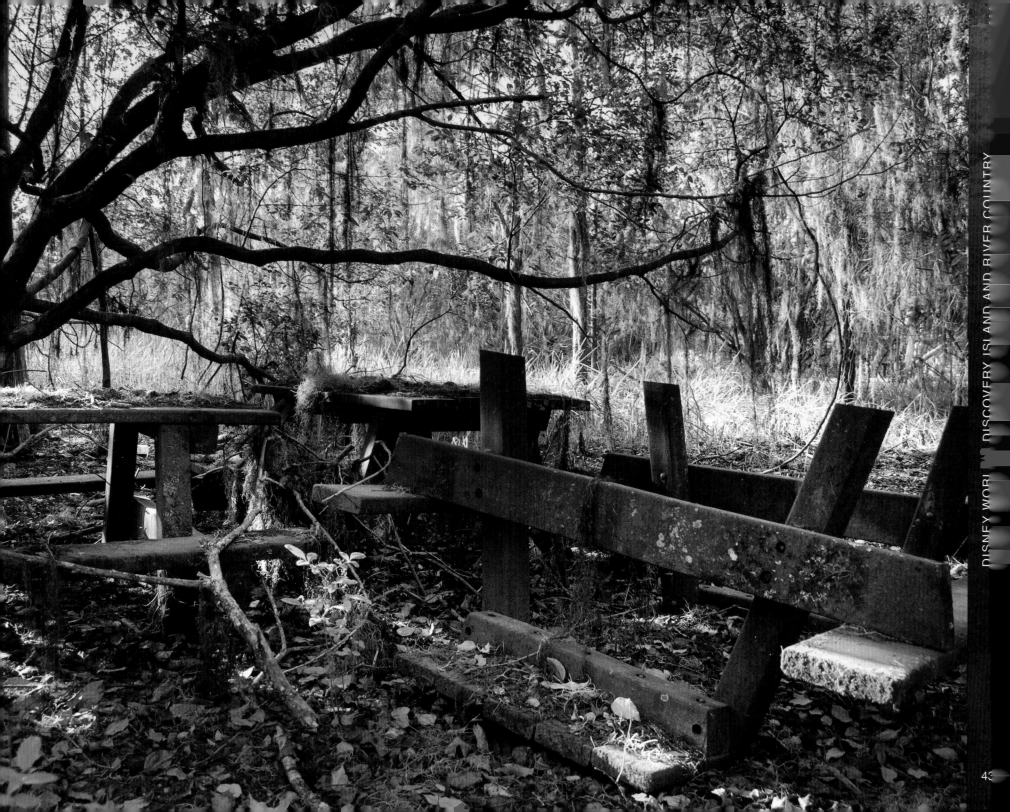

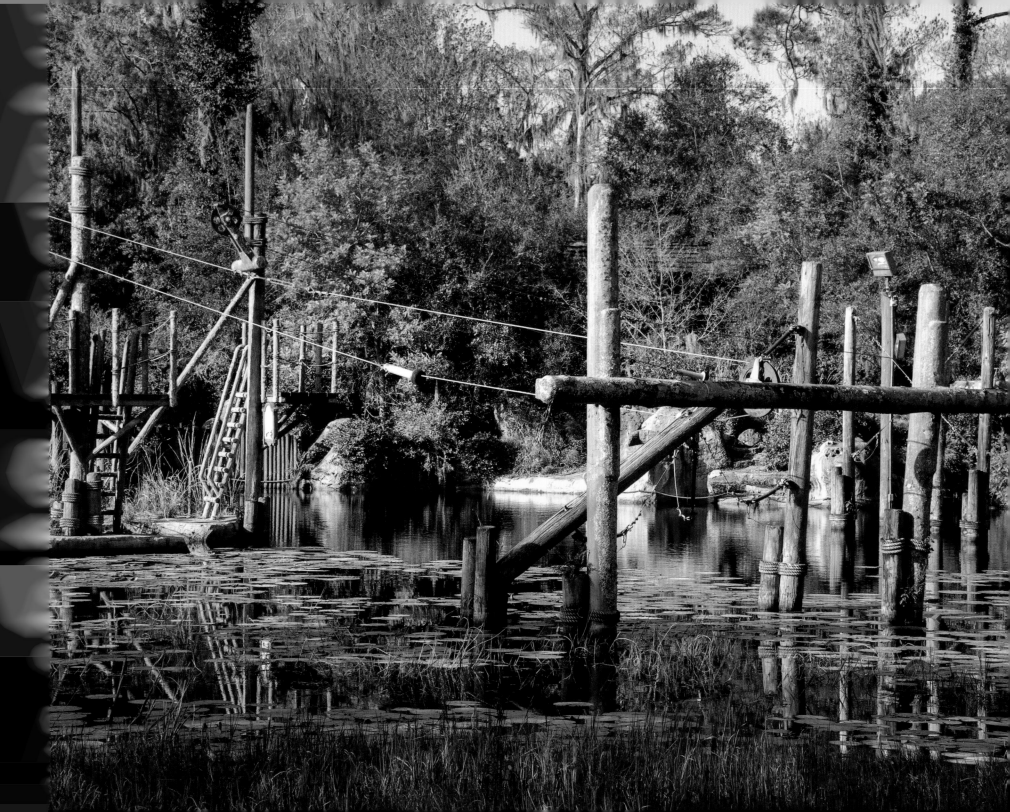

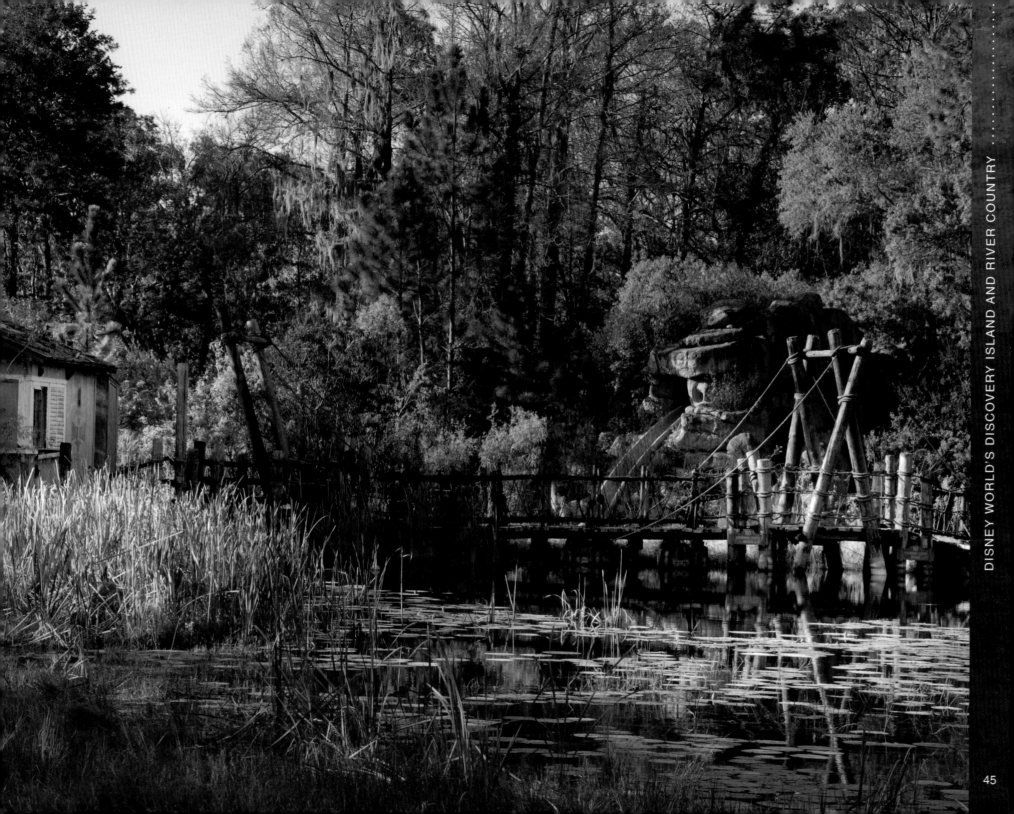

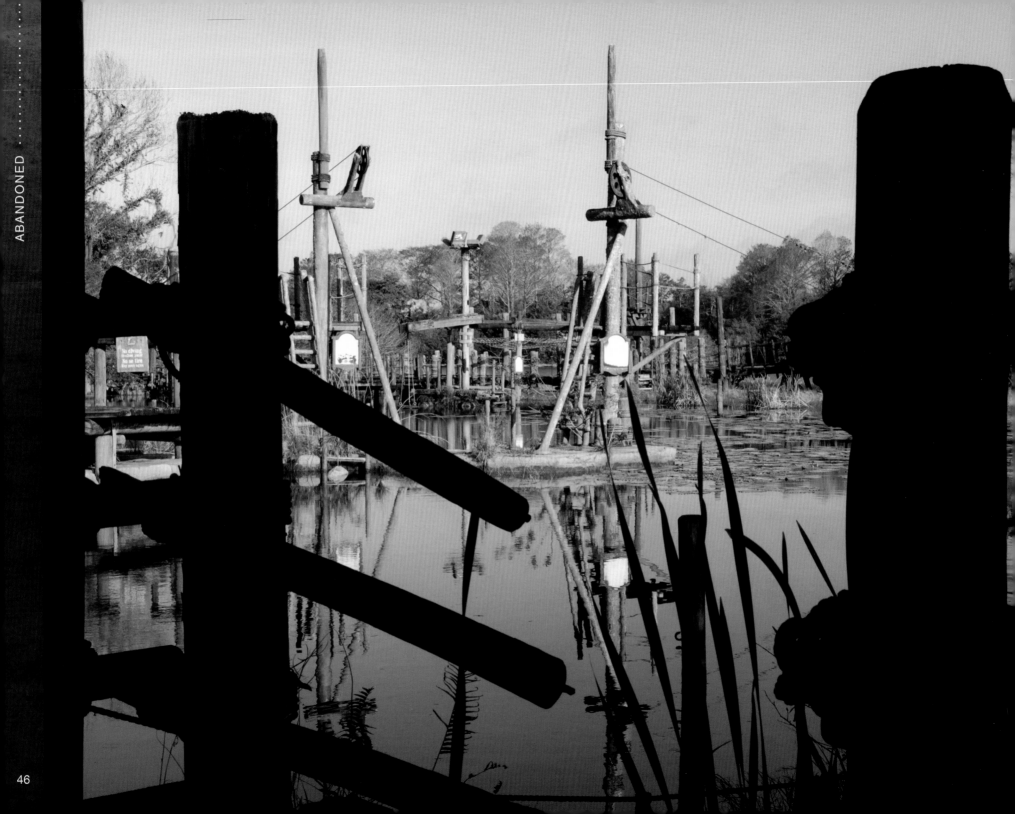

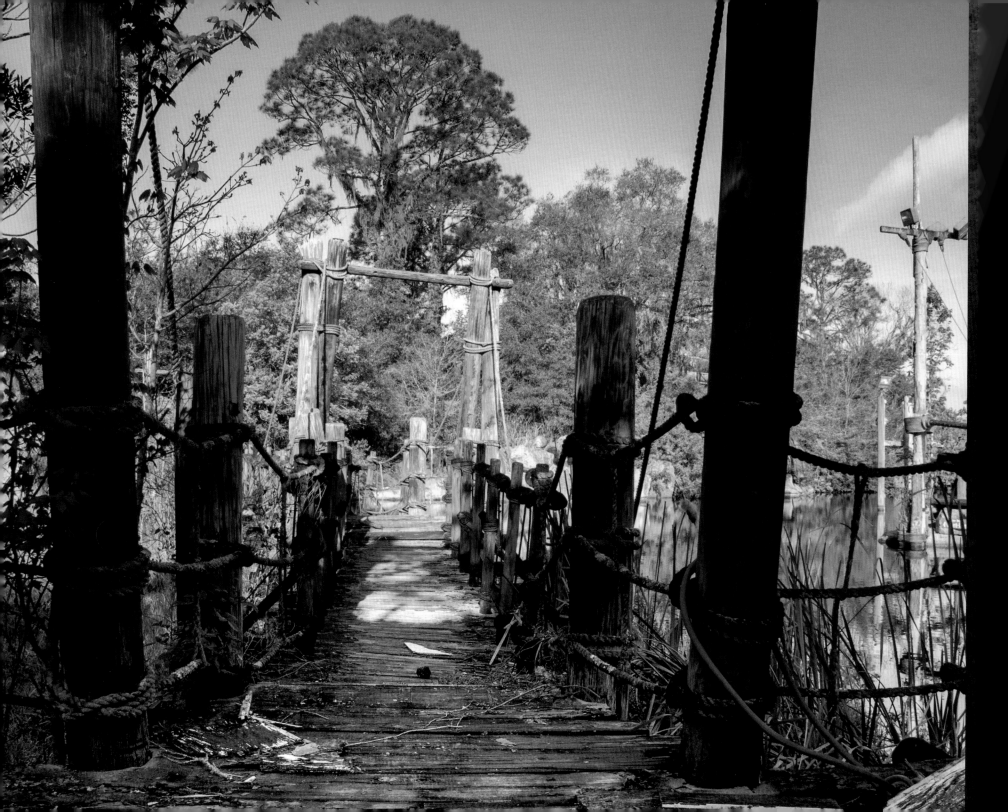

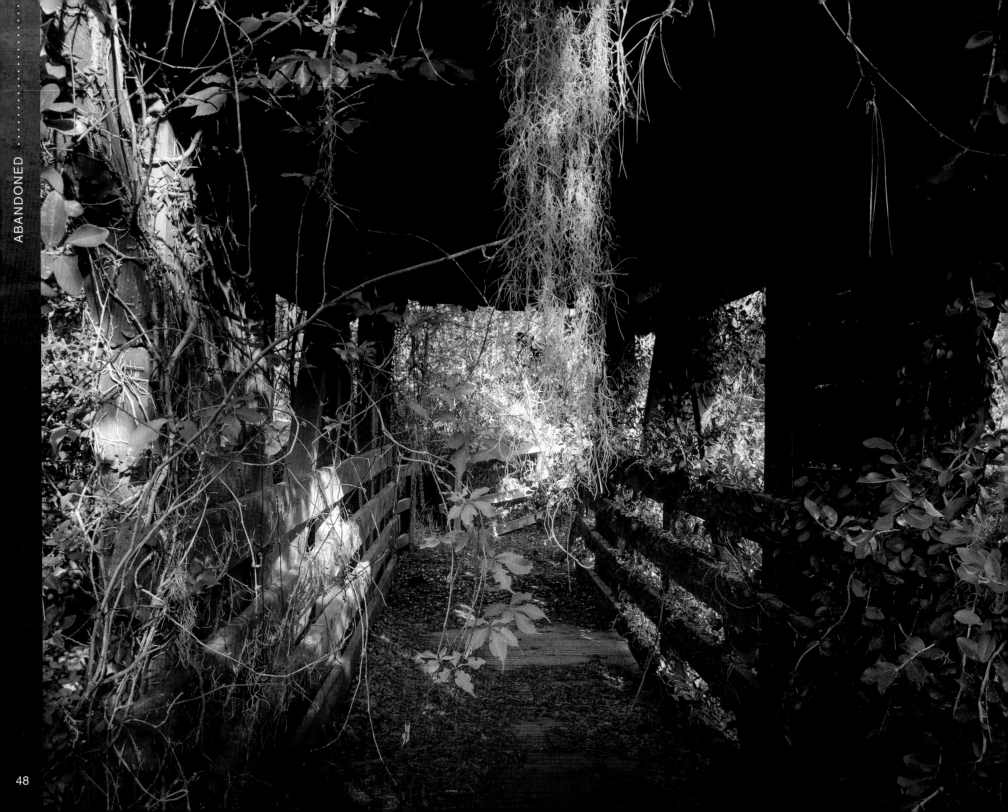

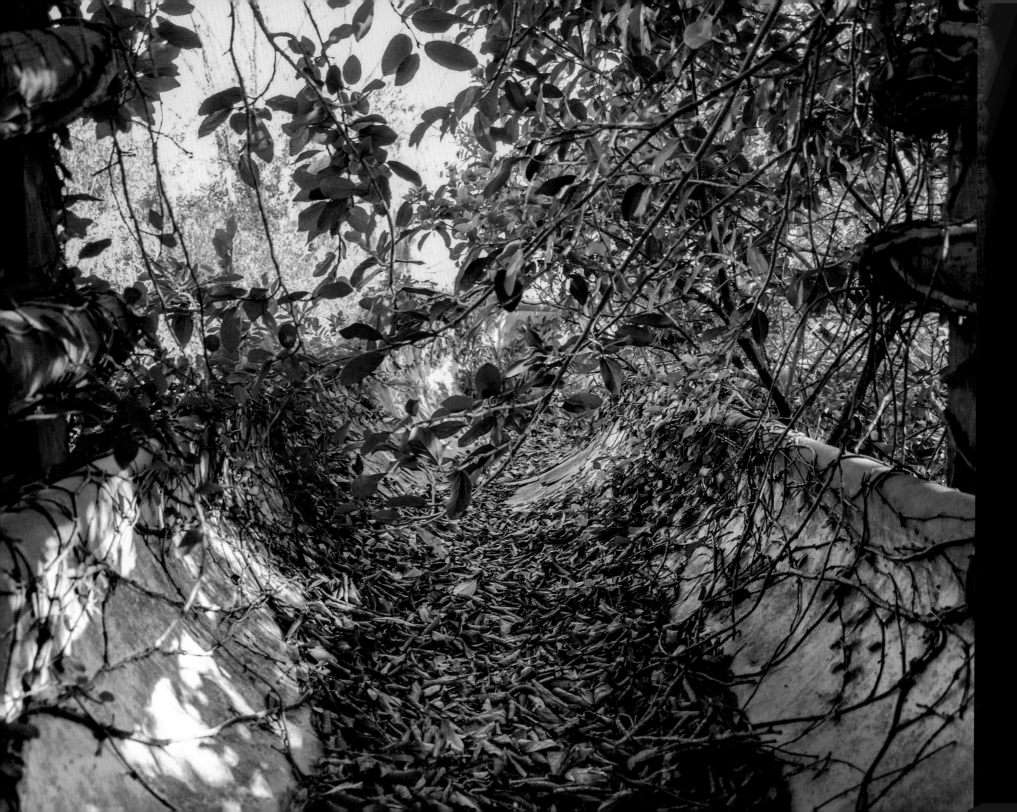

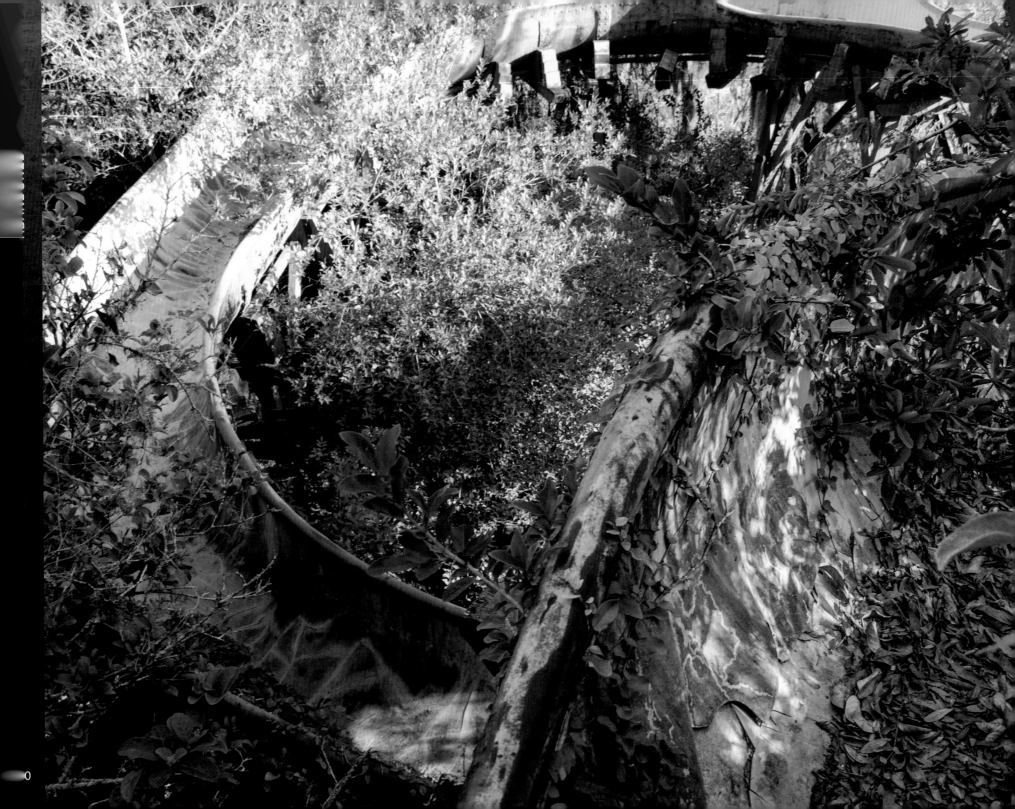

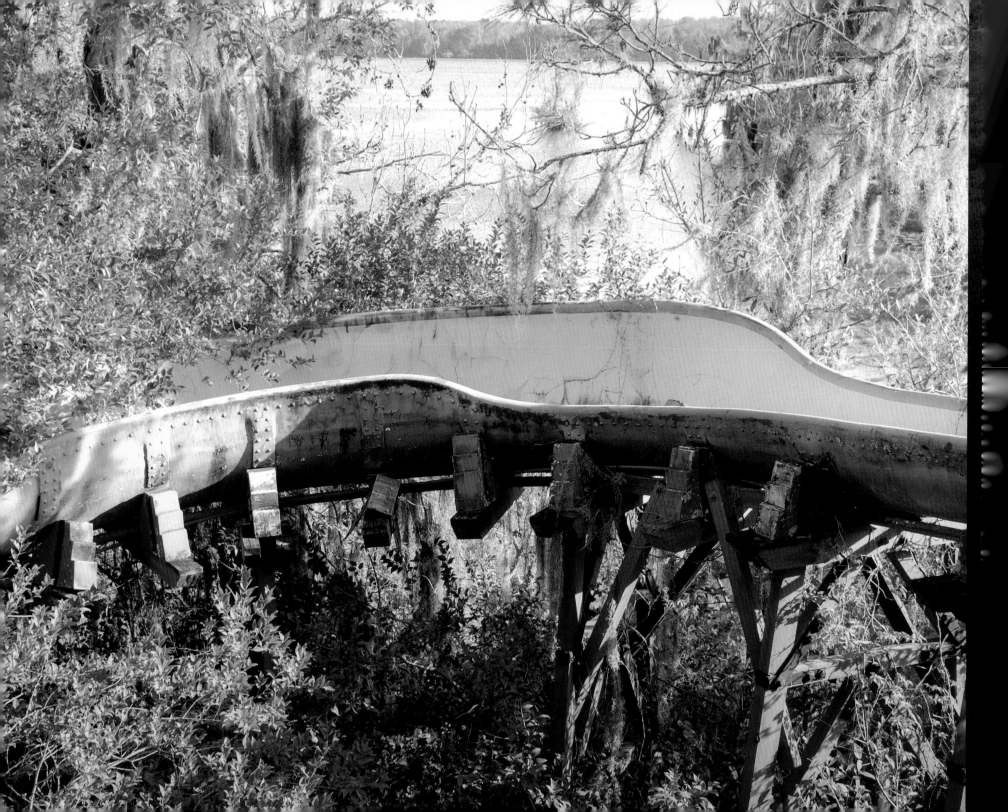

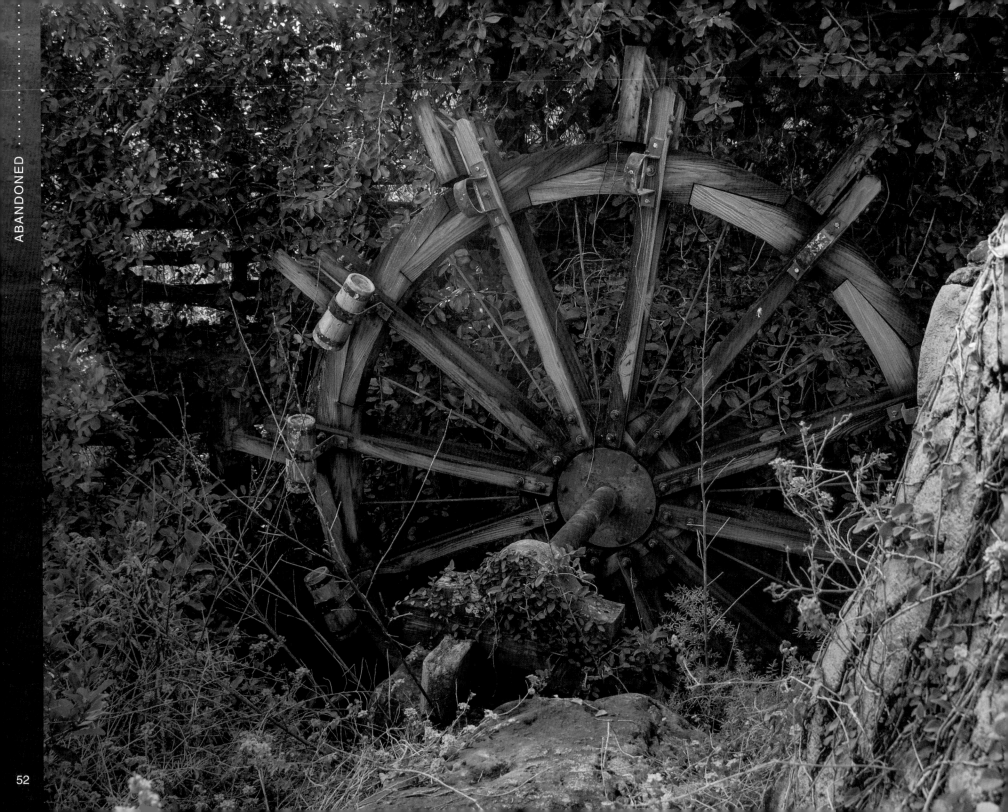

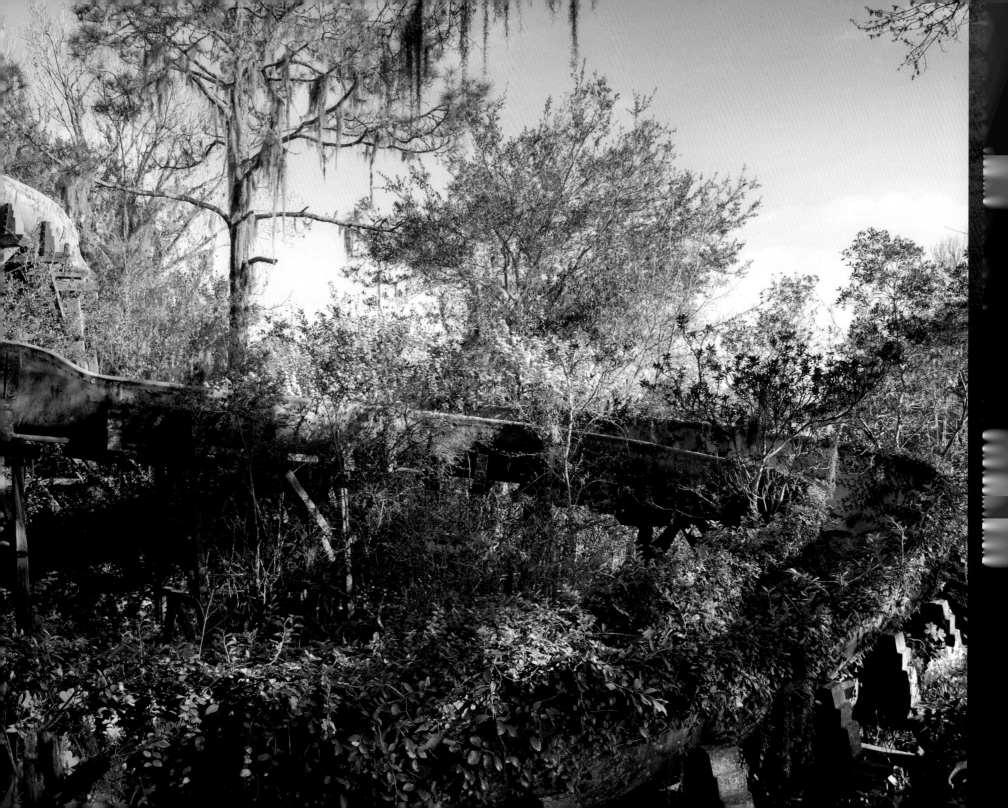

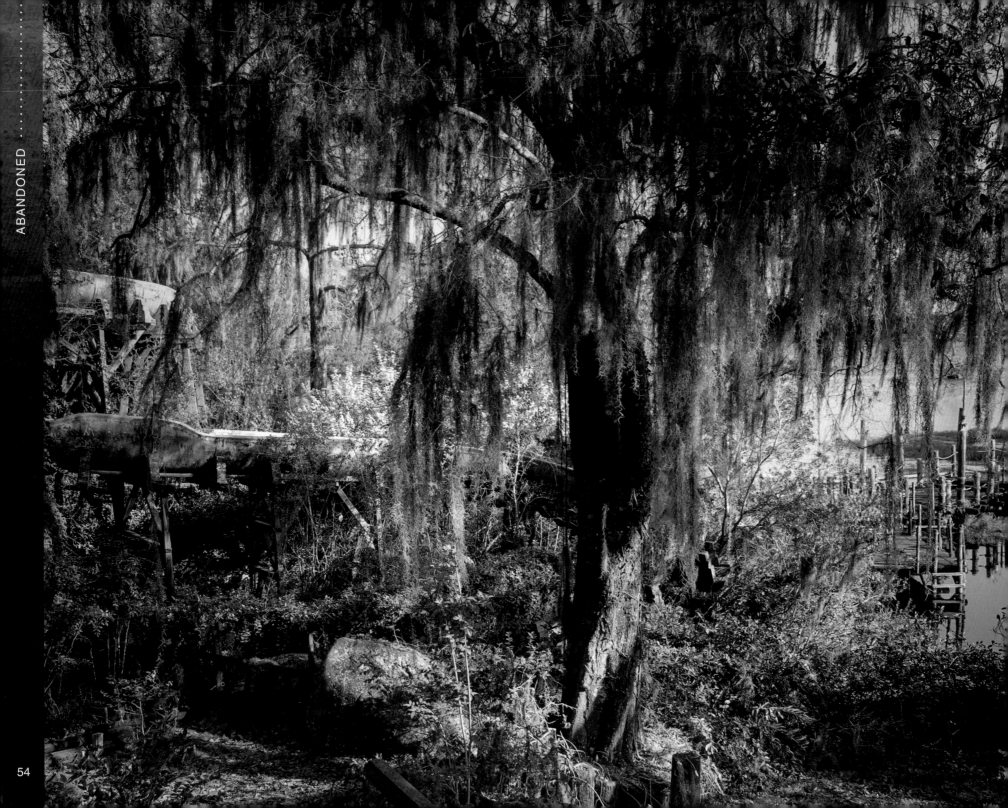

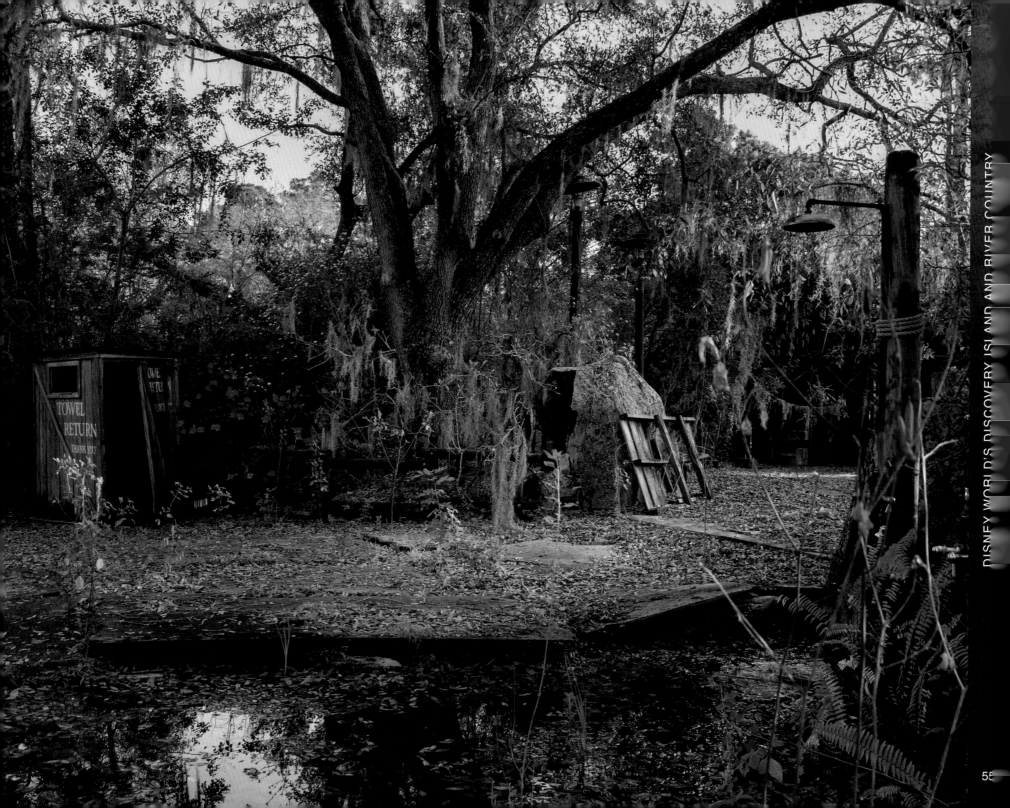

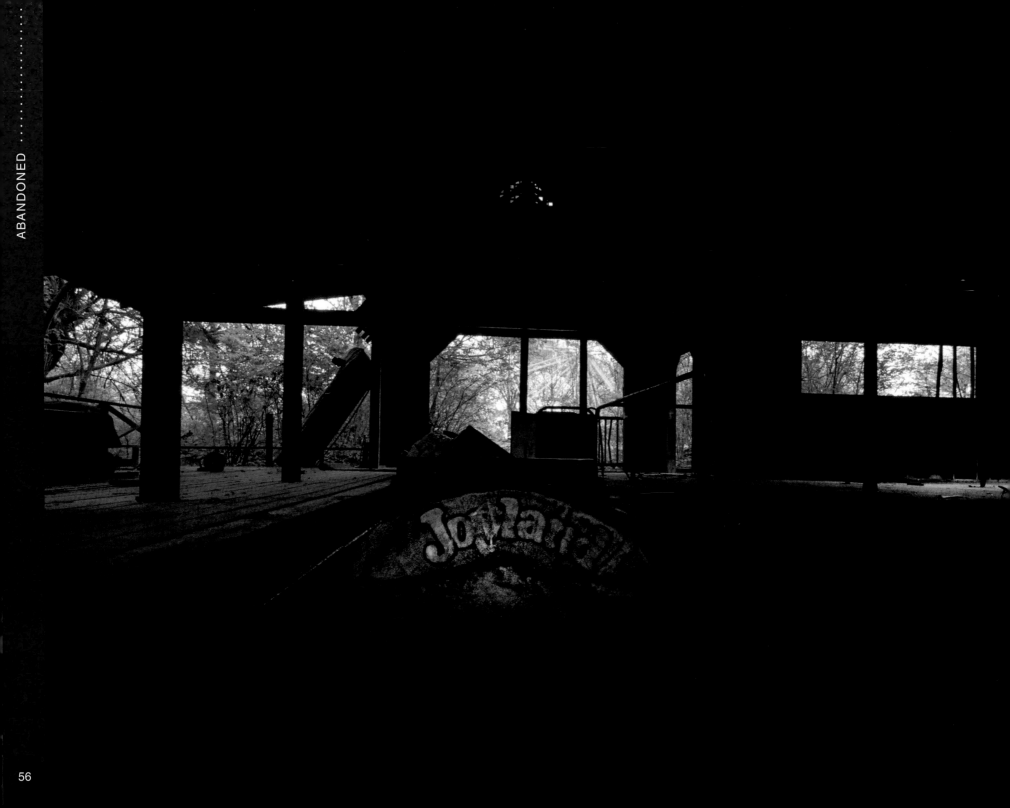

JOYLAND AMUSEMENT PARK

WICHITA, KANSAS
1949–2006

Joyland Amusement Park in Wichita, Kansas, was a joy to photograph. It was best known for the park's attraction, Joyland's Wacky Shack, among other rides.

The iconic yellow Ferris wheel still eerily stands among the ruins. It was opened in 1949 and was the site of a tragic accident in 2004, in which a young girl fell fifty feet from the top of the ride and was critically injured, causing the park to close for the 2004 season and inevitably lead to its permanent closure in 2006.

Photographing this abandoned theme park proved challenging, even potentially deadly, for me. You can see throughout my series of photographs taken within about sixty minutes of each other how rapidly the sky suddenly changes. Dark, ominous clouds can be seen moving quickly overhead.

Suddenly, a massive storm cell moved over me as I took the last image of the Wacky Shack. I remember looking up and seeing nothing but black as the sun was swallowed by the dark clouds. Hail bounced off the pavement below me as I sprinted out of the park back to my car. I was so caught up in the tranquil beauty of the abandoned park that I forgot that I was in Kansas during tornado season. I immediately took off in my car, speeding in the opposite direction, and ended up in St. Louis that night.

Later that night, I saw on the news that the same storm cell that hovered over me in those last moments produced nine tornados and went on to devastate parts of Oklahoma and Texas with wind damage and floods. This abandoned amusement park journey was one of the most exciting but frightening experiences I have ever endured. The park suffered extensive damage during that storm, and any surviving rides were demolished shortly thereafter, making these the last photographs ever taken of Joyland.

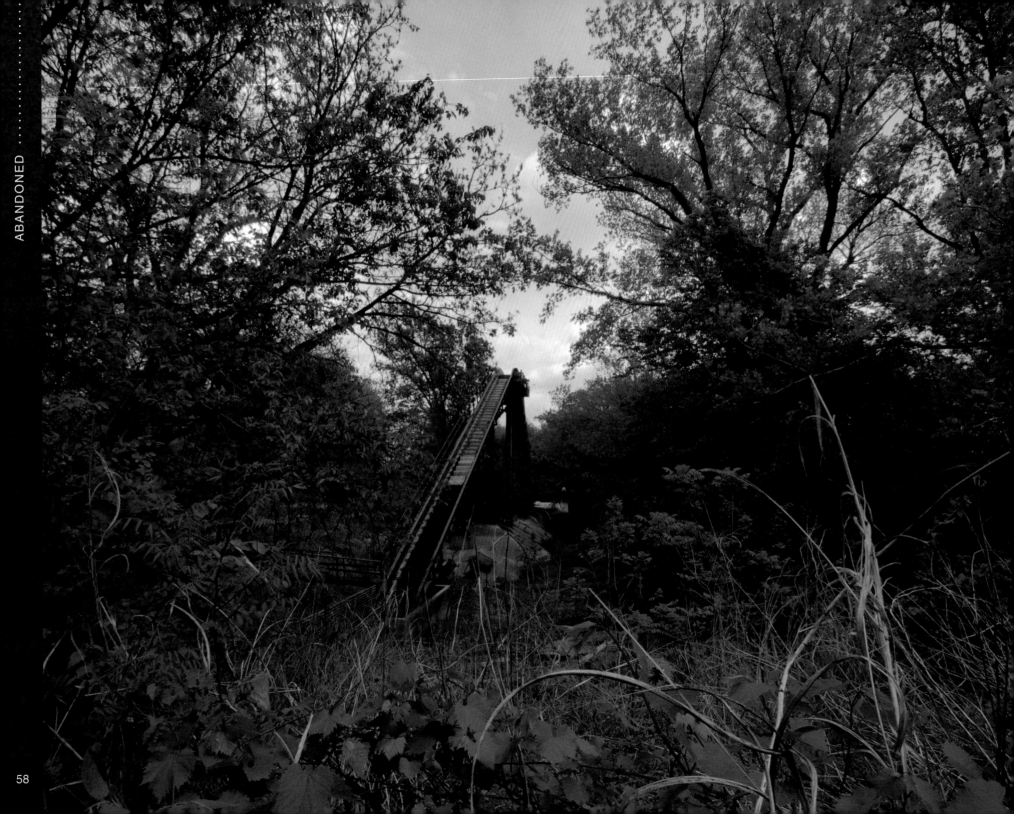

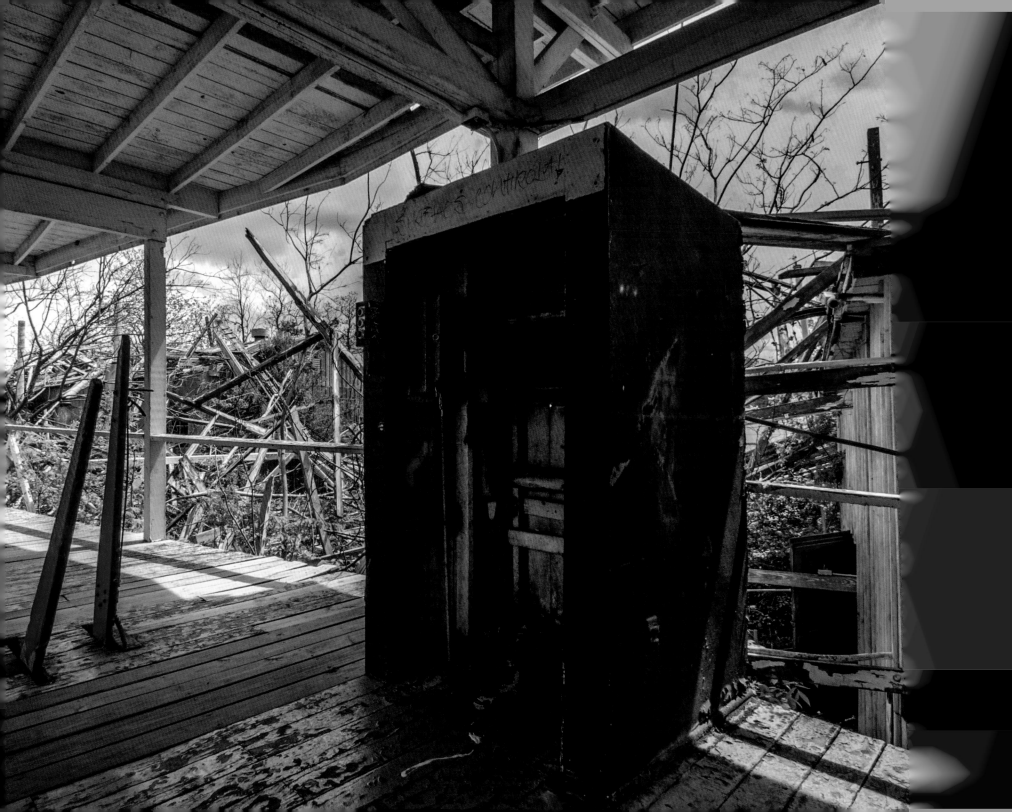

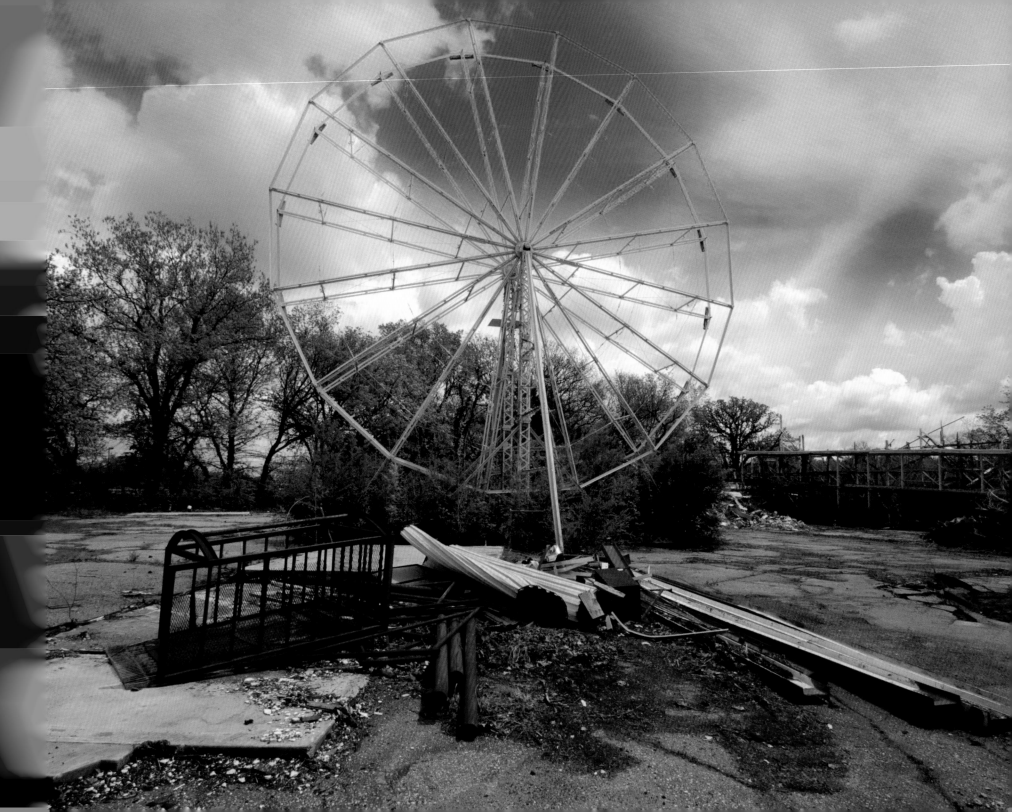

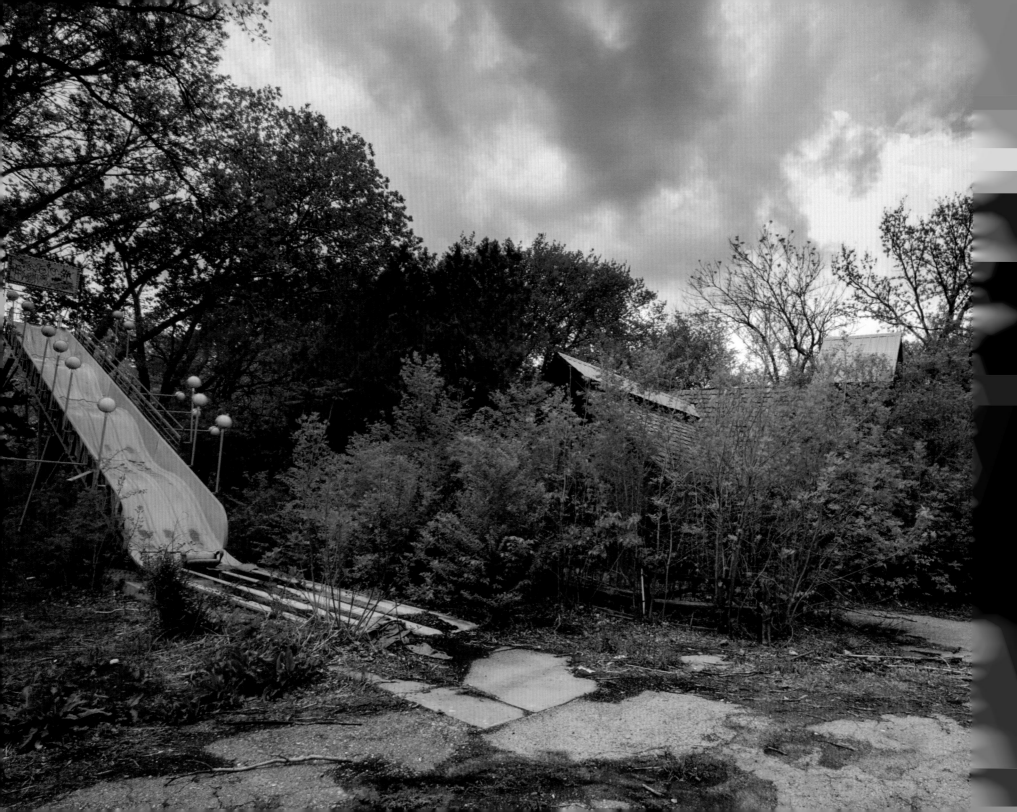

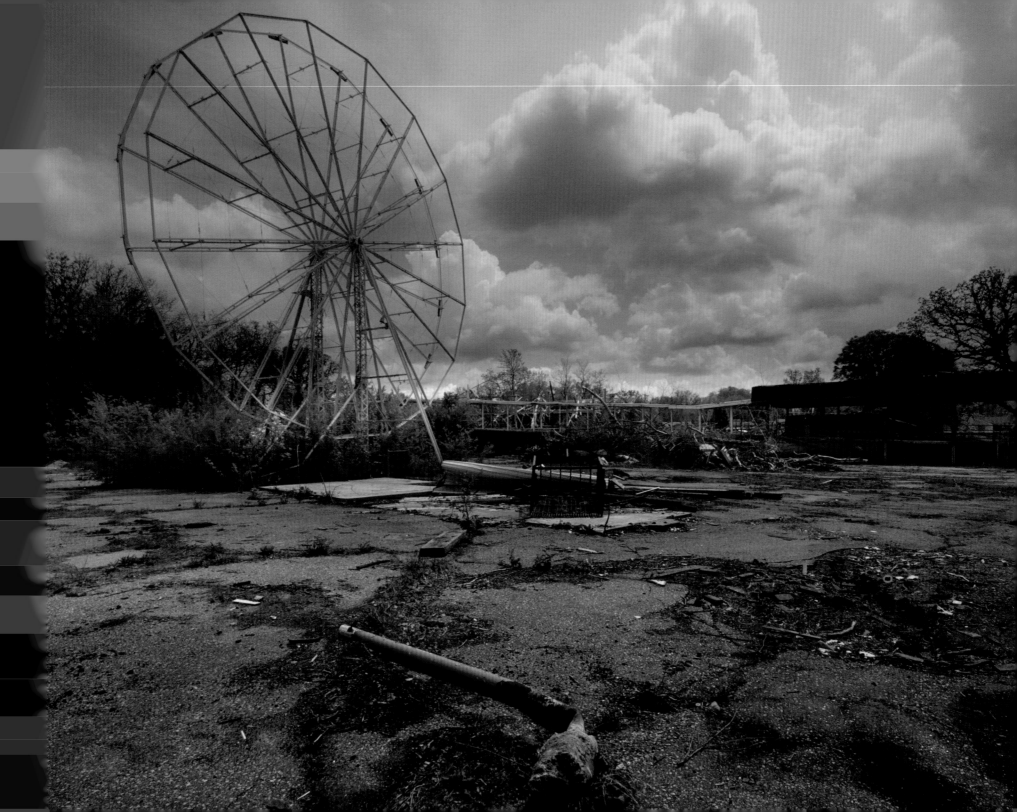

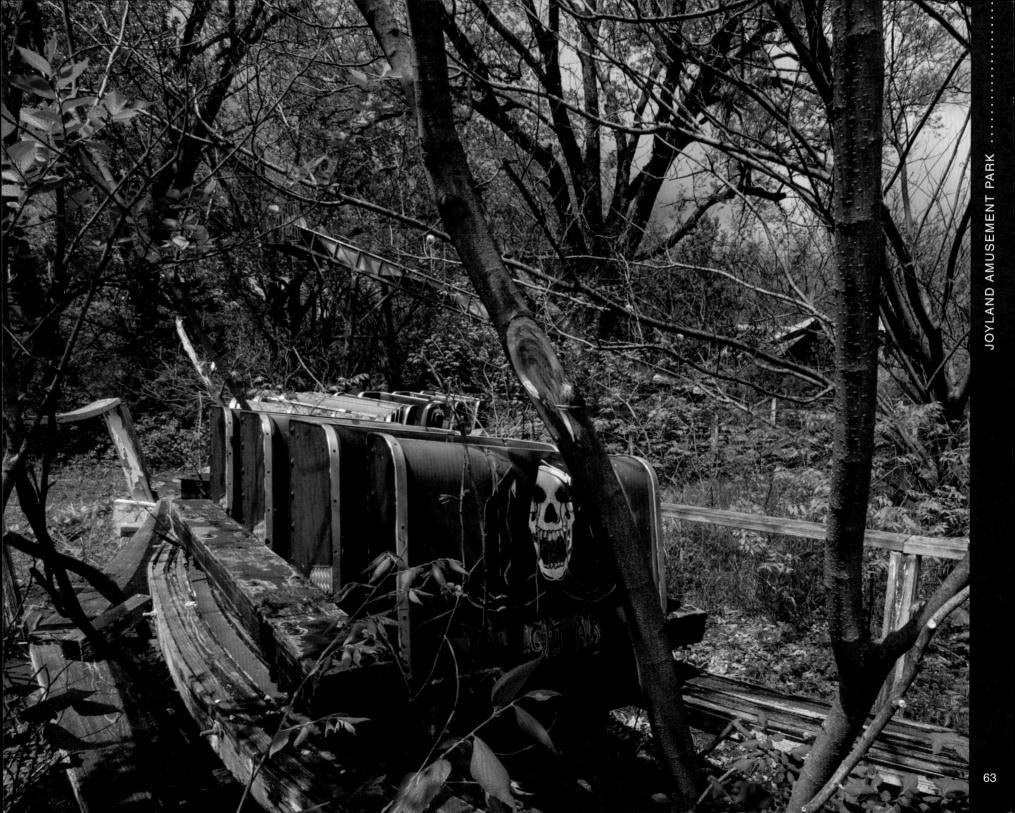

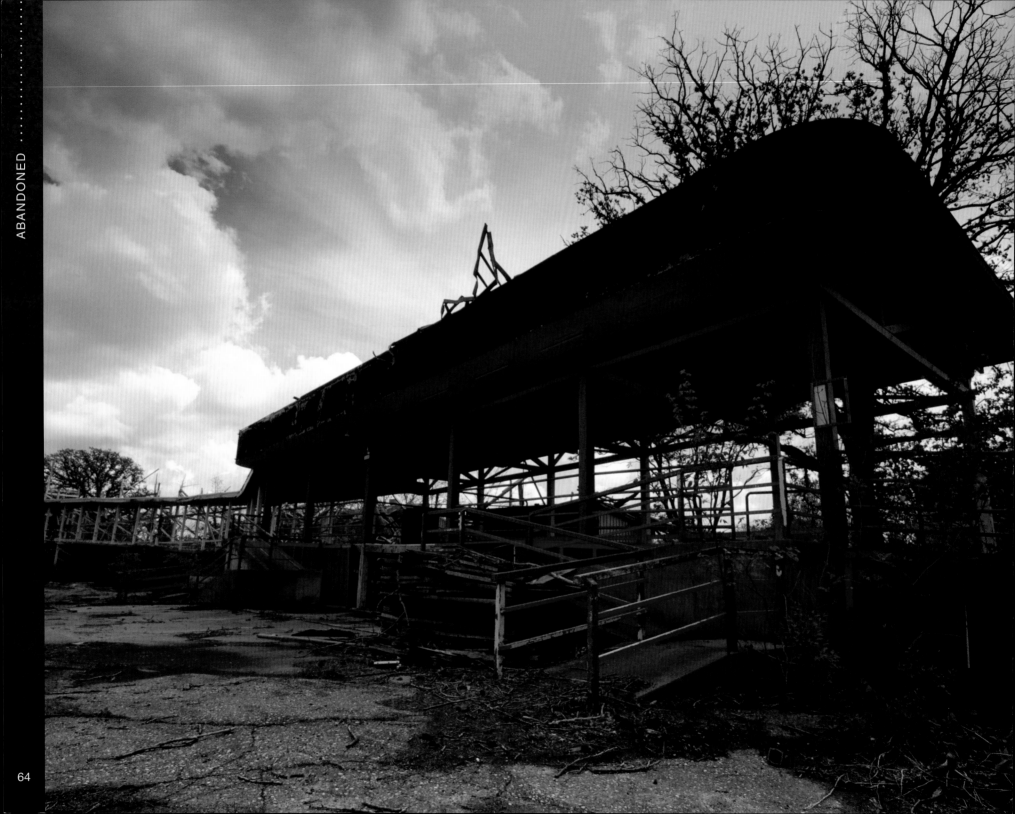

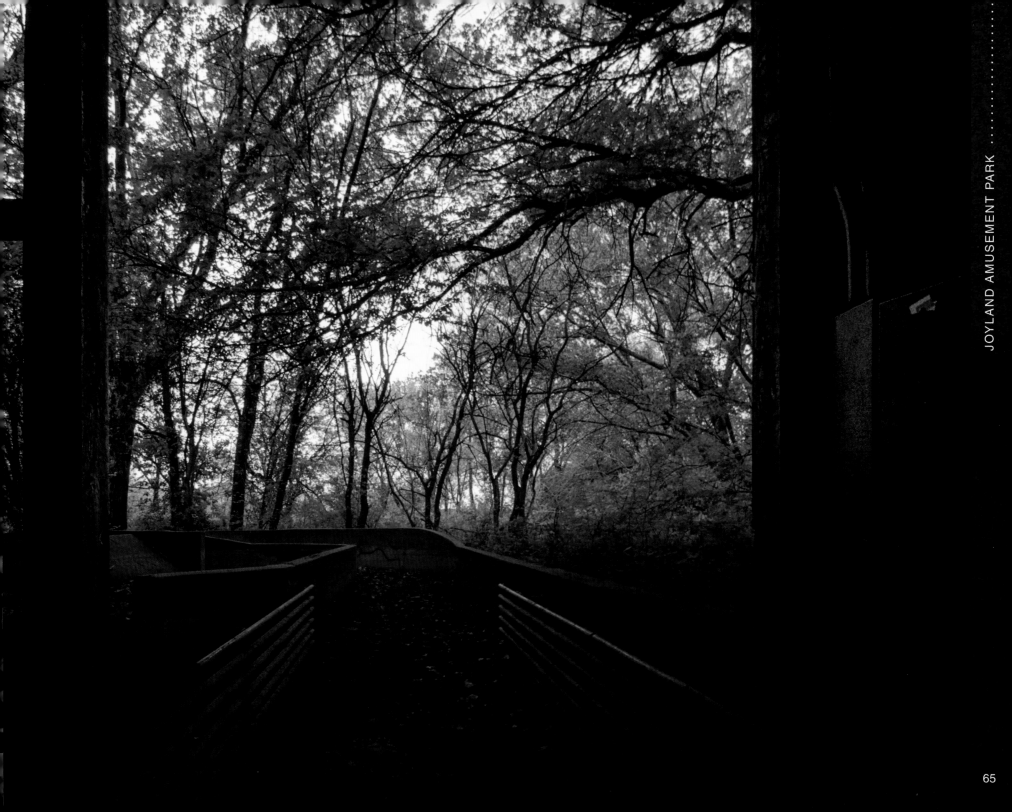

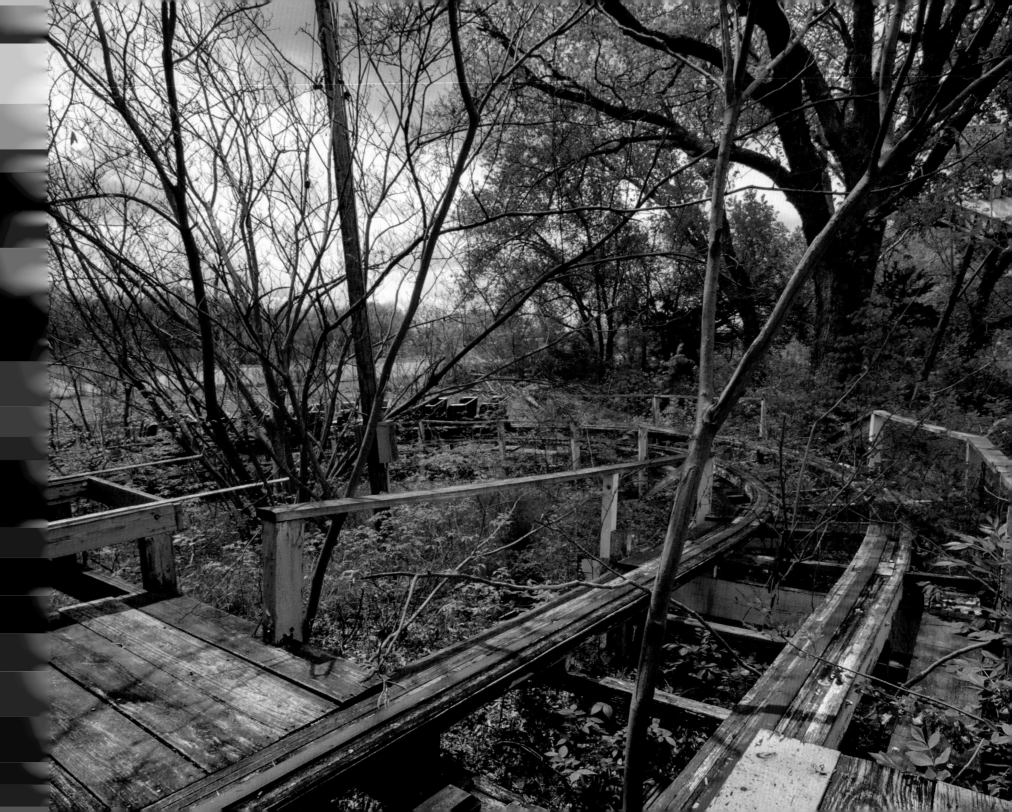

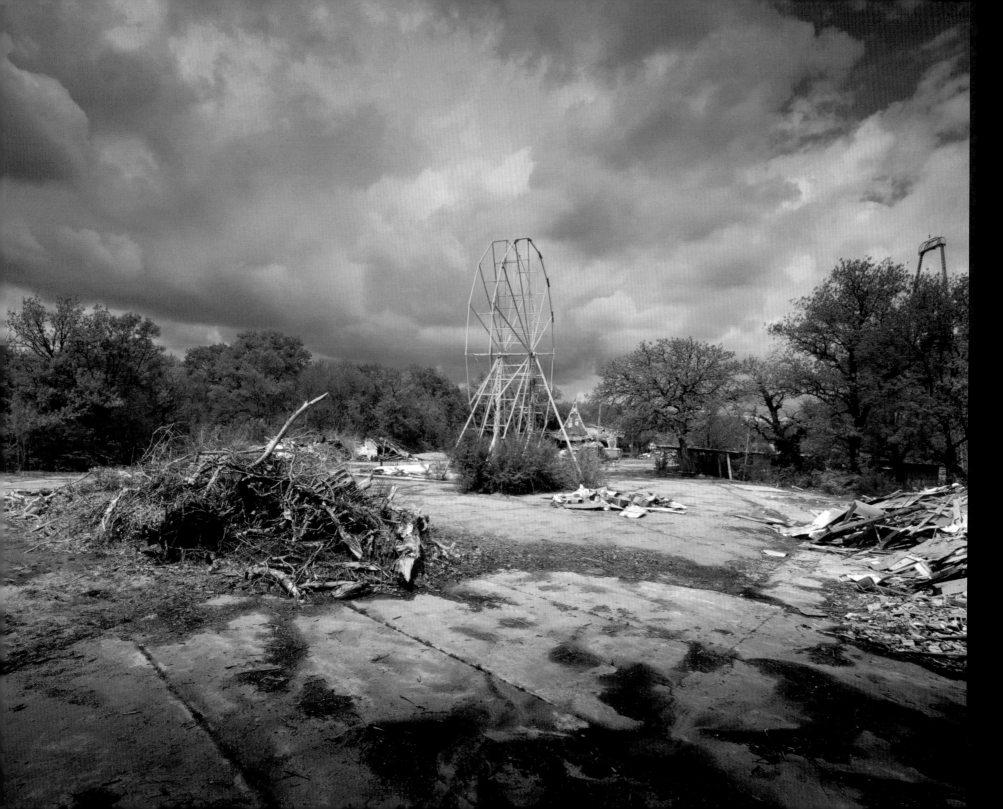

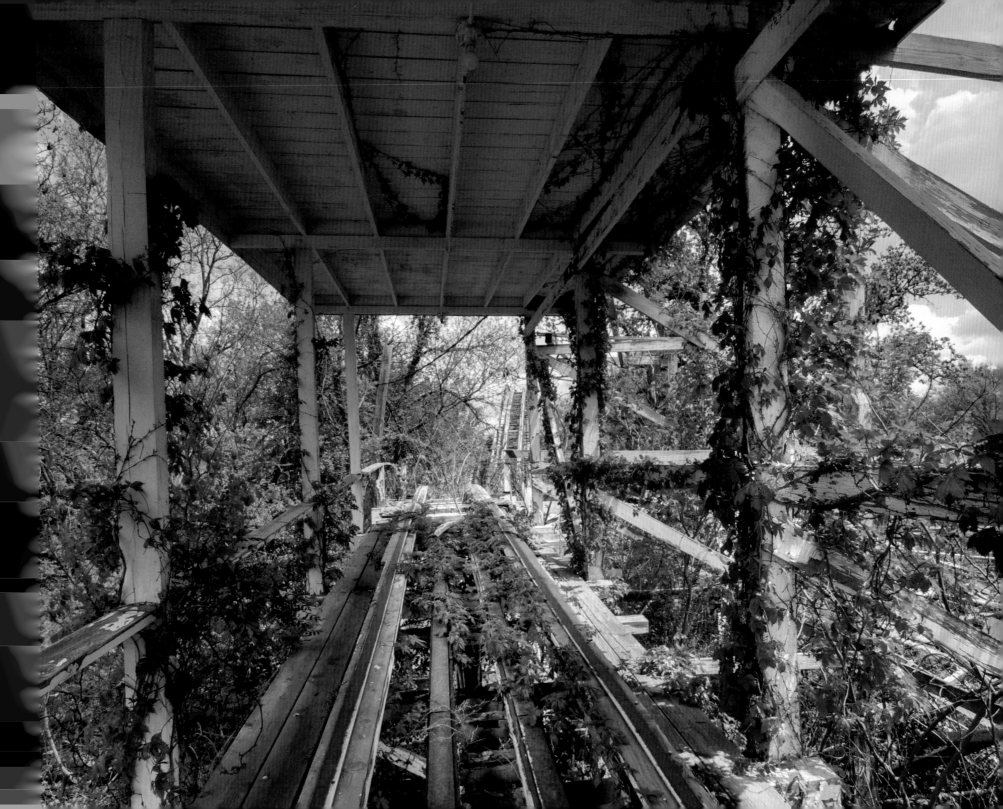

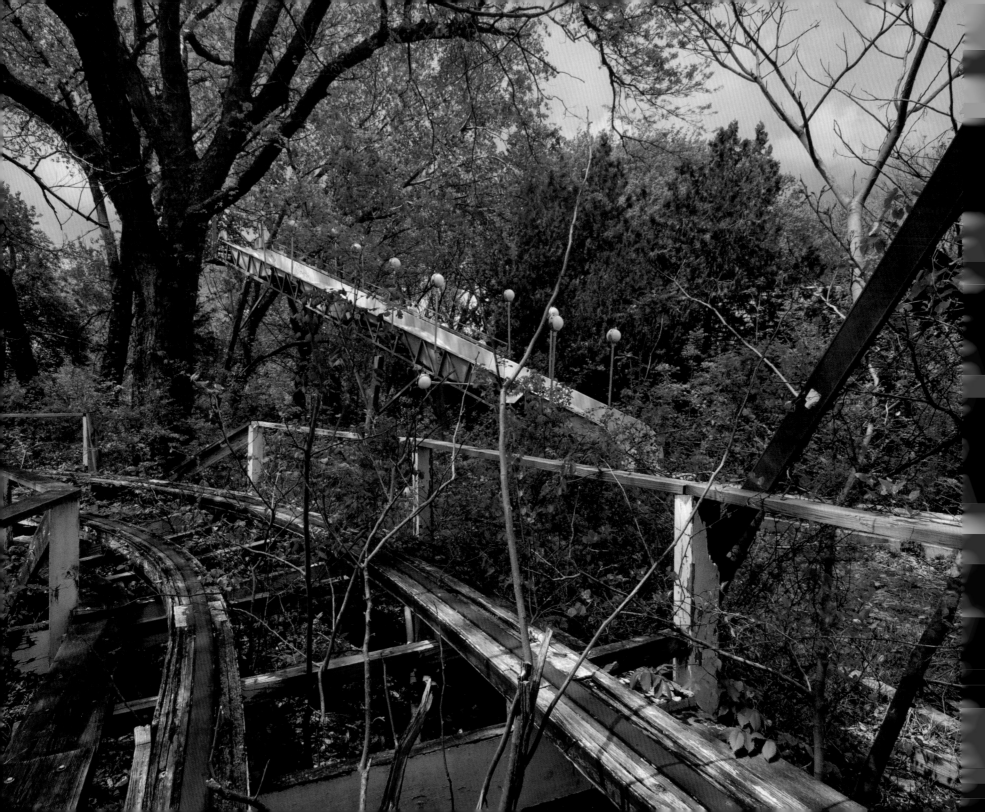

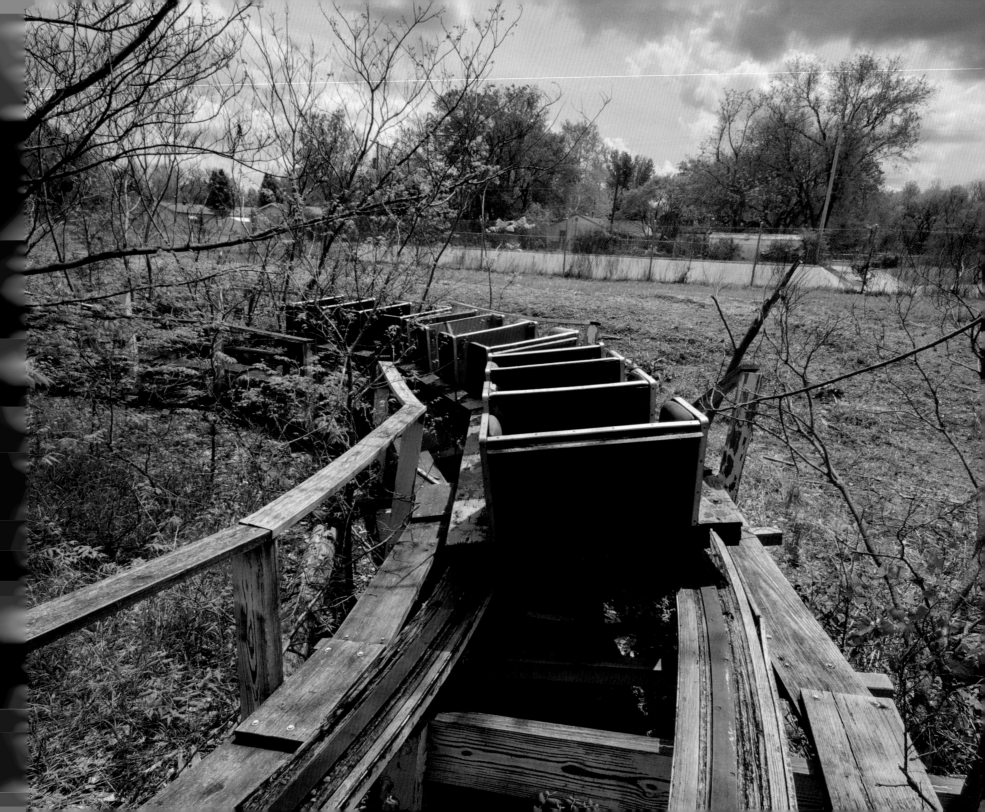

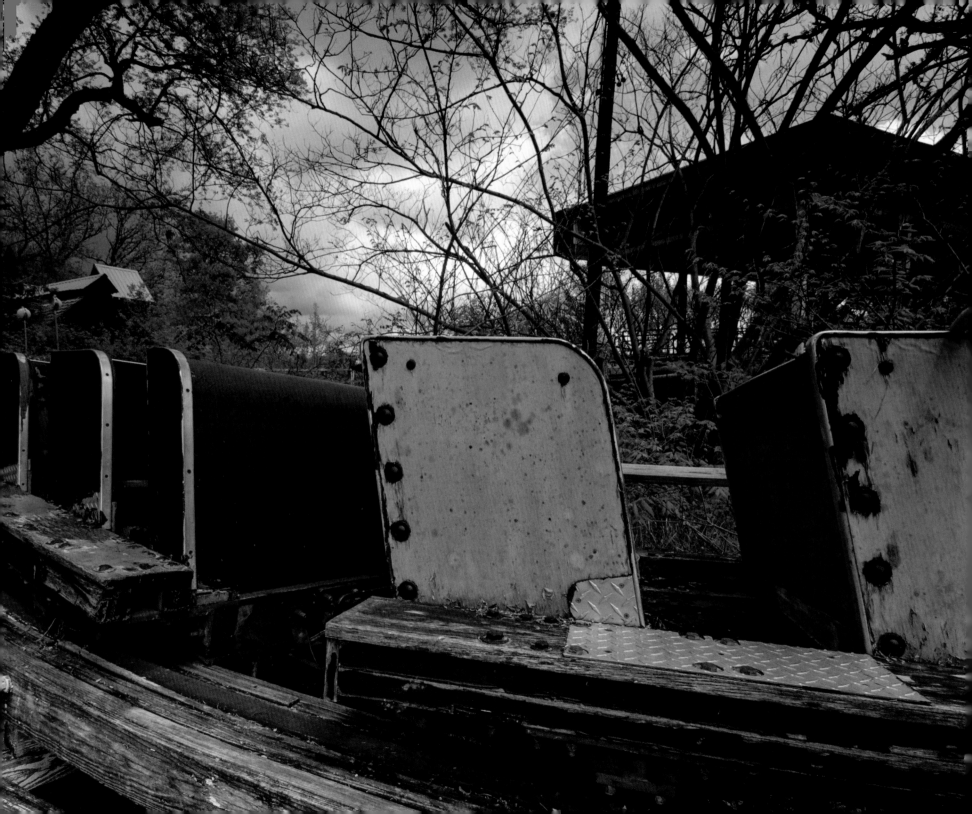

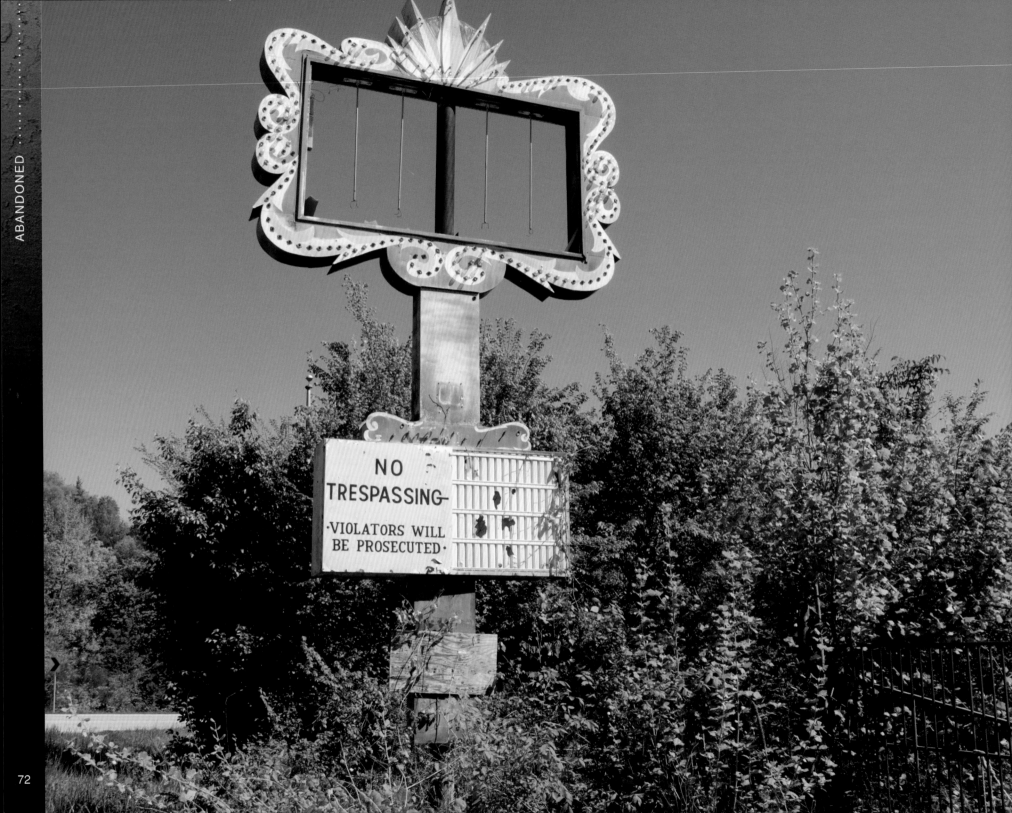

DOGPATCH USA

MARBLE FALLS, ARKANSAS
(1968–1993)

Dogpatch USA opened in 1968. It was based on the popular comic strip "Li'l Abner" and set in a fictional village called Dogpatch.

Some Arkansas state officials and residents initially protested the creation of the theme park because they thought that it might encourage negative, Southern hillbilly stereotypes.

Since the town was set up as the fictional village Dogpatch, it consisted of a trout pond where patrons could catch their own fish and have the restaurant cook it for them. It also had a ride, which consisted of gas-powered model T cars that went around a wooded track. Other rides included a boat train, a rotating thrill ride called Hairless Joe's Kickapoo Barrel, and Li'l Abner's Space Rocket, a ride that simulated a journey into outer space. Earthquake McGoon's Brain Rattler was a toboggan rollercoaster, which appeared on opening day in 1968. The park also had natural caverns on the site; the popular tourist attractions were known as Dogpatch Caverns.

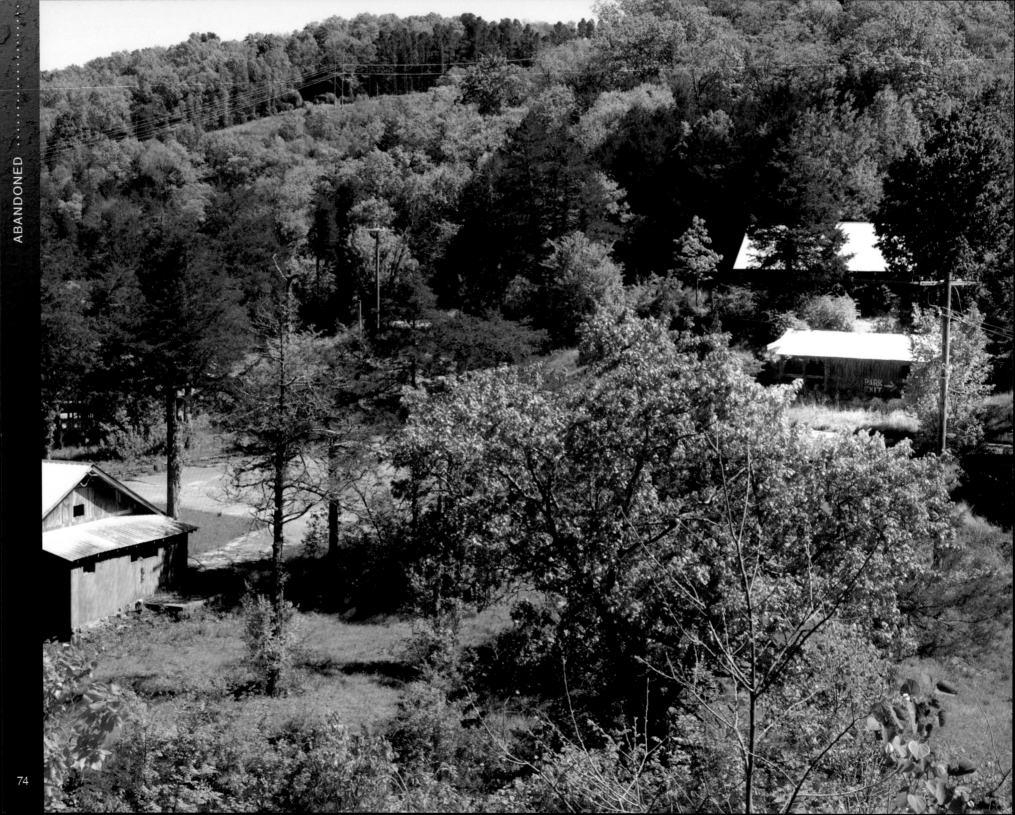

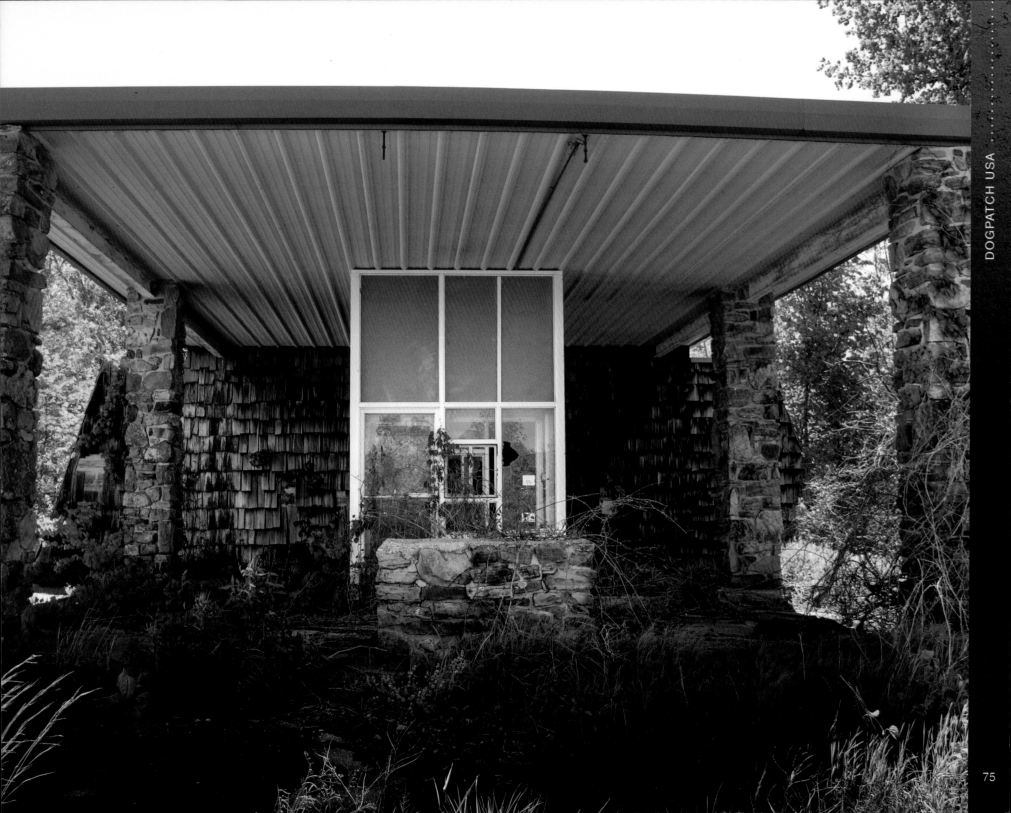

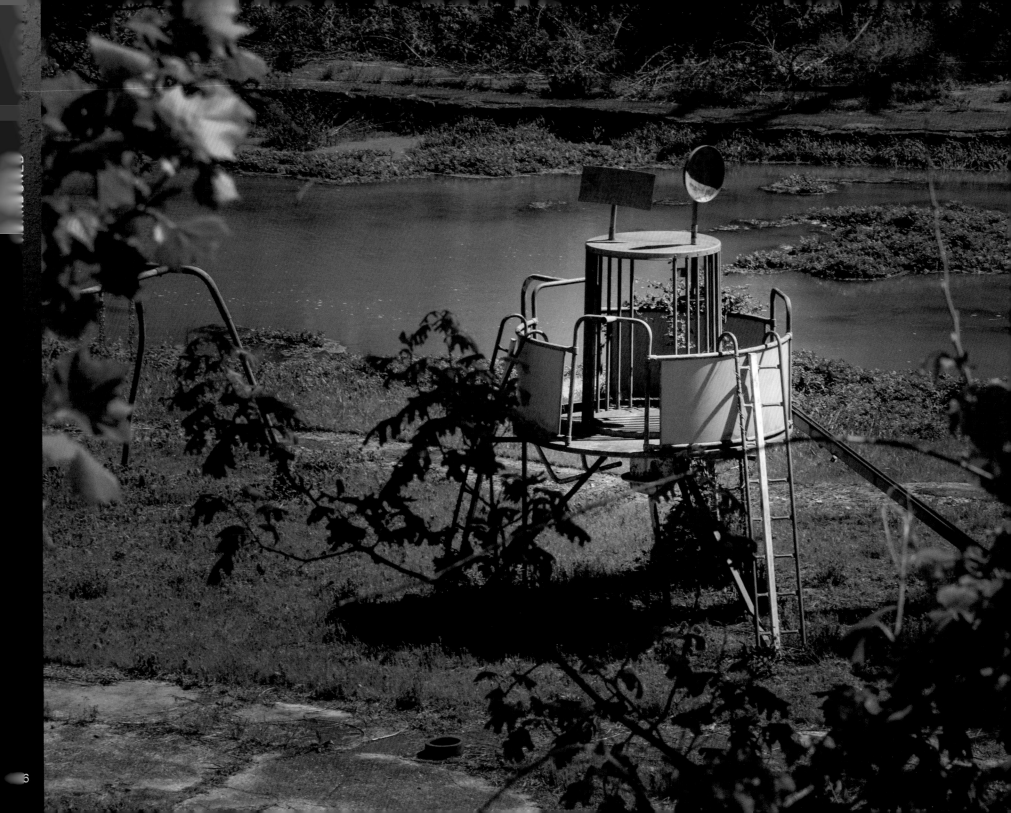

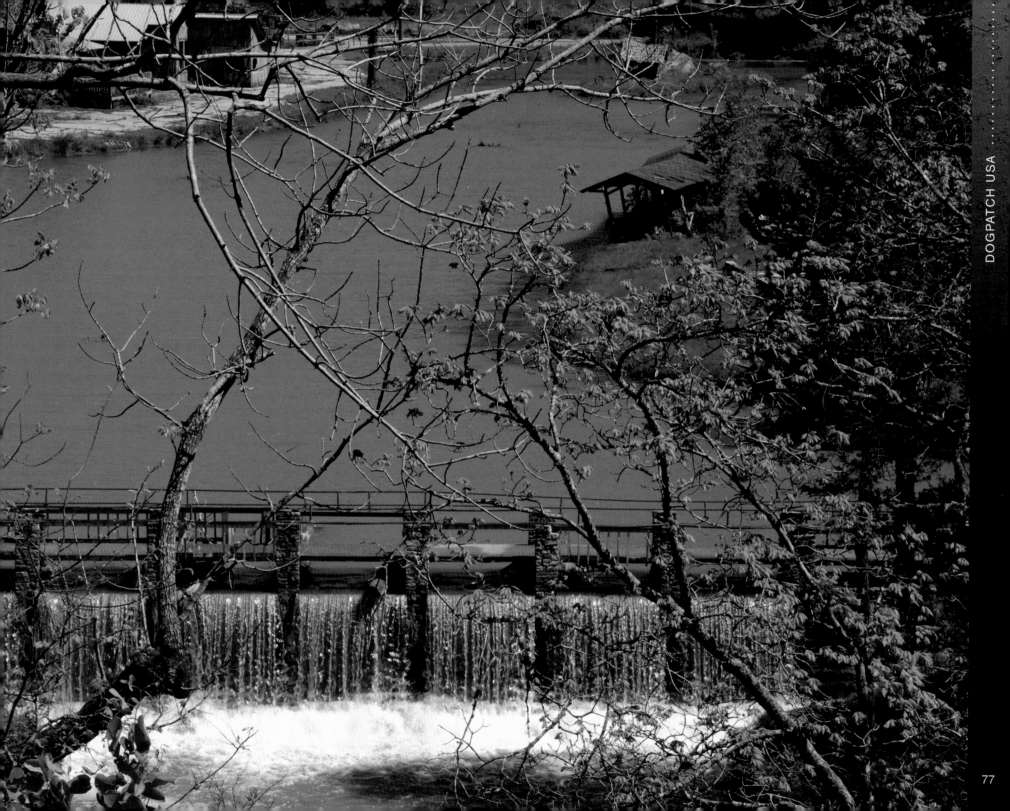

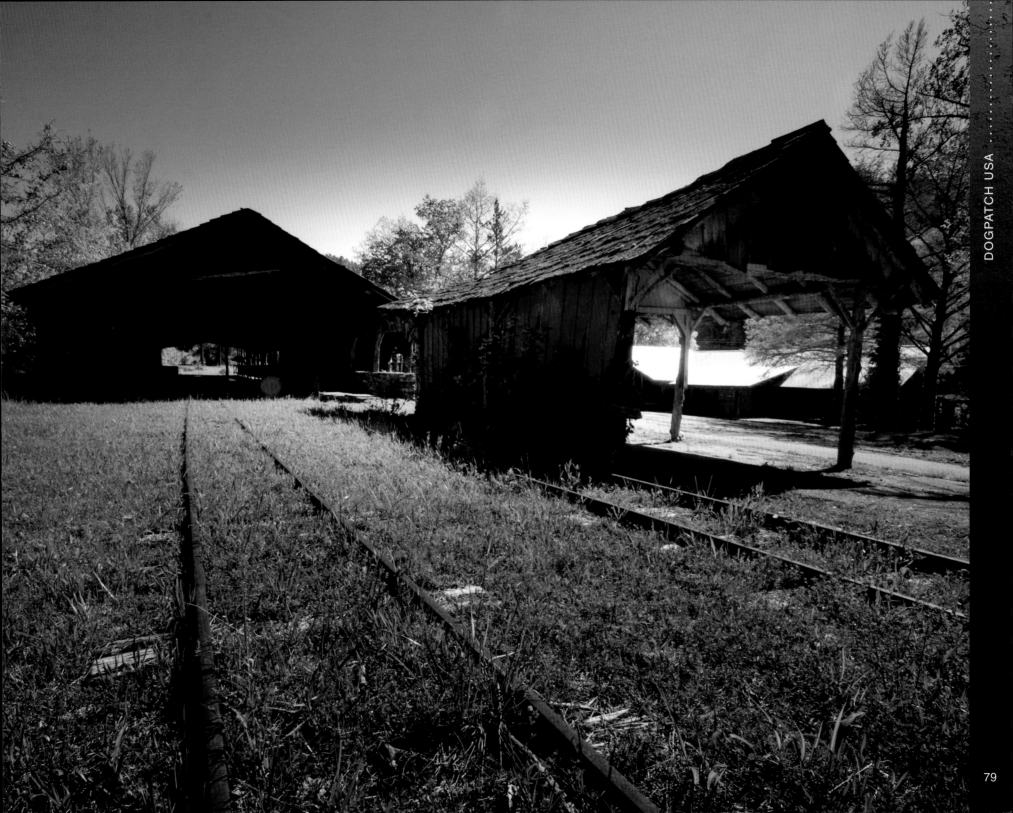

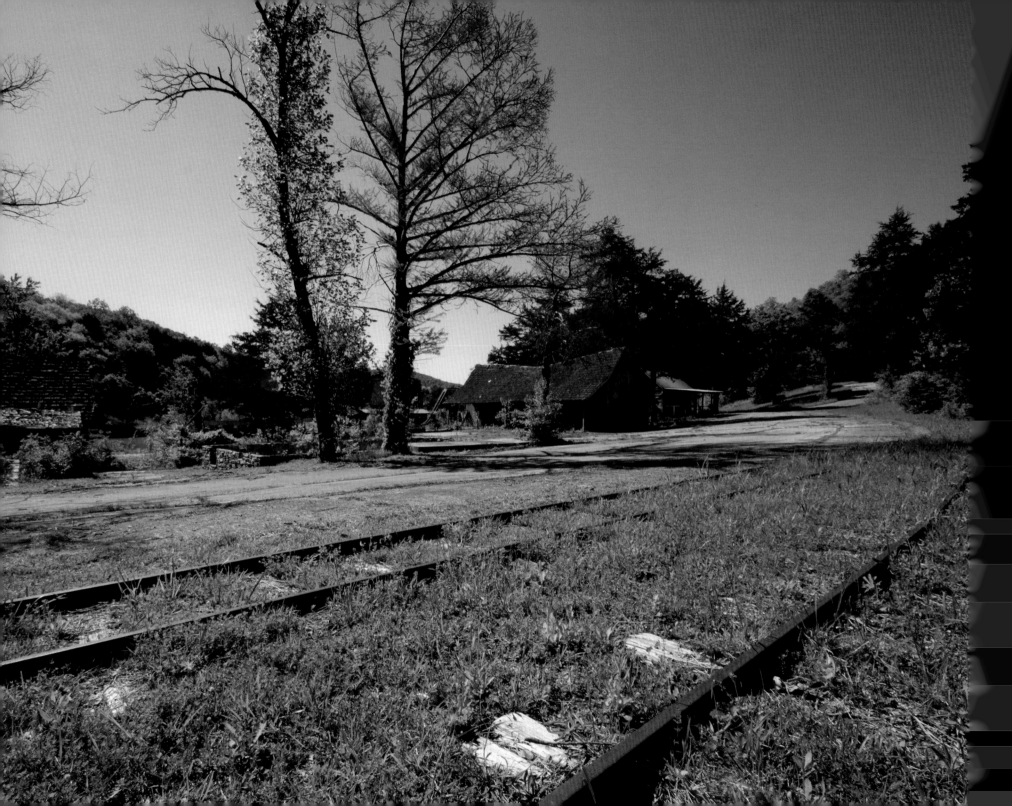

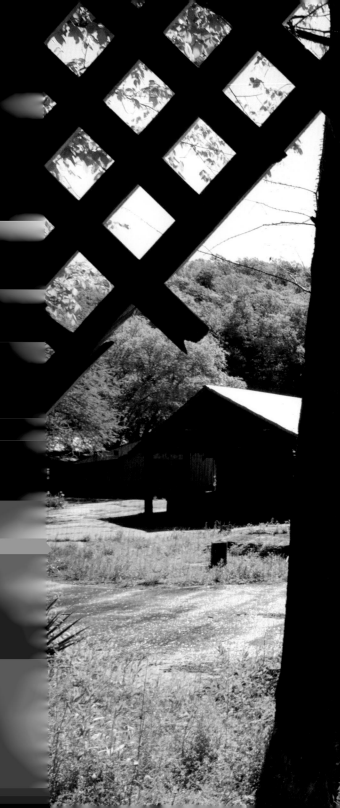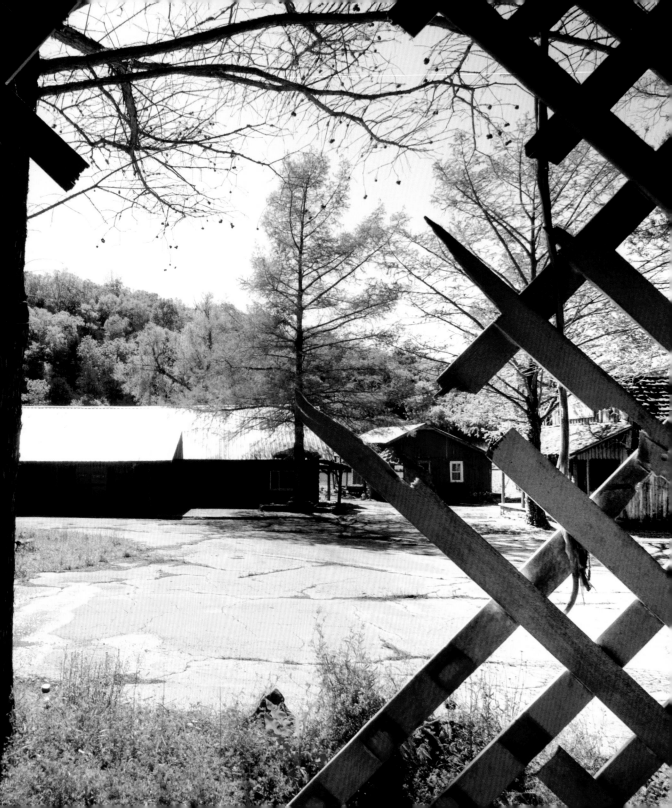

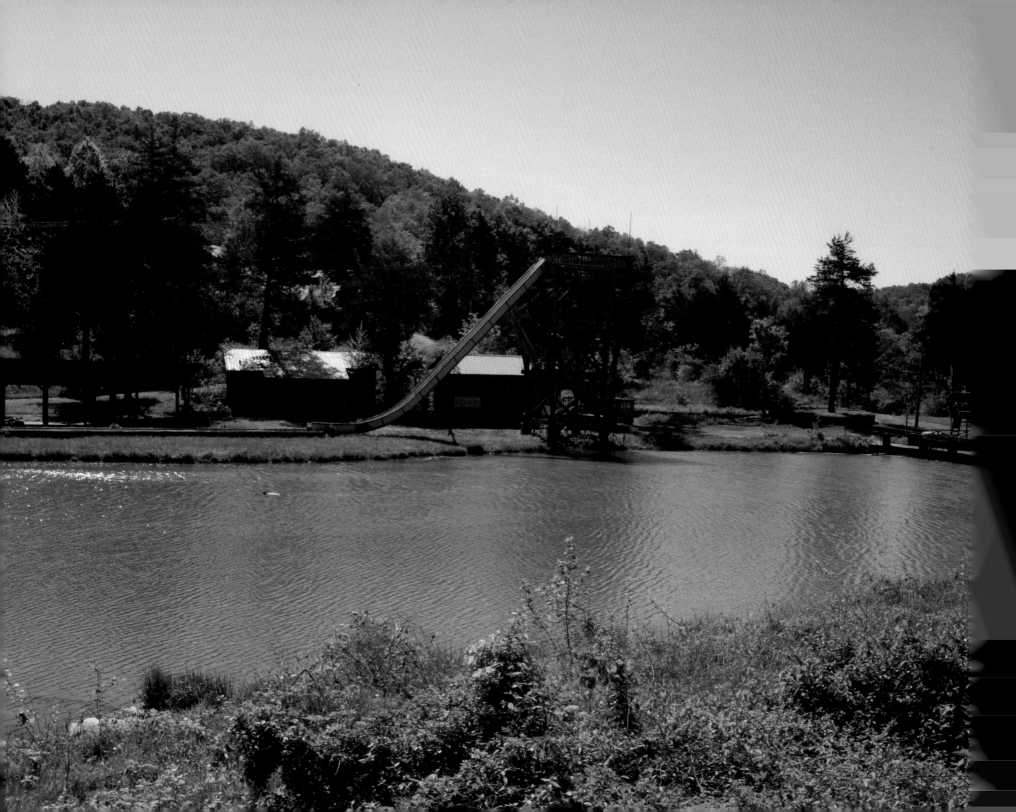

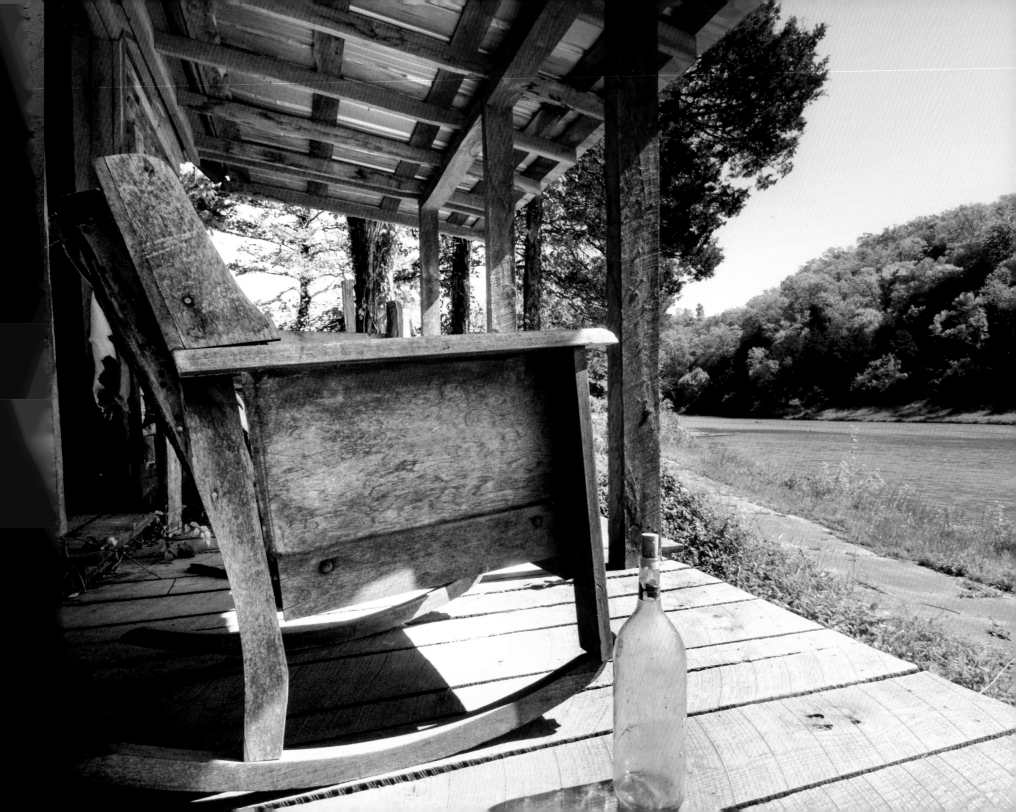

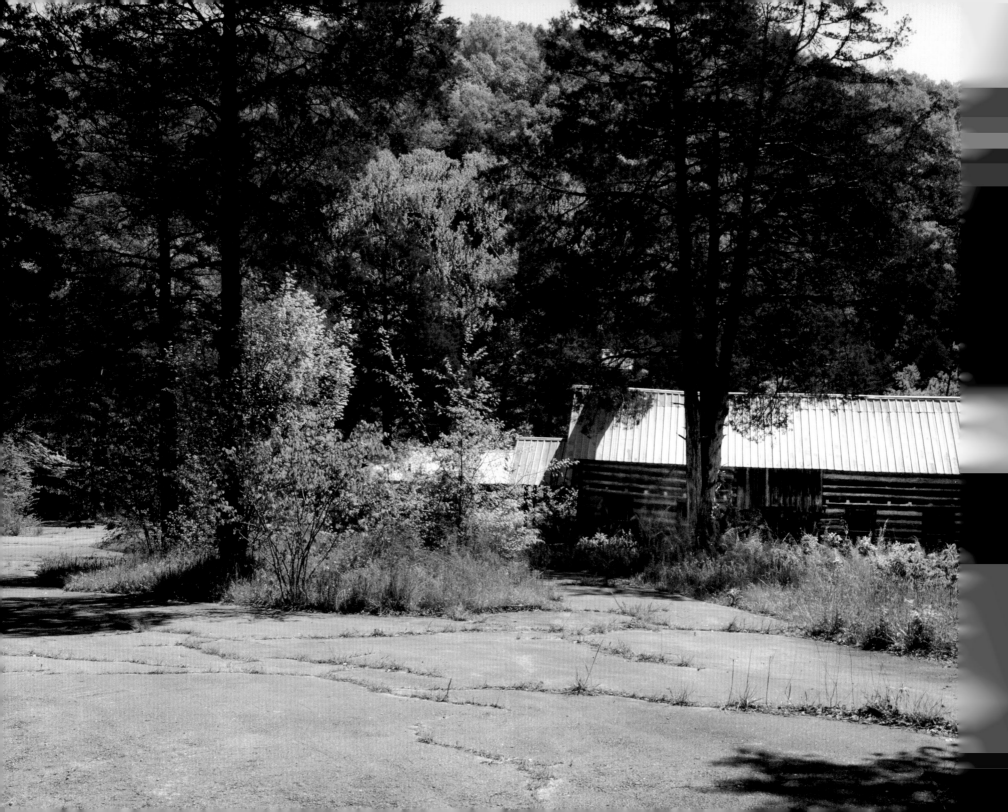

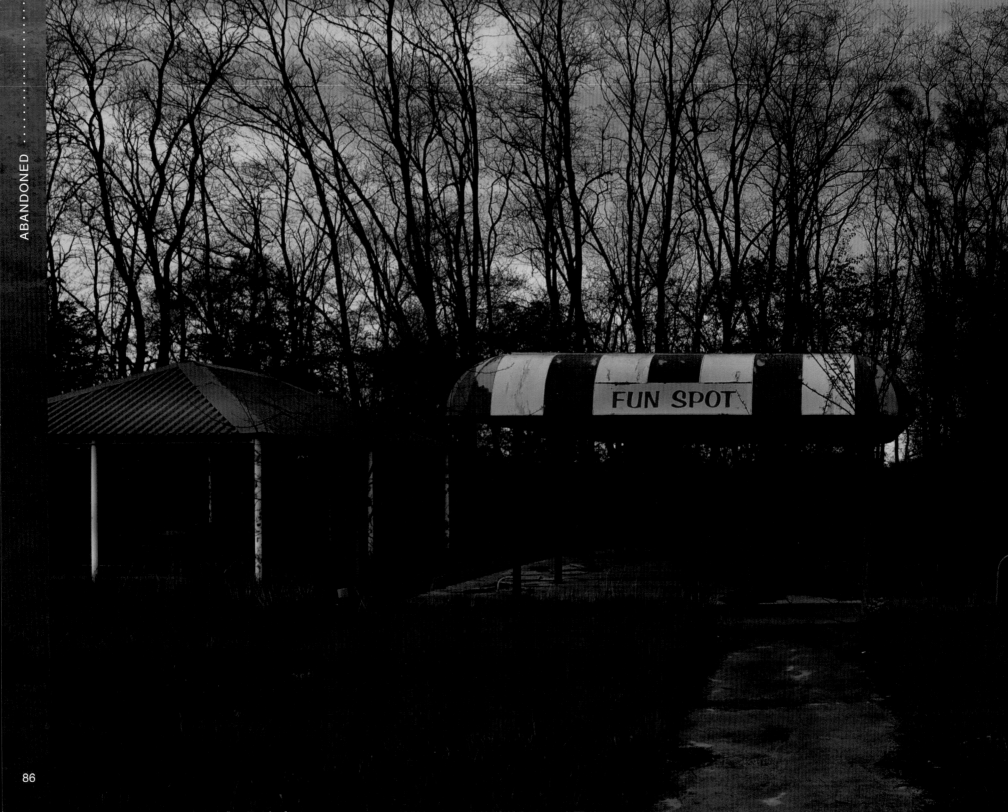

FUN SPOT AMUSEMENT PARK AND ZOO

ANGOLA, INDIANA
1956–2008

"America is like a ride at an amusement park. We'll keep saying our country is great and fun until it stops working."

—Seph Lawless (ABC News; May 2015)

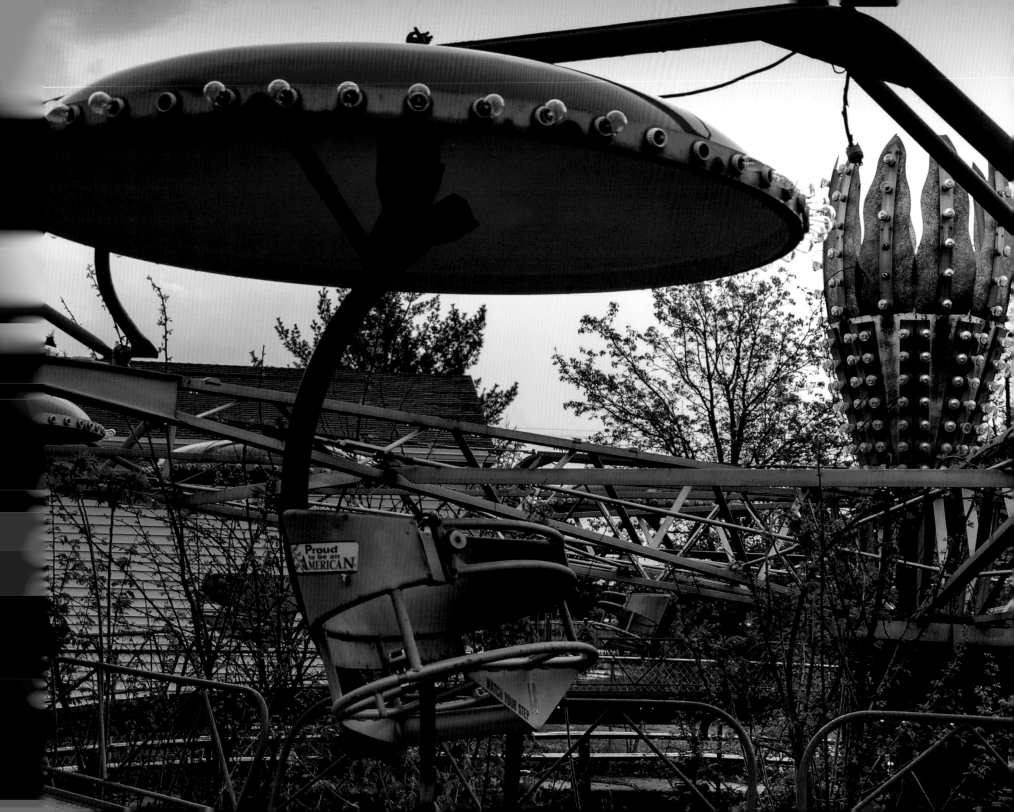

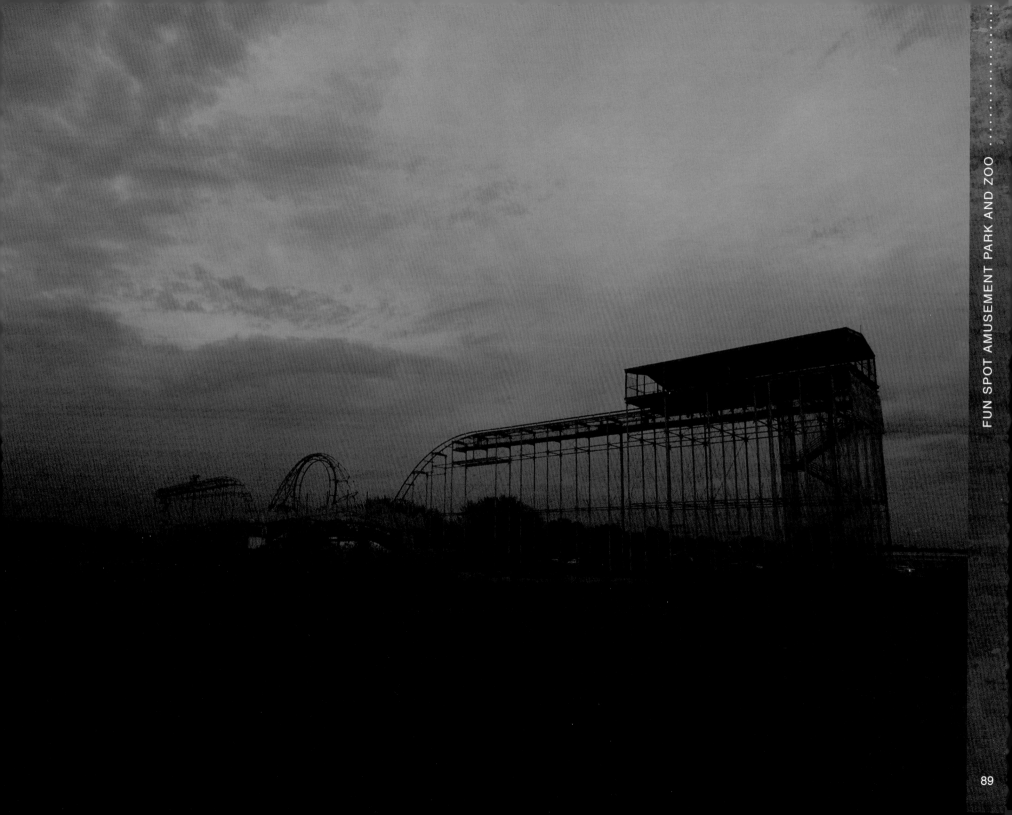

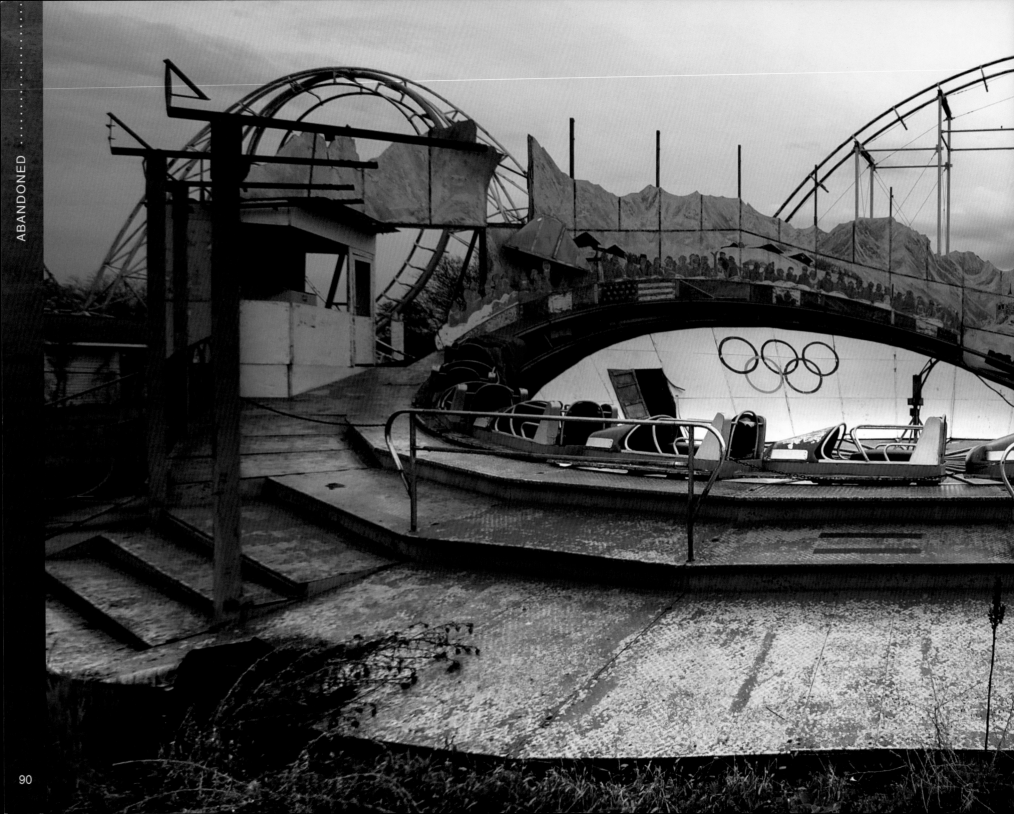

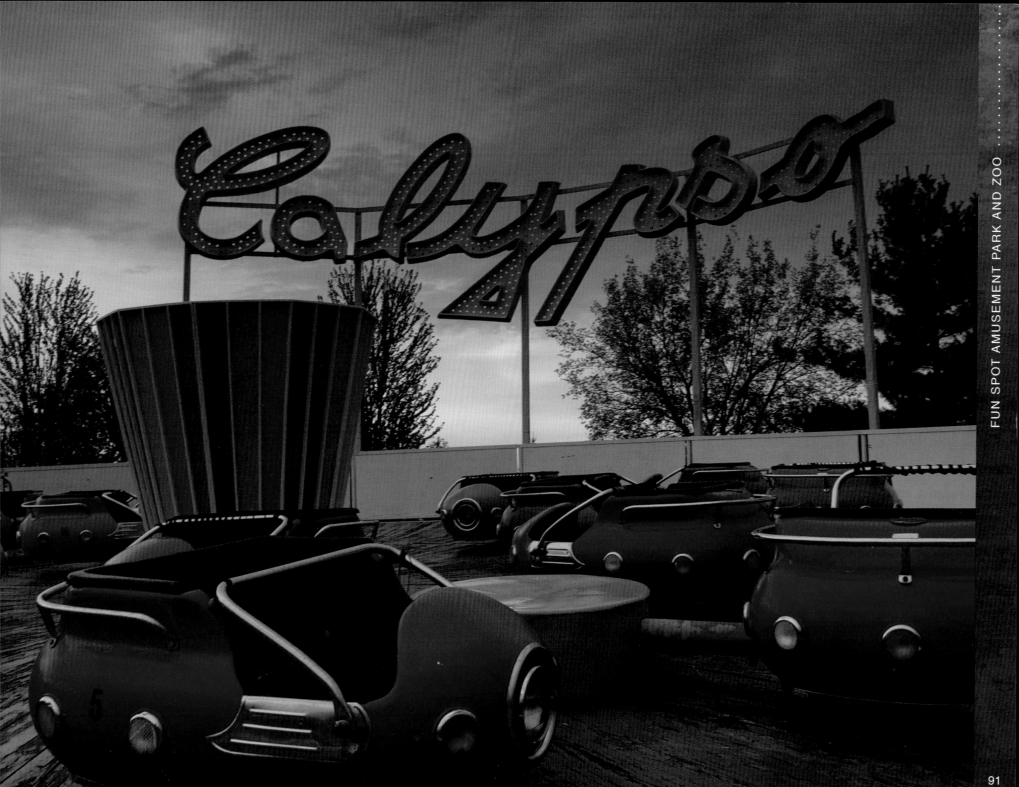

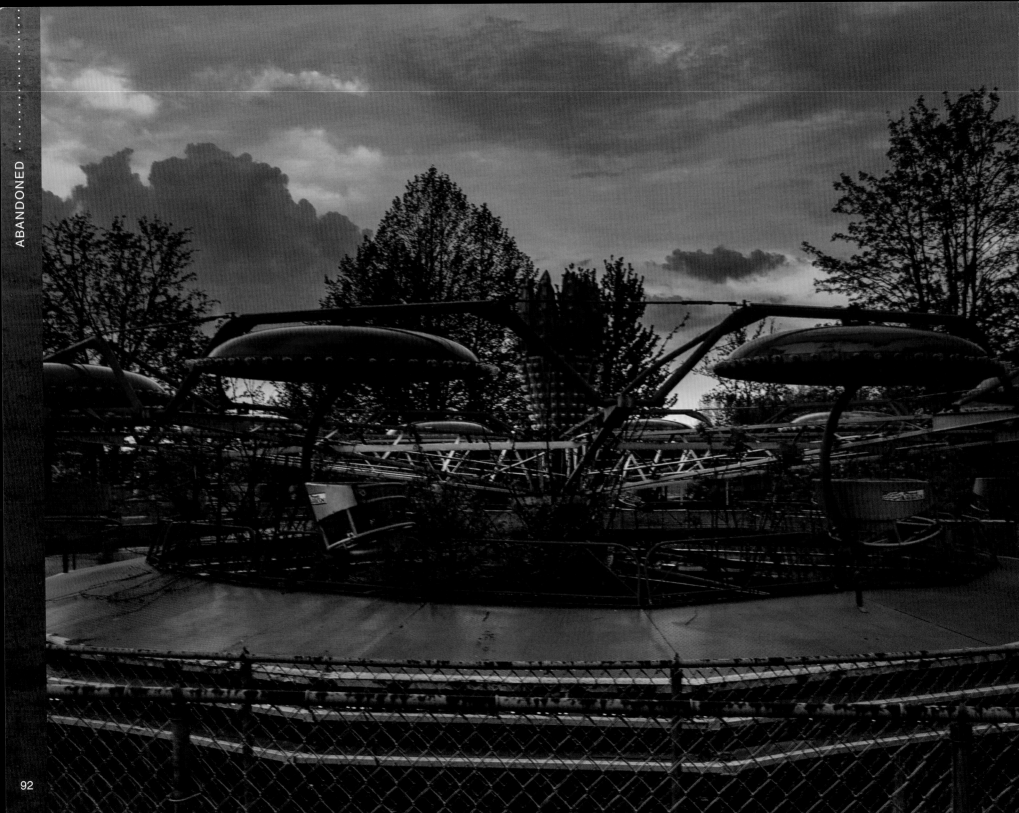

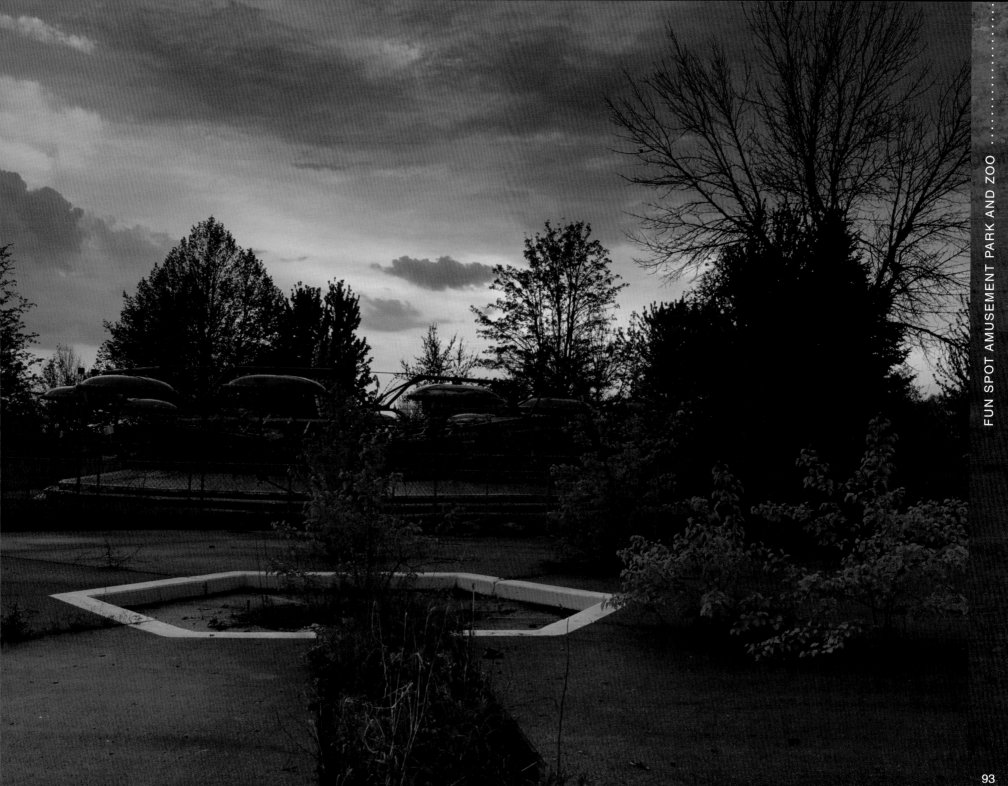

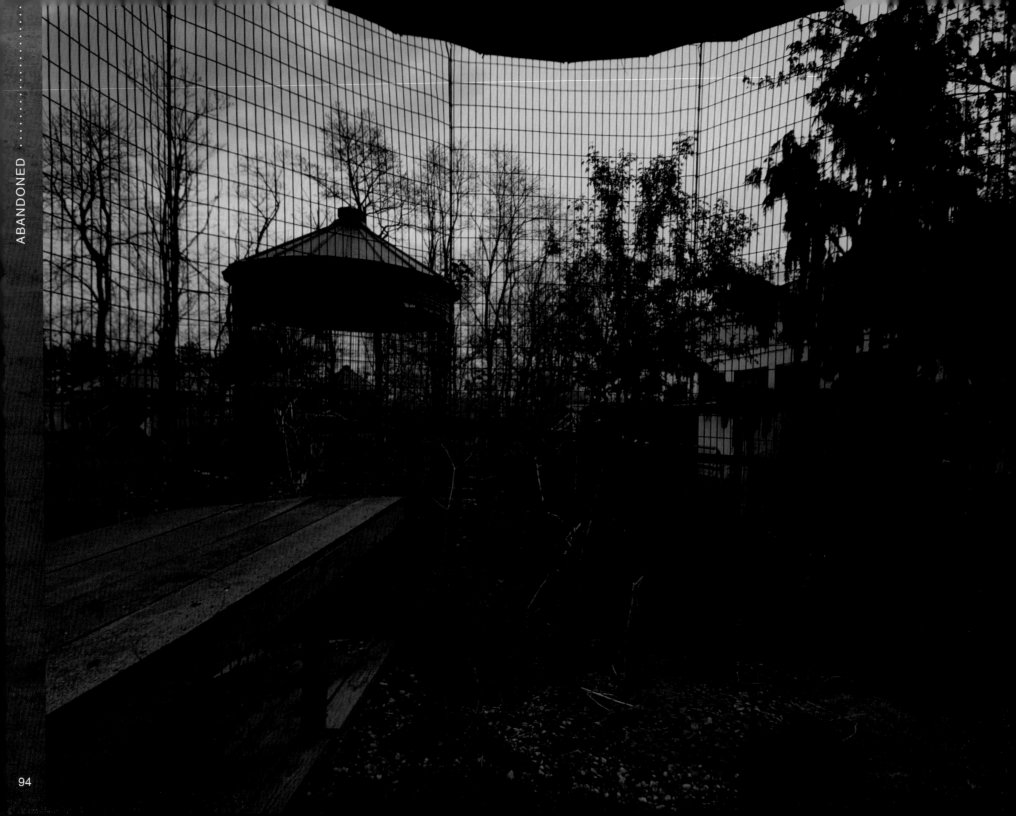

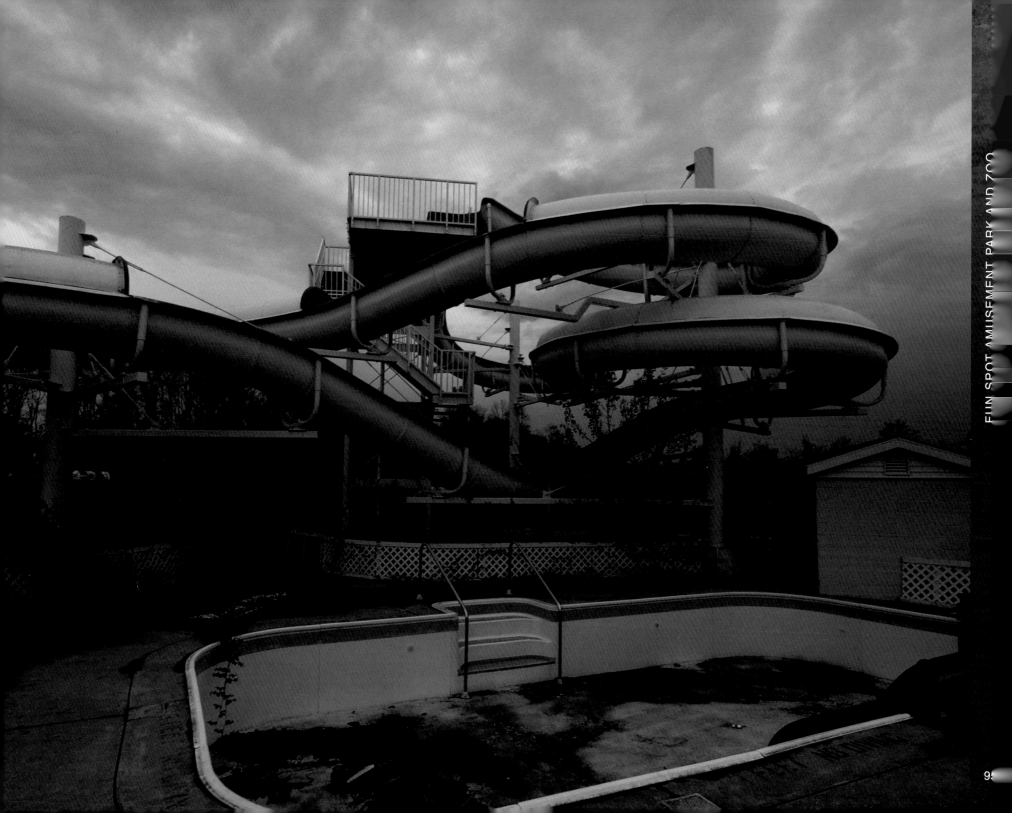

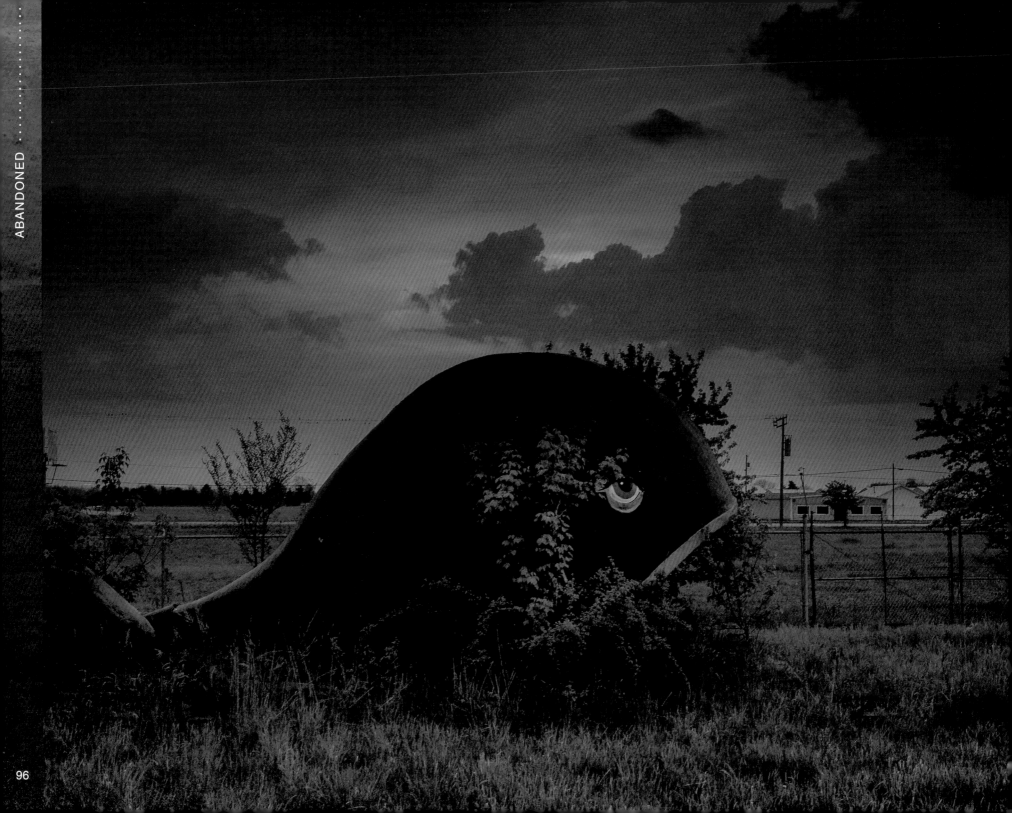

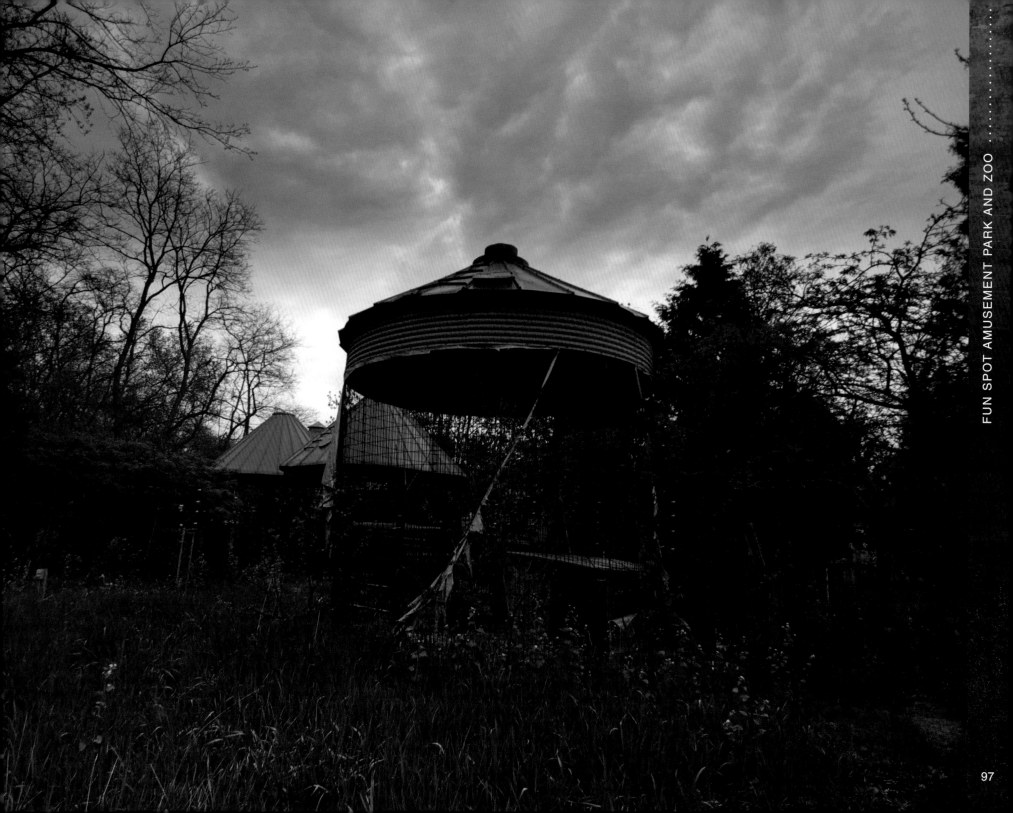

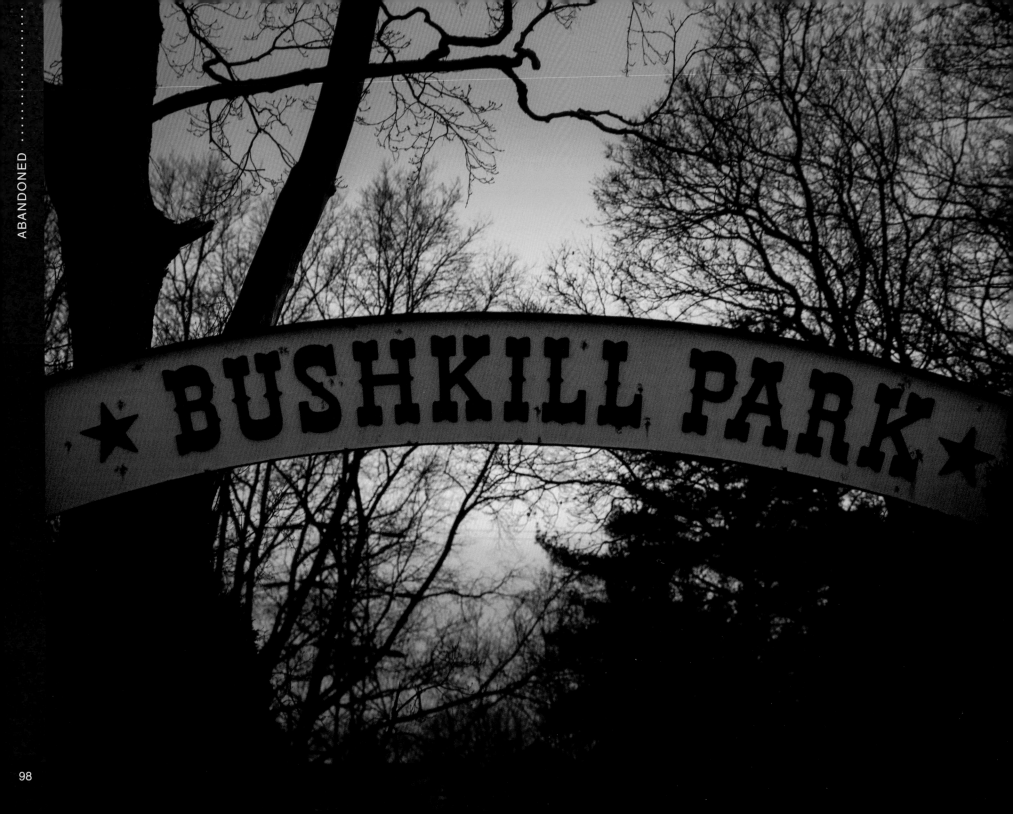

BUSHKILL AMUSEMENT PARK

EASTON, PENNSYLVANIA
1902–2004

Bushkill Park was known for its antique rides such as bumper cars, "The Whip," "The Haunted Pretzel," and "The Bar'l of Fun." It is home to the nation's oldest funhouse. Inside the funhouse, there is a rotating barrel followed by a maze-like layout inside a blackened room with distorted mirrors and other unique funhouse attractions. Its signature large, indoor wooden slide at the end of the funhouse was adored by many patrons over the years.

Sadly in 2004, Hurricane Ivan struck, and the park suffered a devastating "hundred-year flood," which obliterated the park.

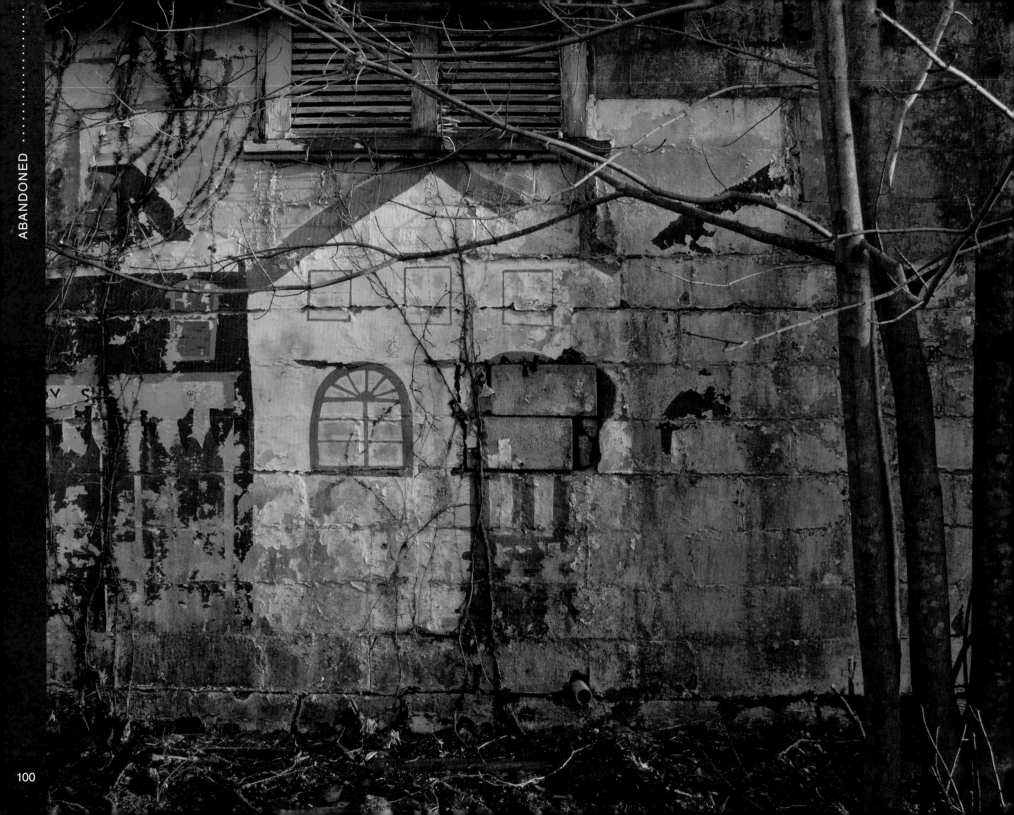

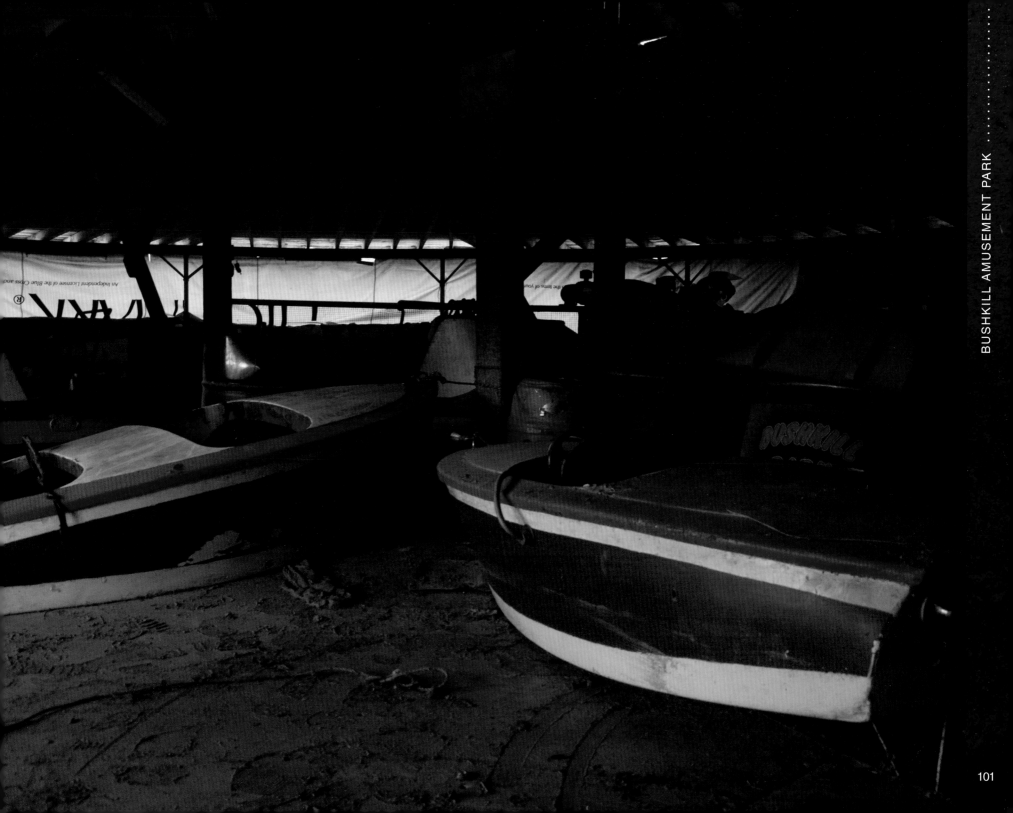

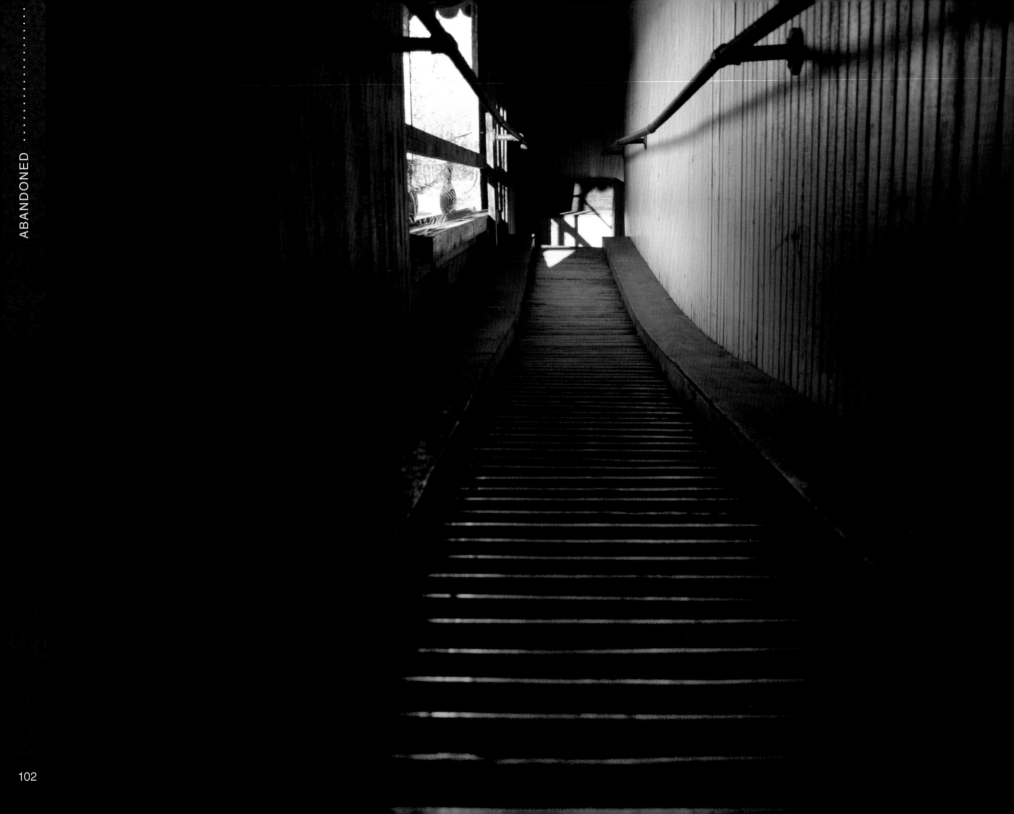

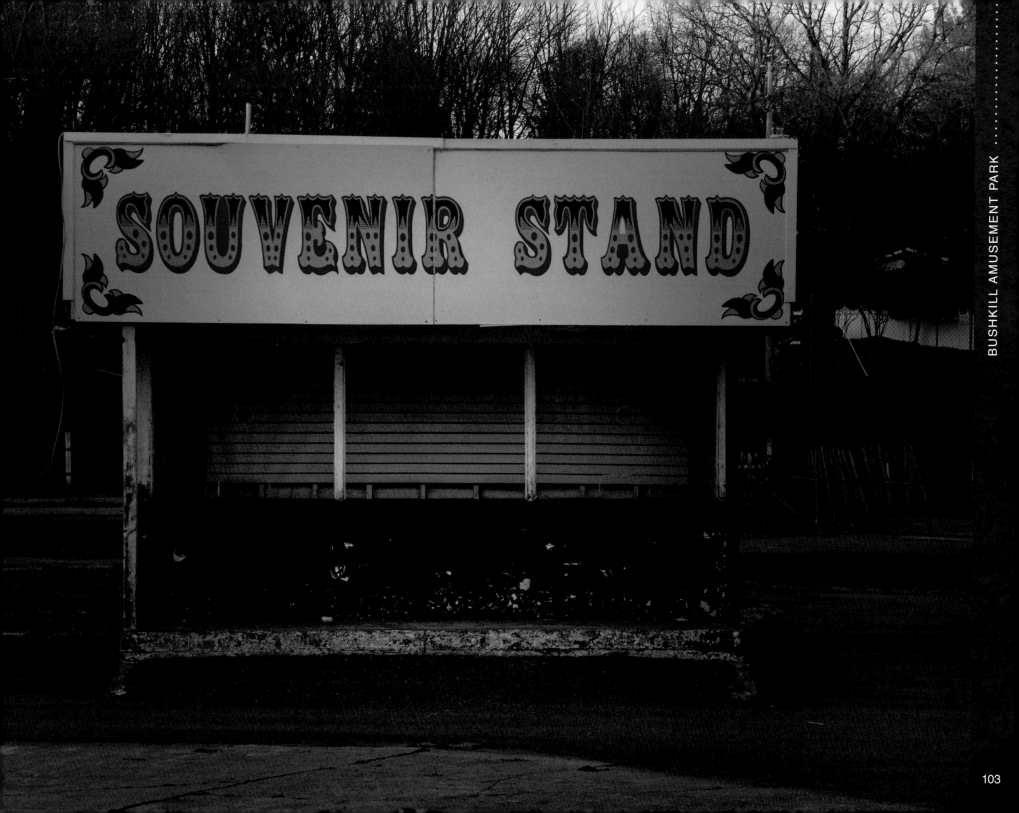

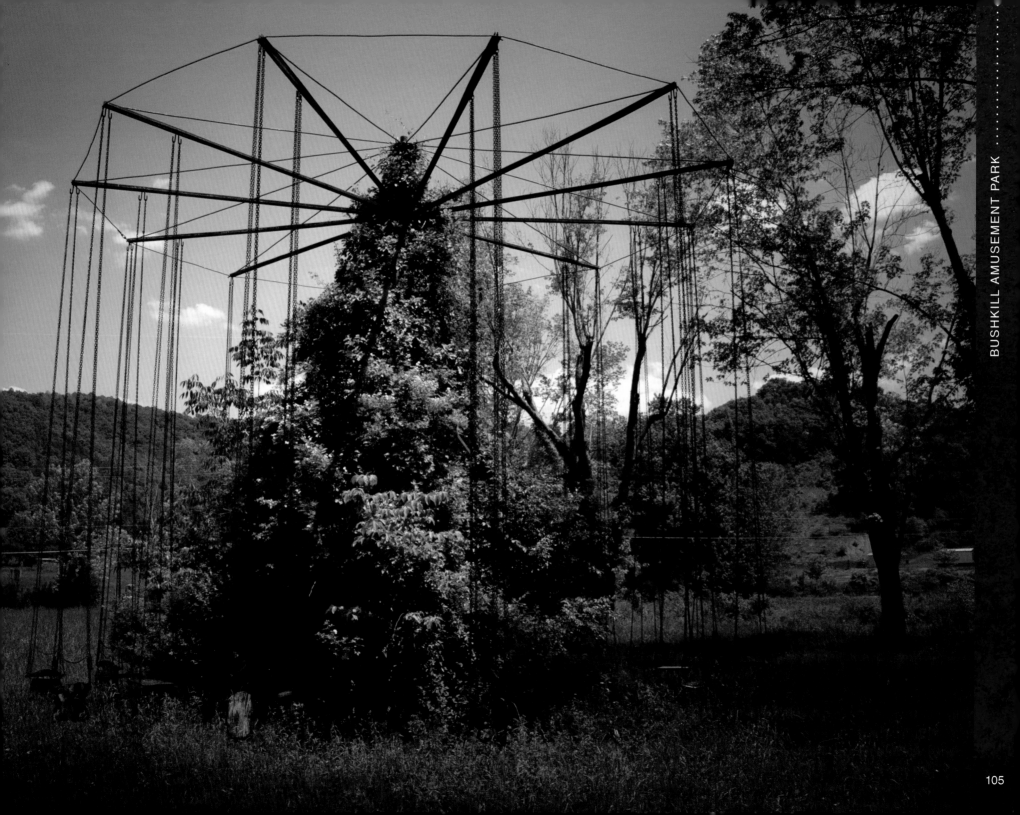

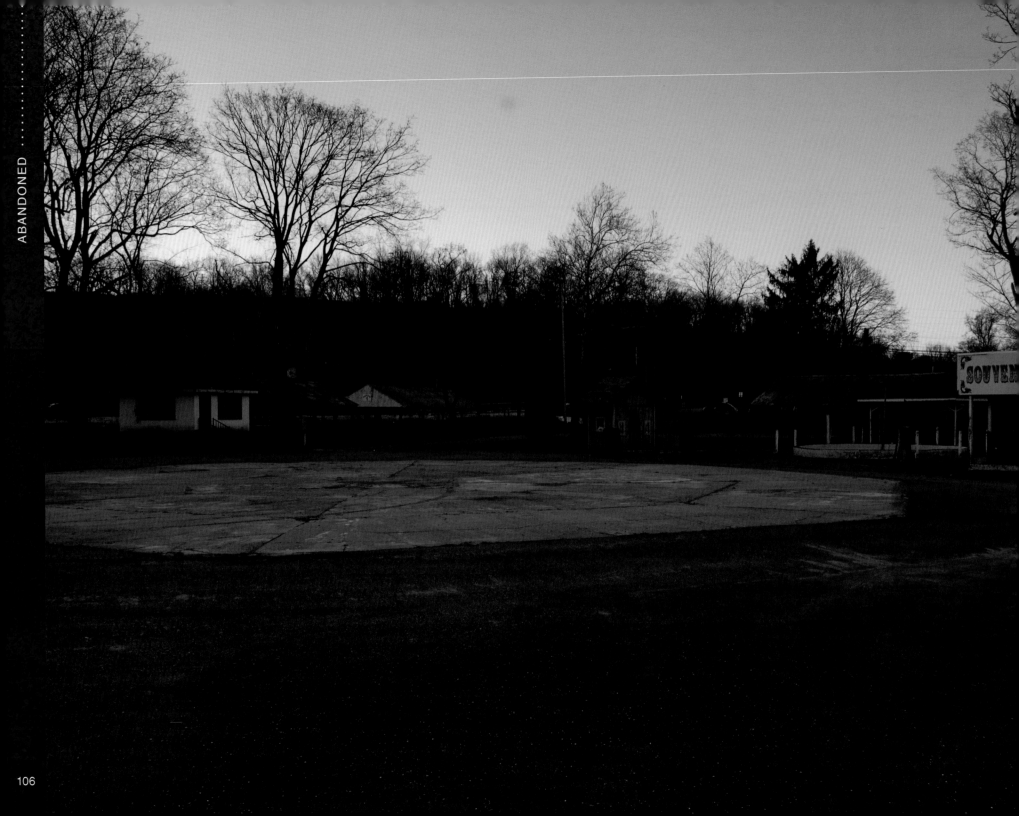

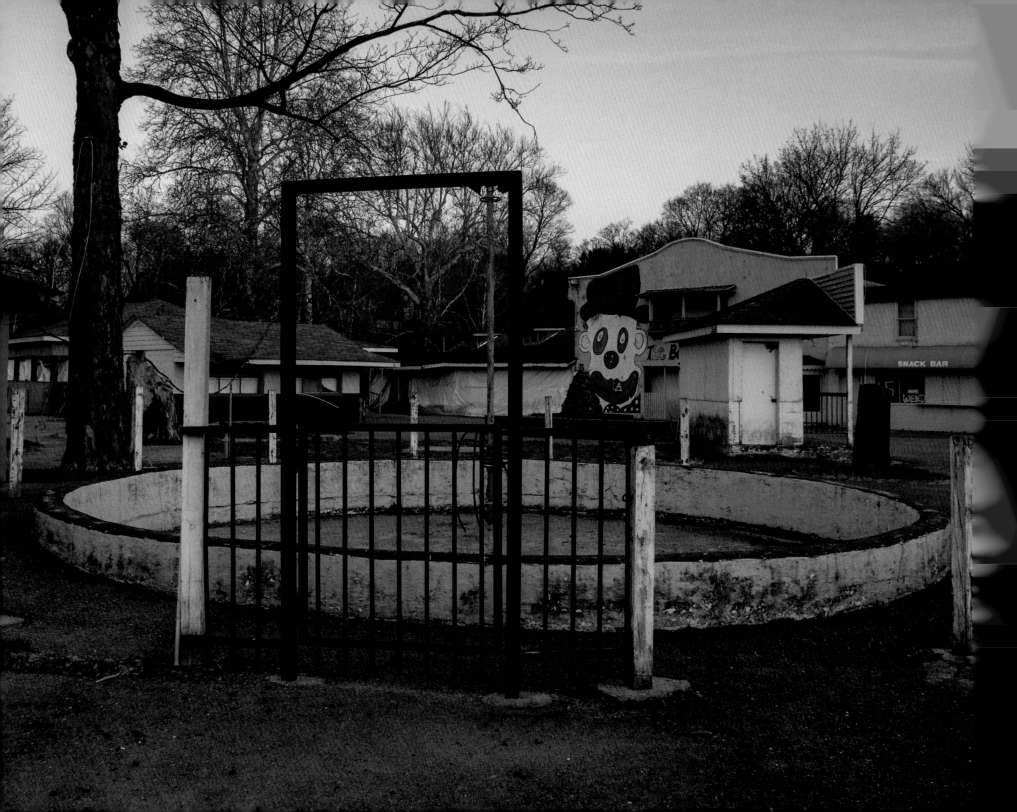

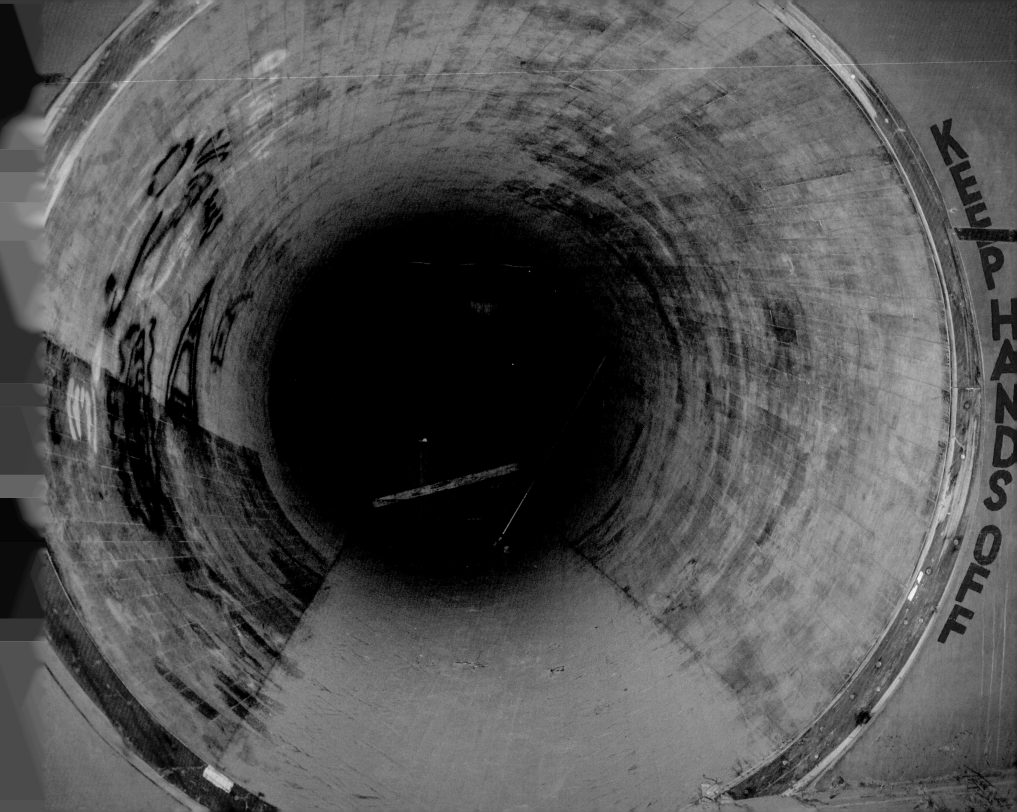

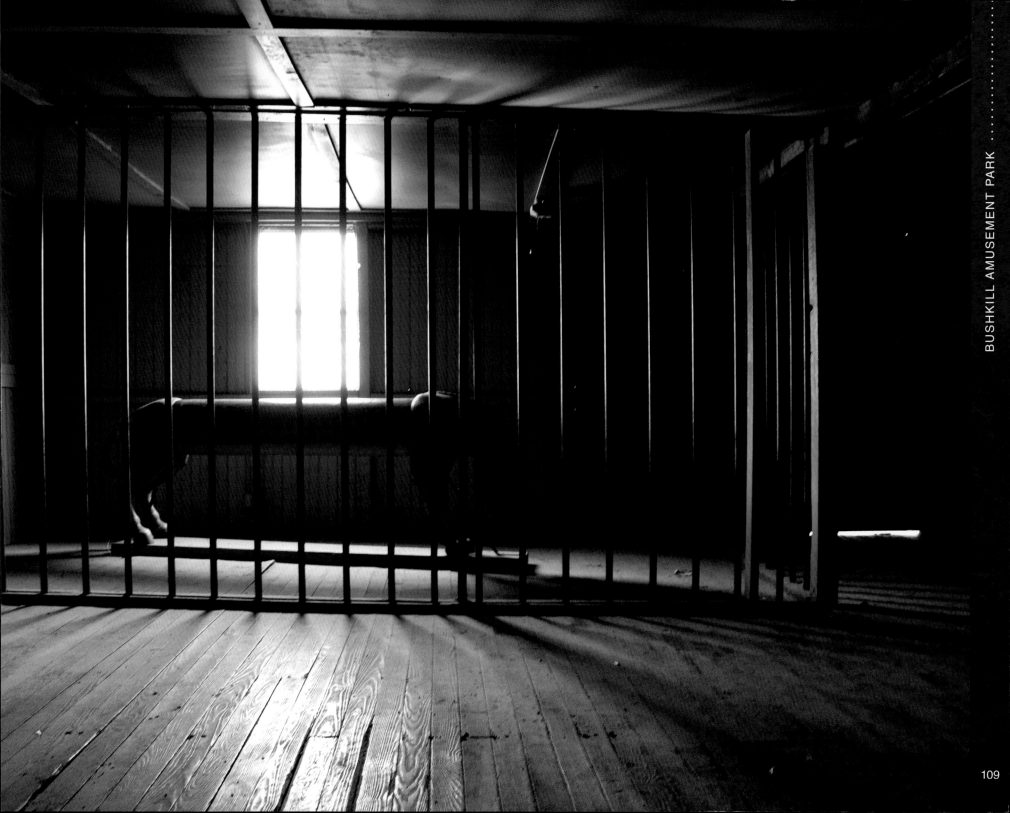

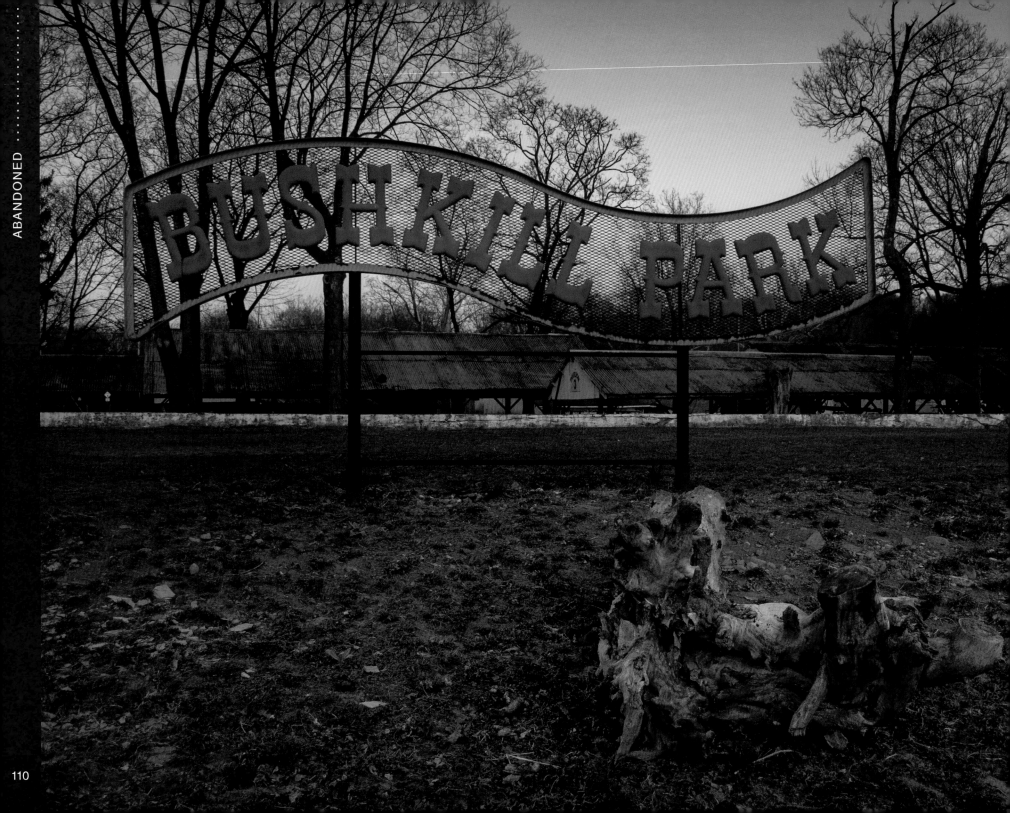

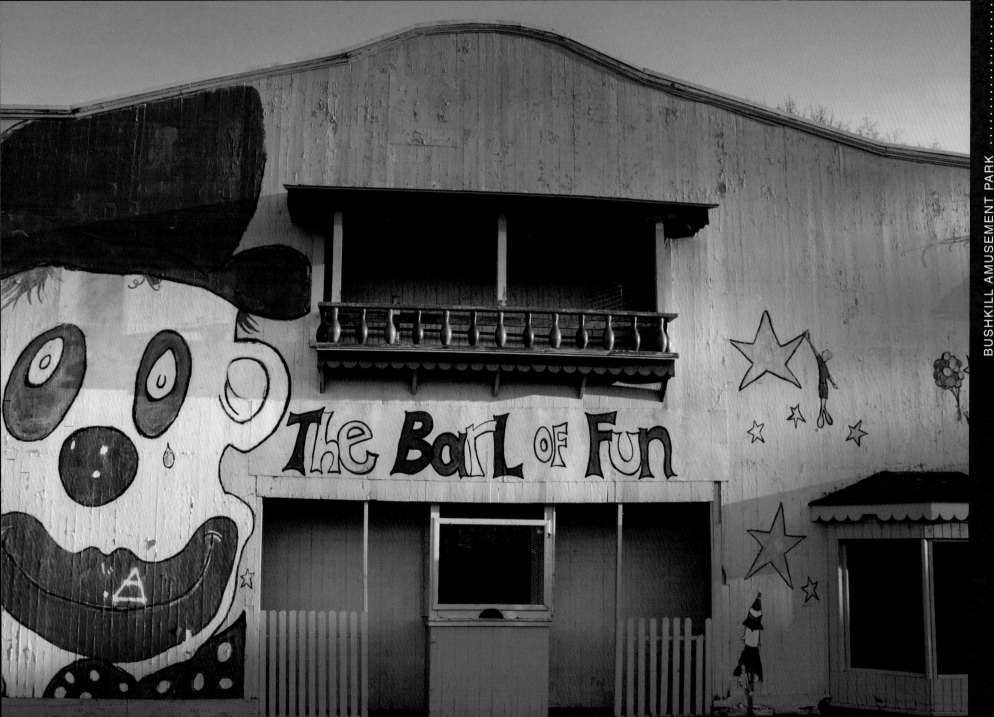

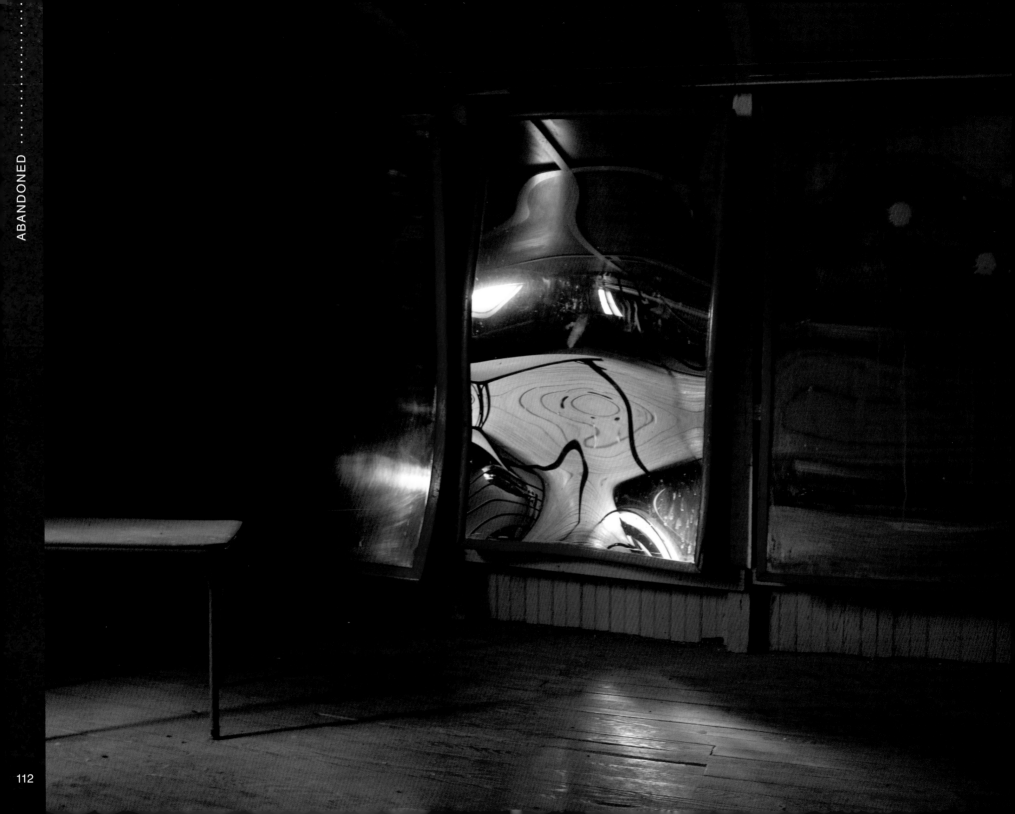

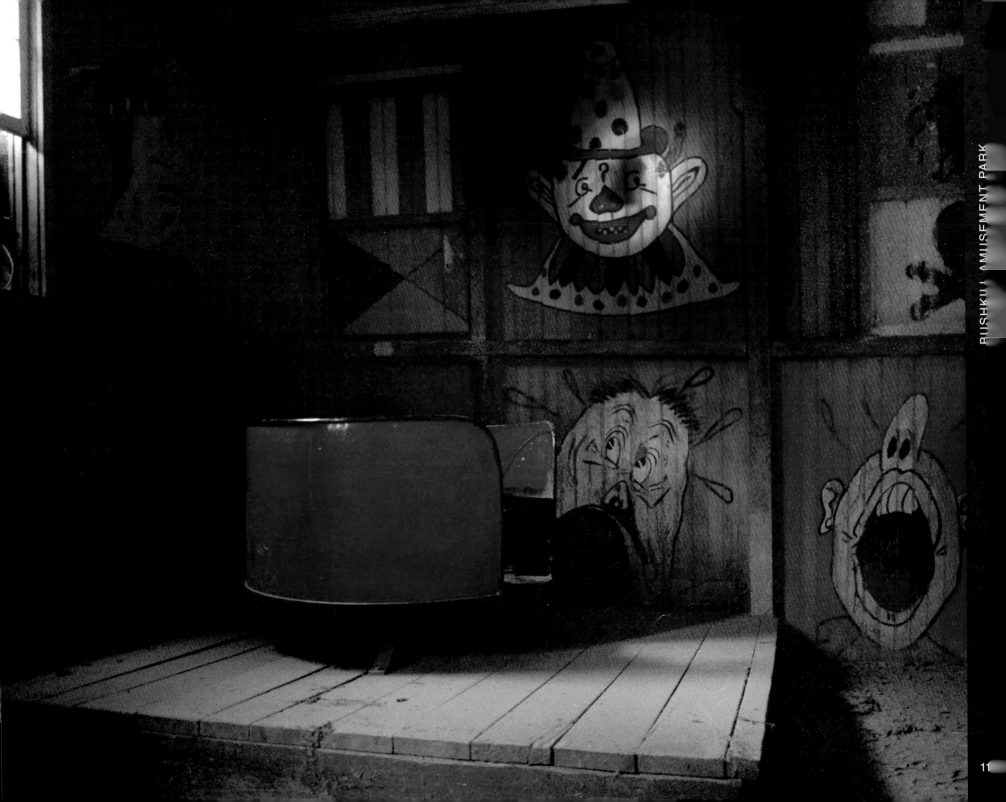

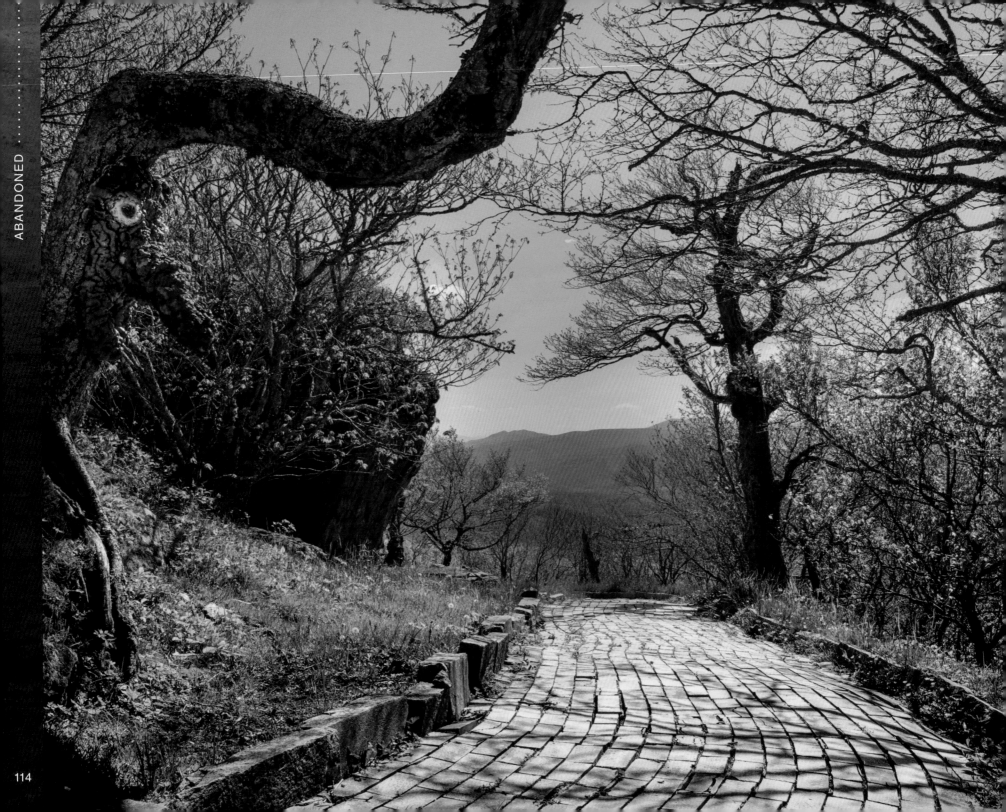

LAND OF OZ

BEECH MOUNTAIN, NORTH CAROLINA
1970–1980

On the very top of one of the highest mountain peaks in the Eastern United States sits this beautiful theme park inspired by the classic film *The Wizard of Oz*. Its high and very isolated location seemed rather fitting, considering being inside the abandoned theme park seemed out of this world.

This is one of the most beautiful places I've ever visited. Since it has become abandoned, owners have maintained the property. They even rent the location for special events, and open the park to the general public briefly for an annual event where locals can visit the abandoned theme park and reminisce as they walk down the yellow brick road of memories.

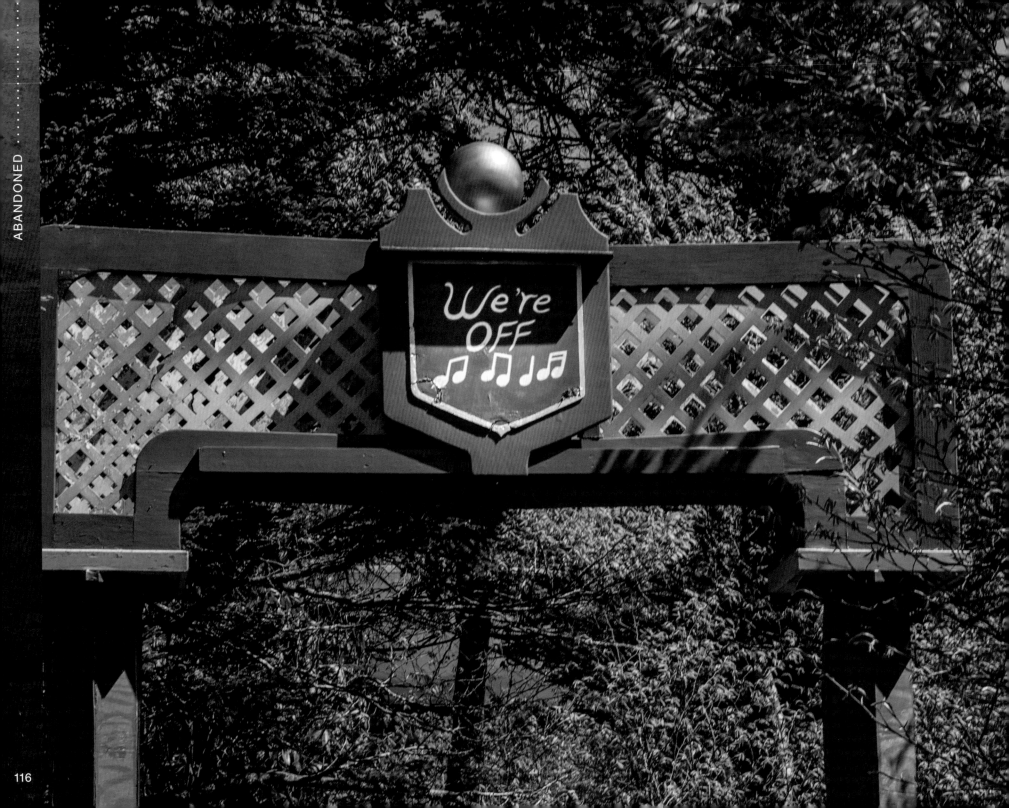

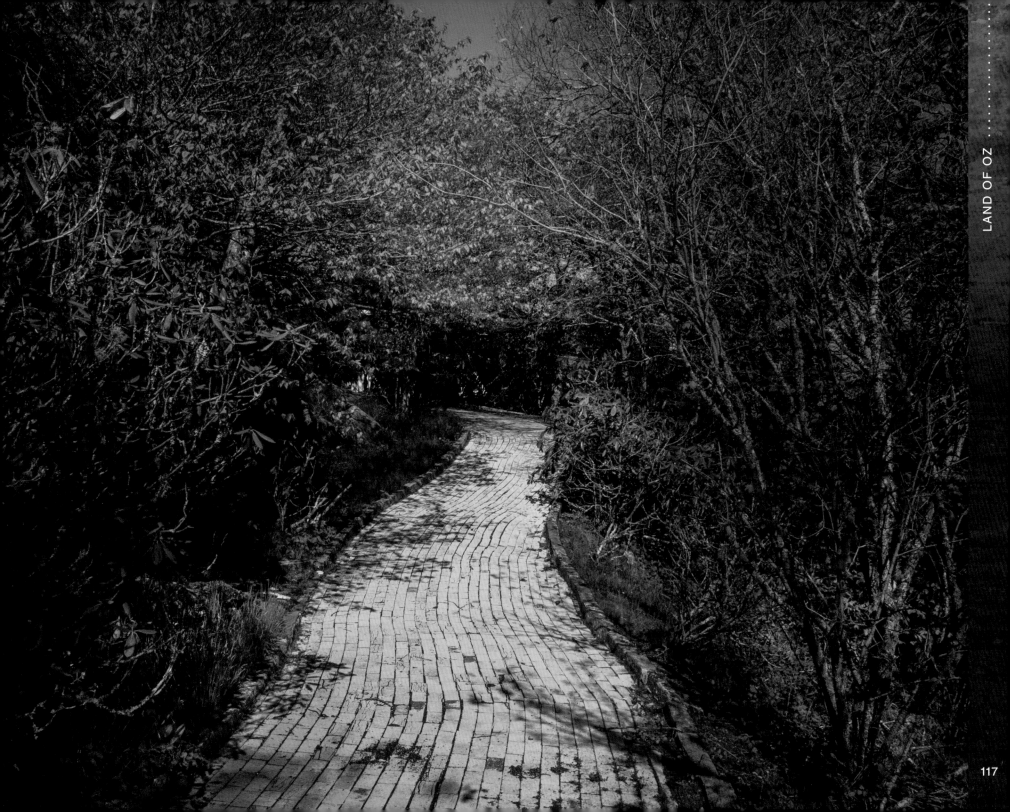

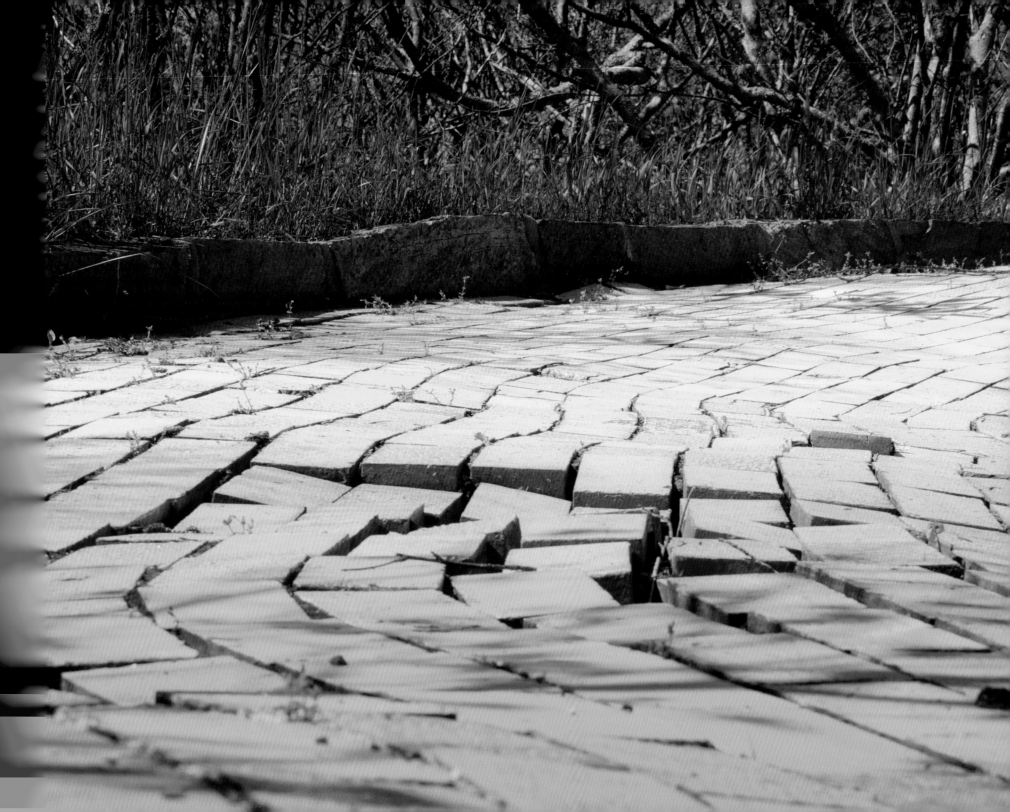

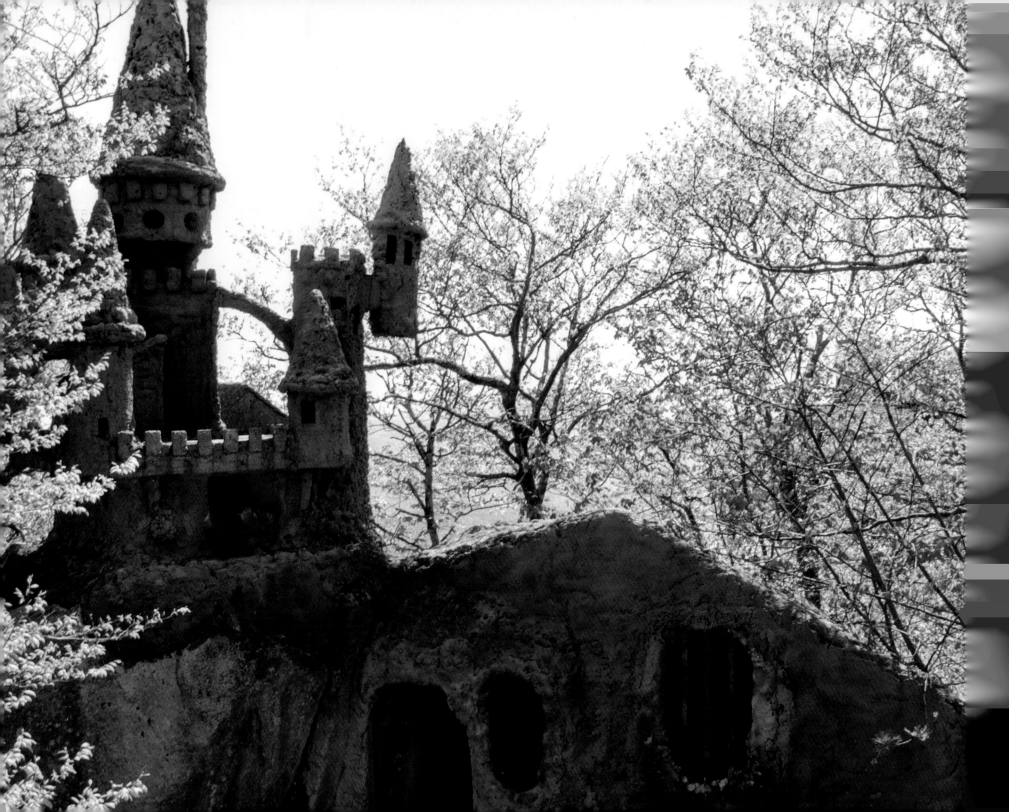

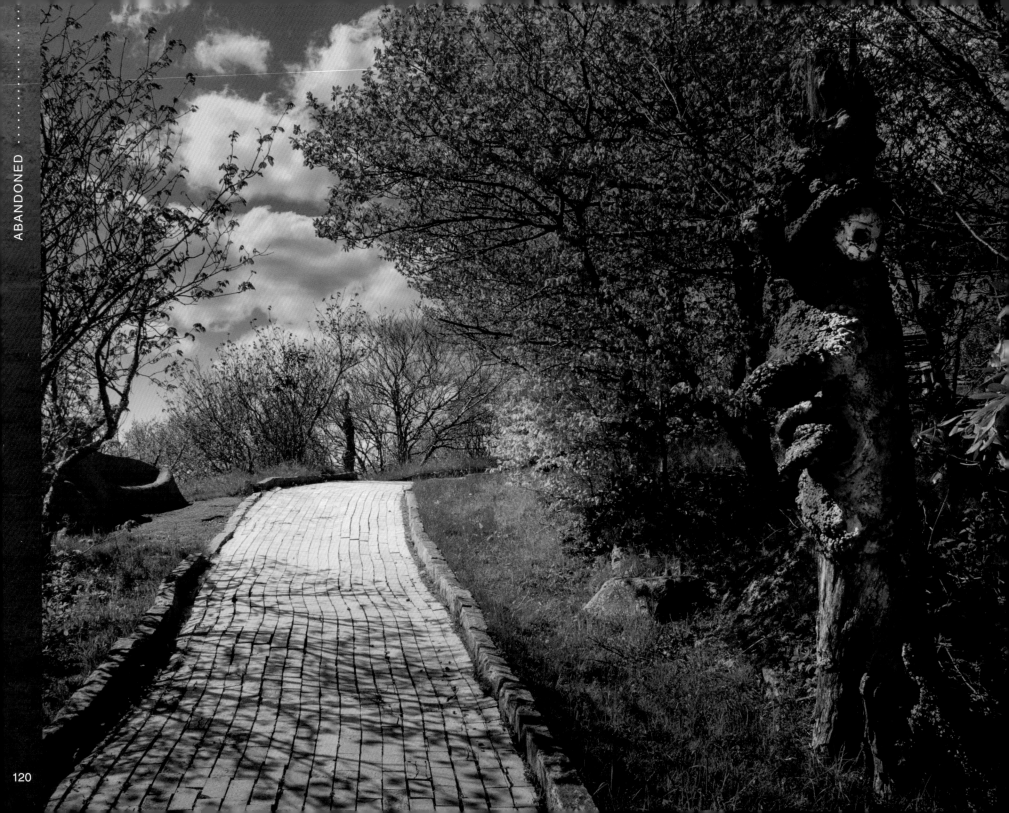

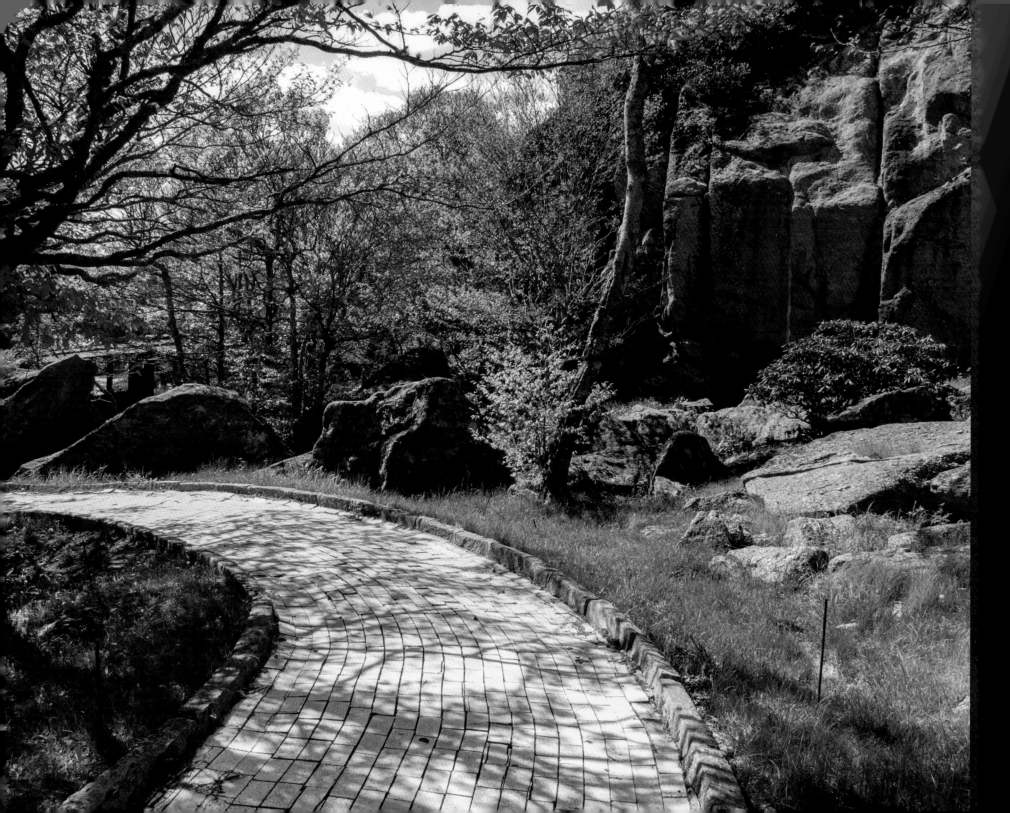

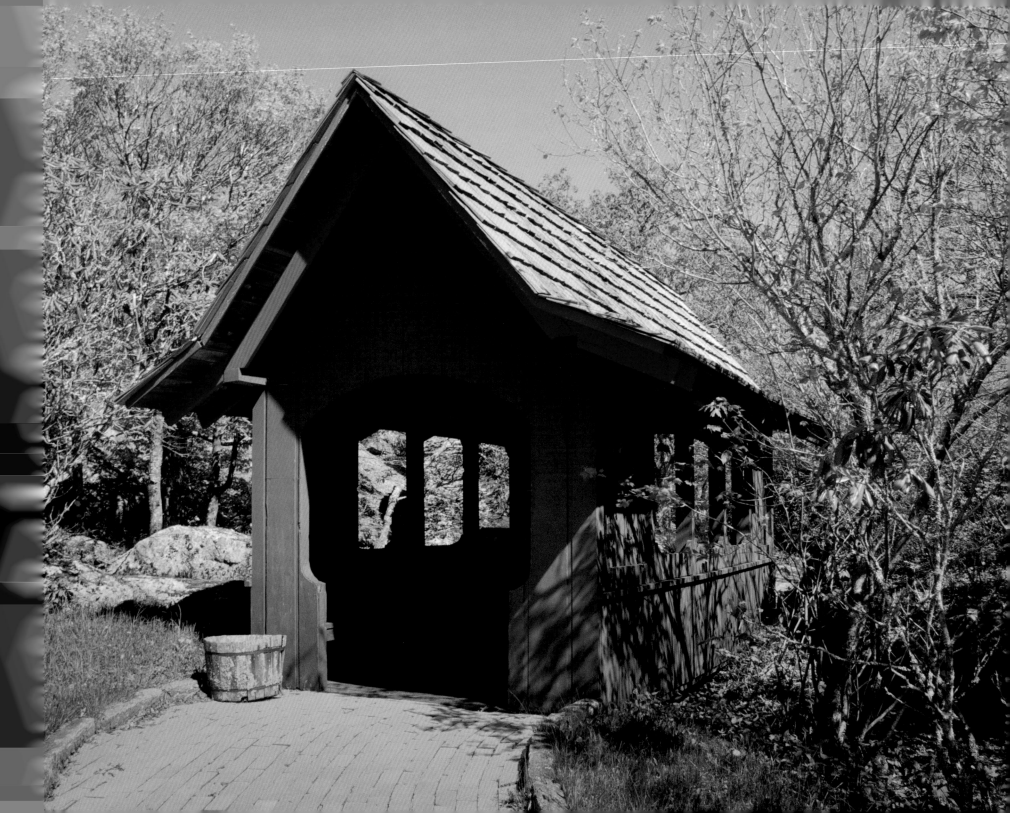

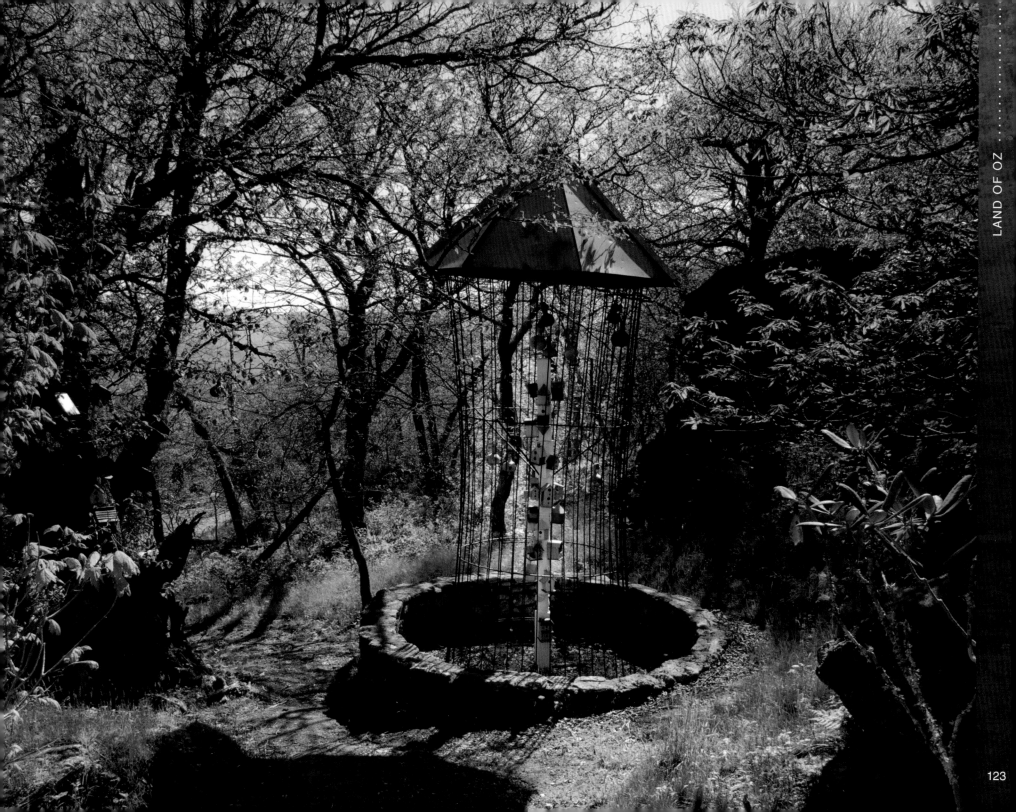

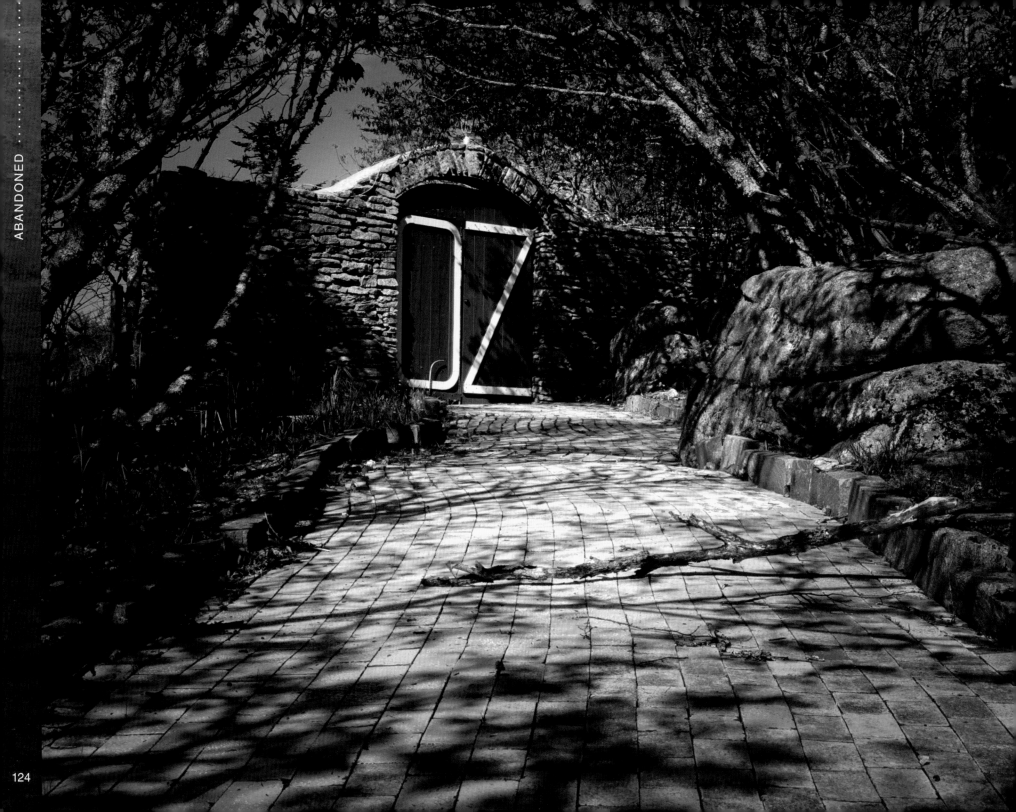

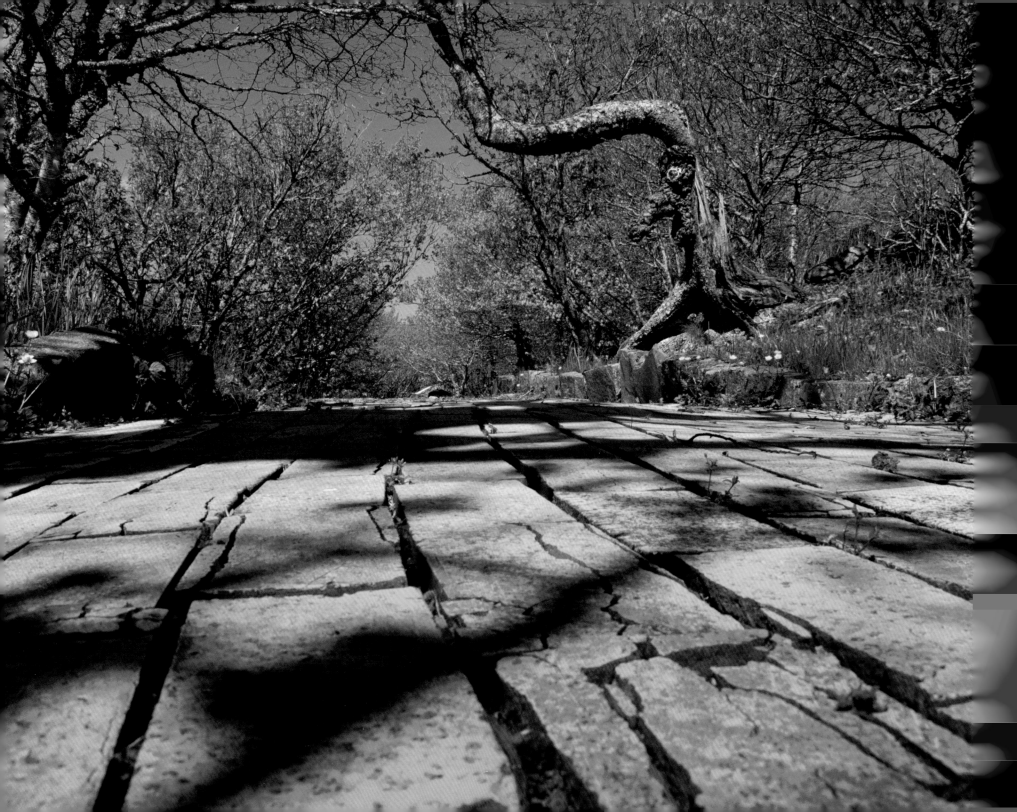

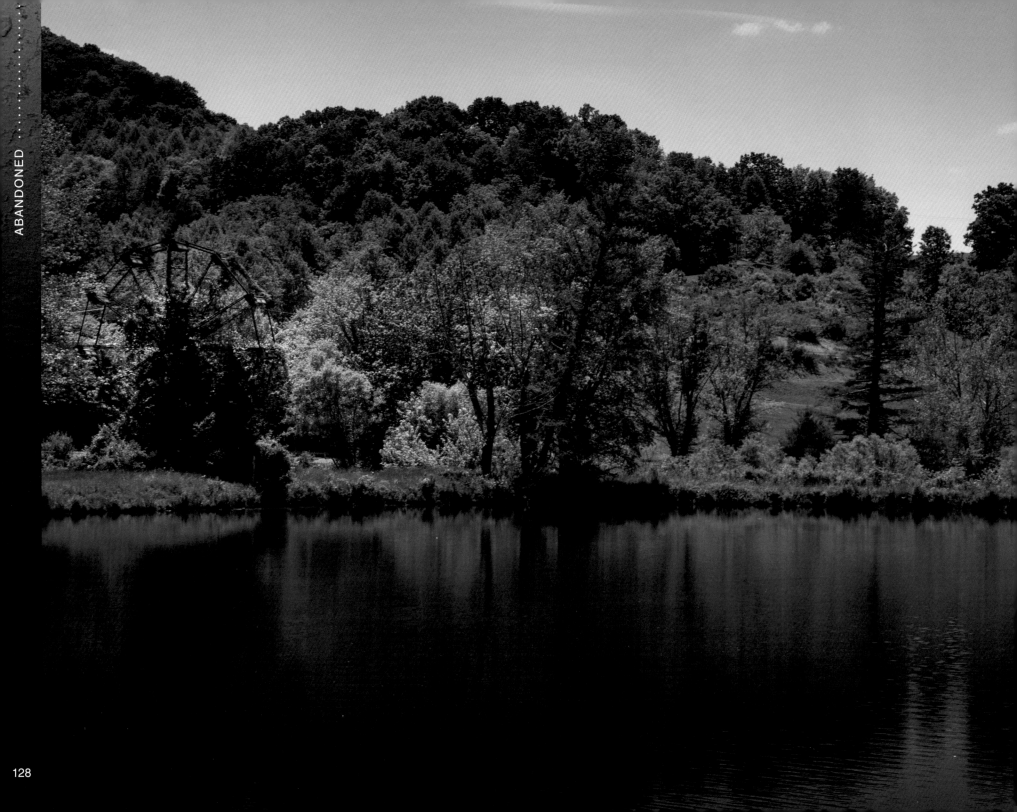

LAKE SHAWNEE AMUSEMENT PARK

LAKE SHAWNEE, WEST VIRGINIA
1926–1966

The skeletal remains of the Lake Shawnee Amusement Park create an eerie atmosphere, which is appropriate, given the park's history. It was built on a Native American burial ground and is the site of the massacre of several Native American women and children.

The land was home to a Native American tribe until 1783, when Mitchell Clay's European family attempted to settle the land, sparking a violent conflict. One day, Clay was out hunting when a band of Native Americans killed his youngest son, and his daughter was knifed to death in the struggle. His oldest son was later kidnapped and burned alive. Clay sought vengeance for his family and murdered several of the Native Americans, including women and children.

The land was then the site of a Native American burial ground until businessman Conley T. Snidow purchased and built an amusement park over top of it. The park opened to visitors in the 1920s. After separate incidents regarding the deaths of two children on the park's grounds, it finally closed in 1966, leaving behind many of its weathered steel rides. The rusting Ferris wheel and swing ride stand like dead trees tangled in weeds and vines as Mother Nature reclaims her natural order.

Many locals believe the land itself is haunted or possessed by vengeful Native American ghosts or spirits. Some even believe that is why the two children died at the park, forcing it to close.

Today, the land remains abandoned, while the overgrown rides stand as the only haunting reminder of this tragic chapter in American history.

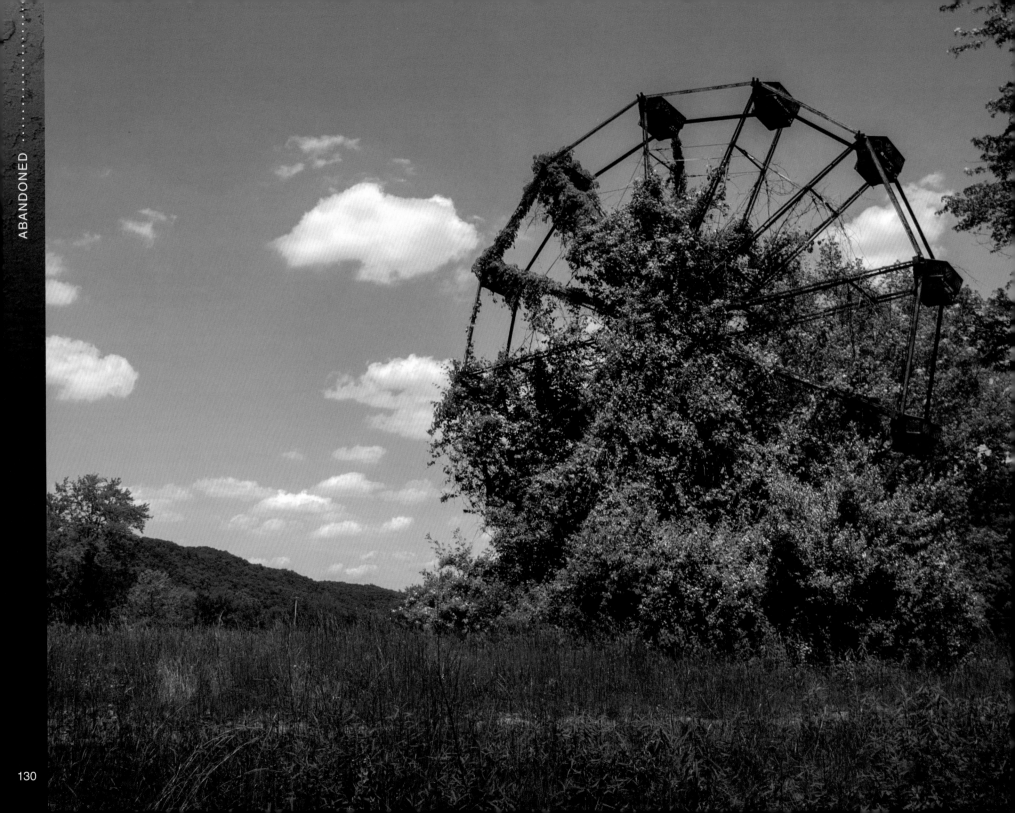

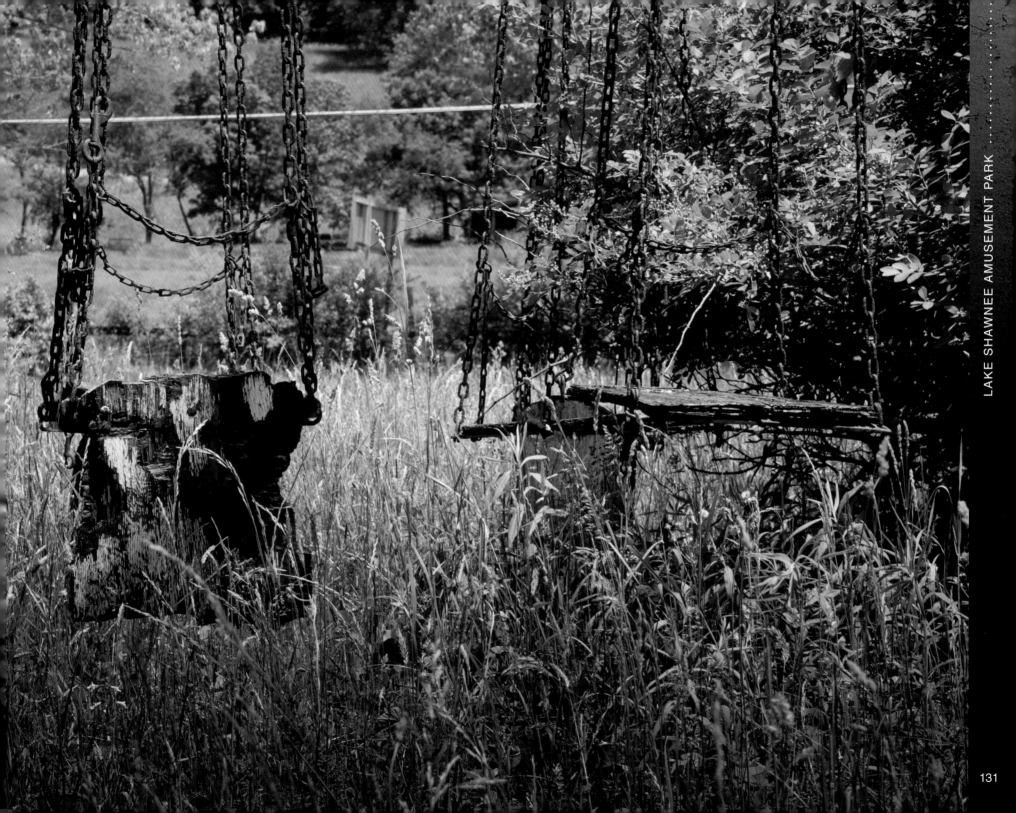

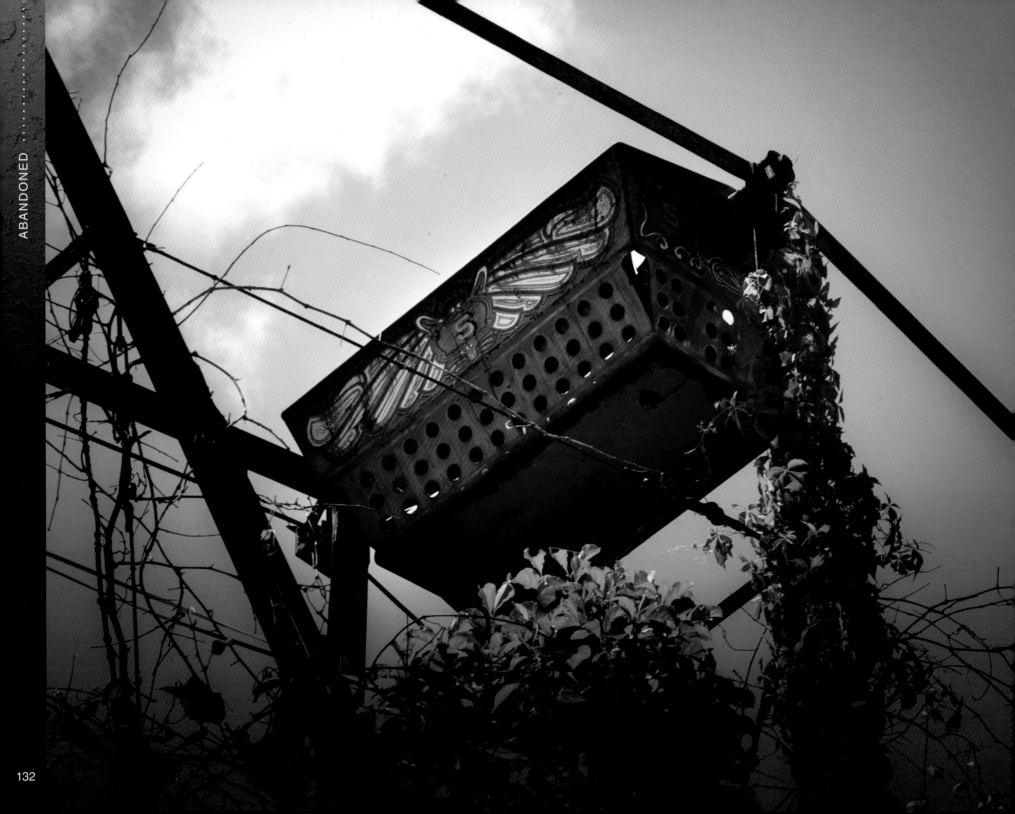

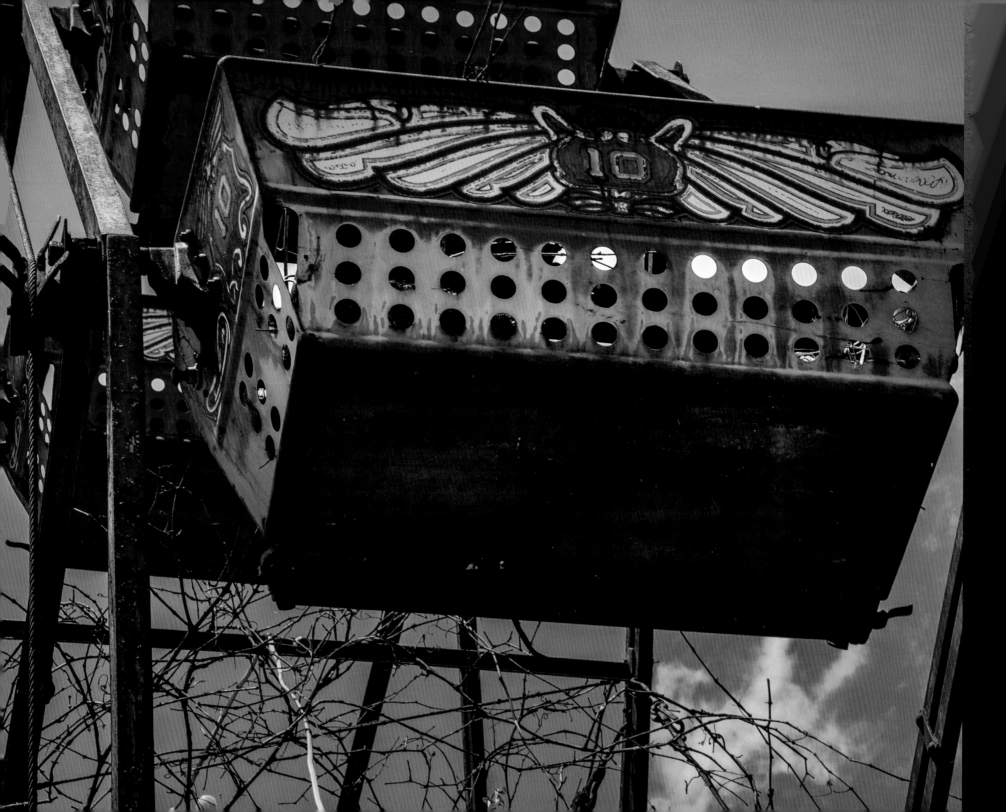

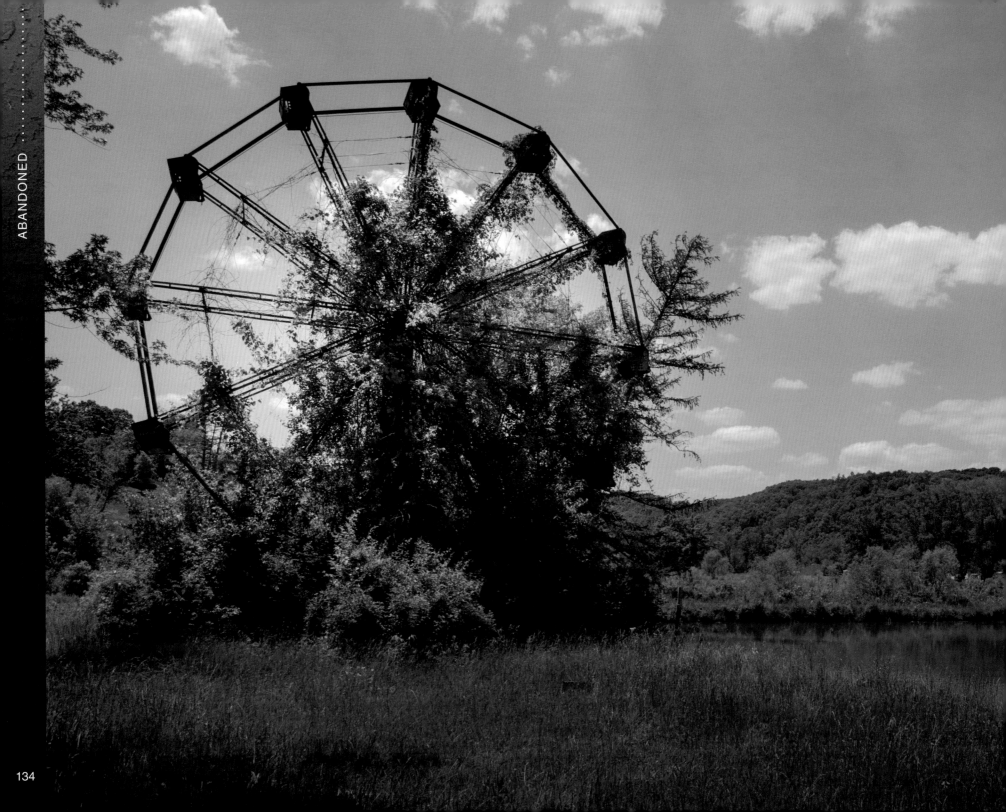

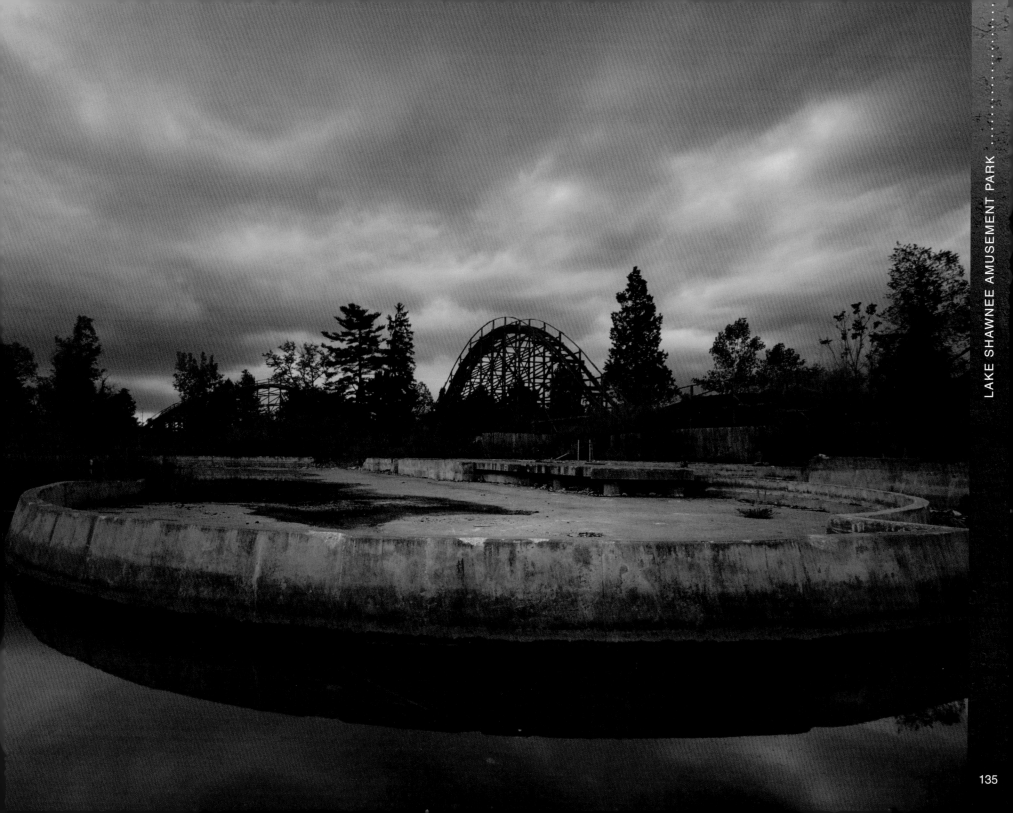

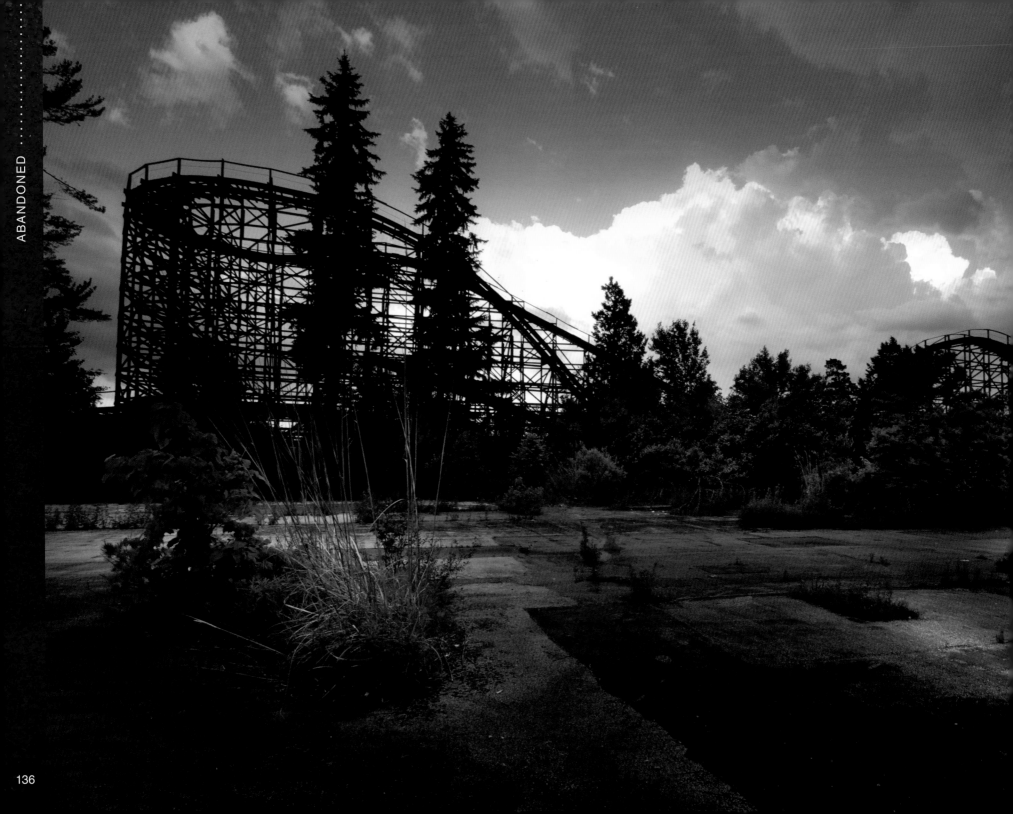

GEAUGA LAKE
AMUSEMENT PARK

AURORA, OHIO
1887–2005

Geauga Lake was an amusement park I grew up with and attended several times over the years. Several owners operated the park over its lifespan, including Six Flags towards the very end of the park's existence, but those that remember the park will always refer to it as Geauga Lake.

The Big Dipper wooden rollercoaster was one of my favorite rides here. I would visit the abandoned park for years, as rides slowly fell apart or were demolished. Each visit became more overwhelmingly sad as I was filled with emotions and nostalgic memories of laughing with my friends and family as we enjoyed the rides and peacefulness of the lake itself.

On my last visit to the park, only one ride remained, and it was the remnants of the Big Dipper rollercoaster. It looked more like the skeletal remains of a once-thriving, roaring, and powerful dinosaur, reminding me that extinction is inevitable and my

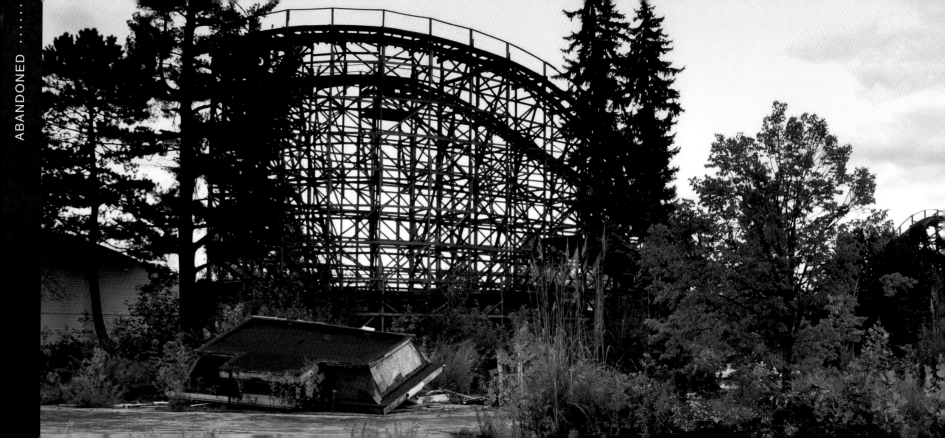

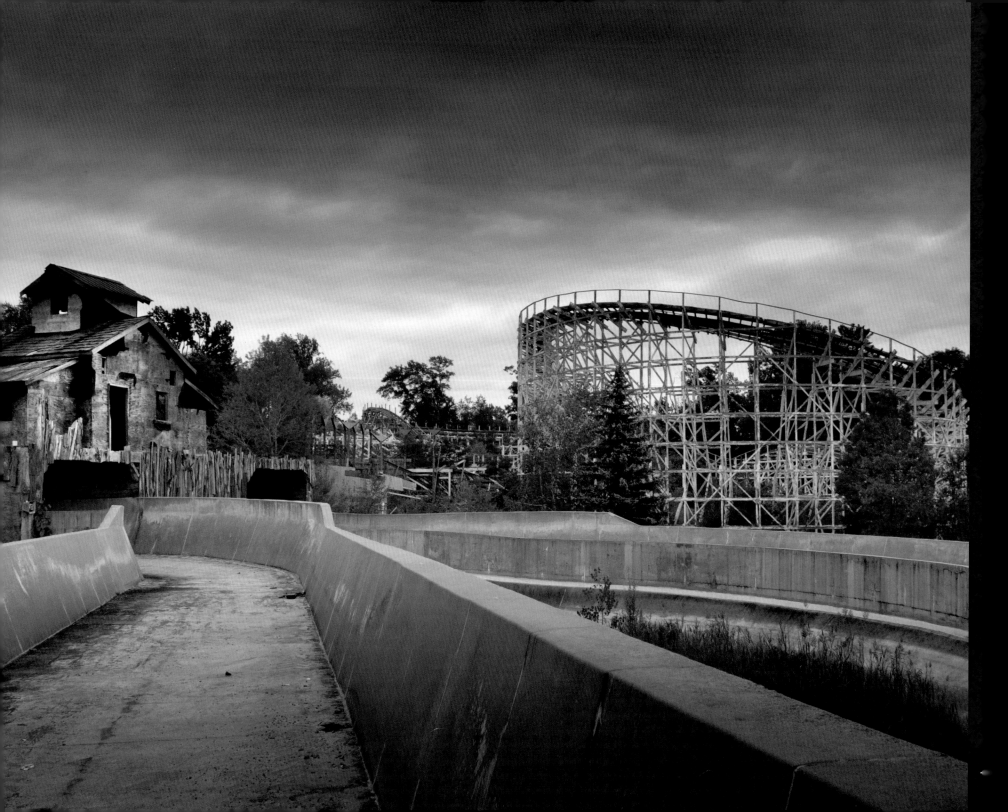

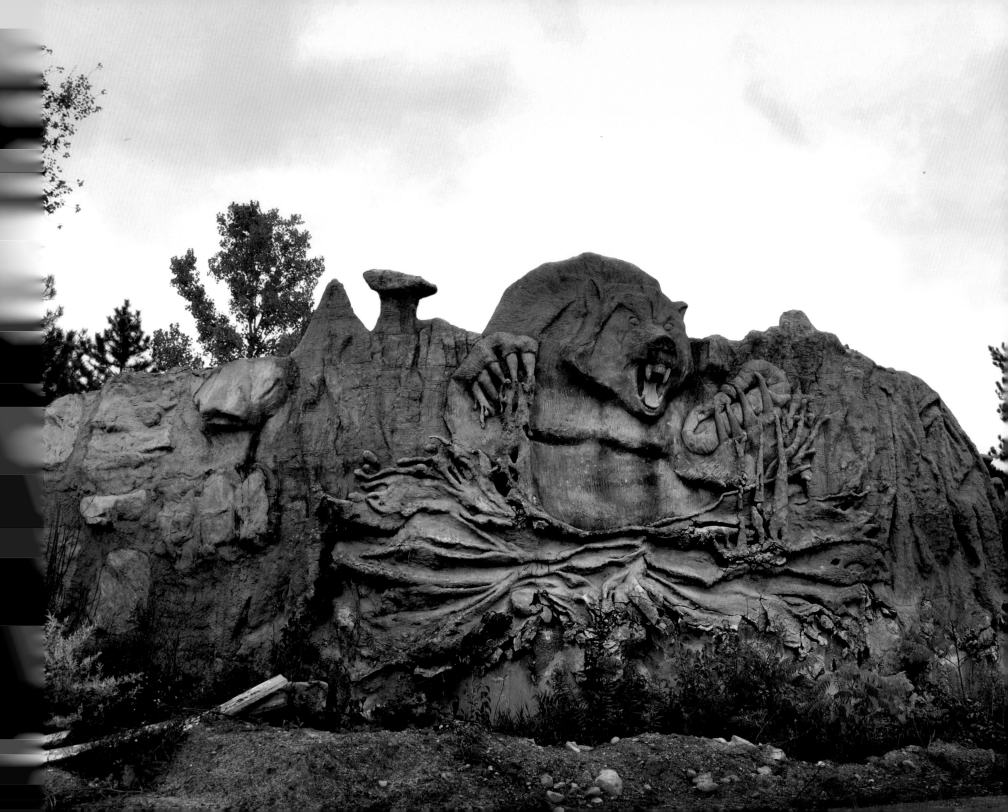

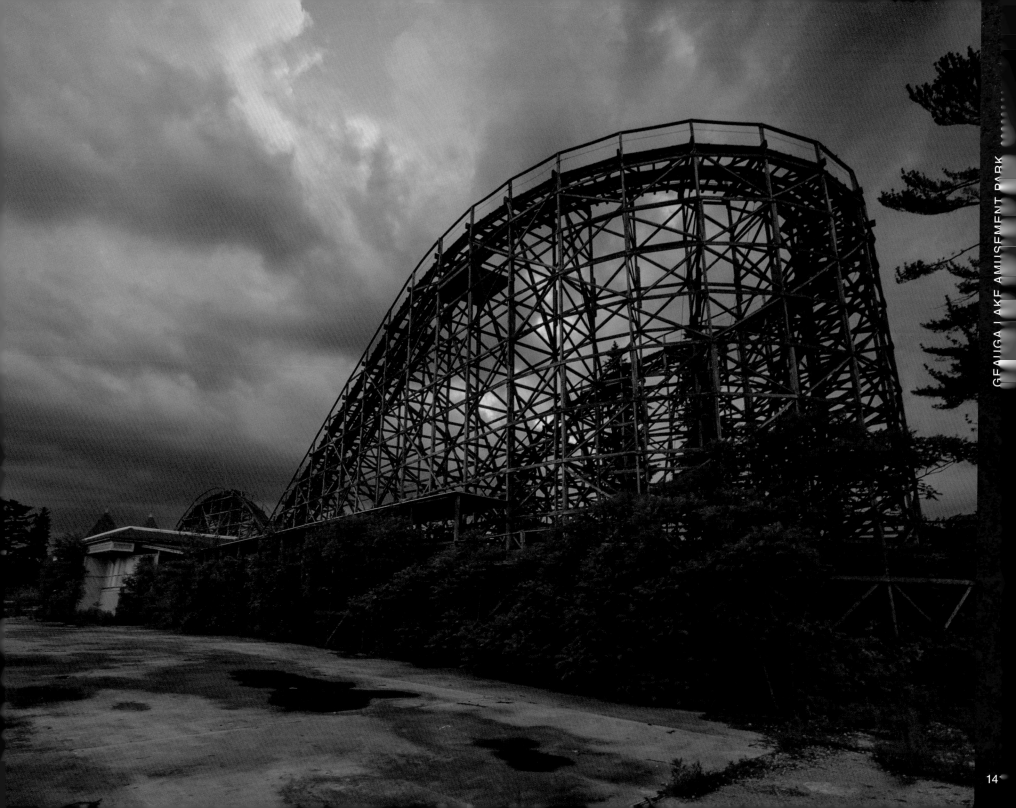

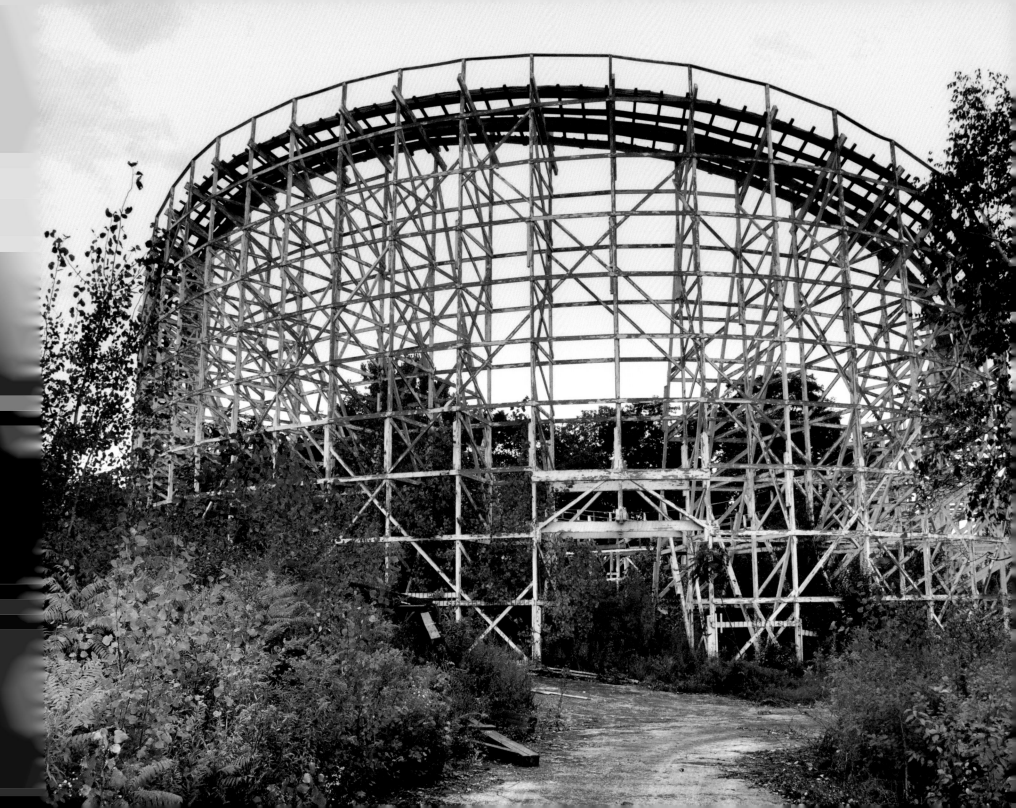

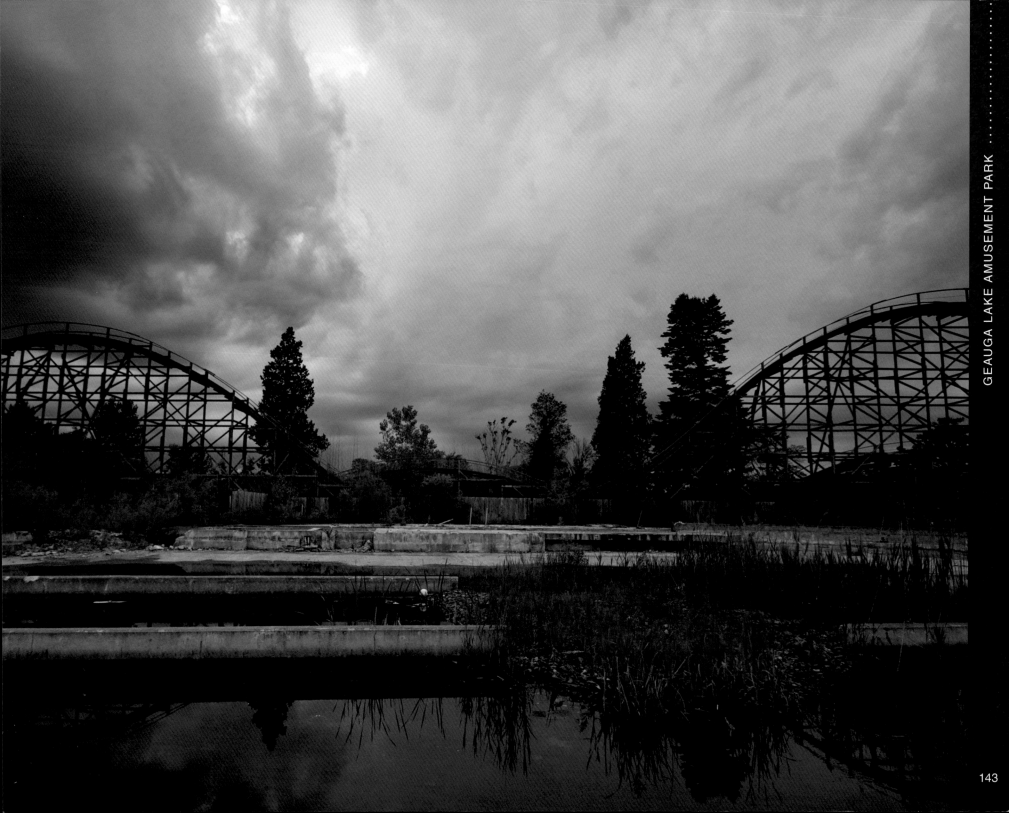

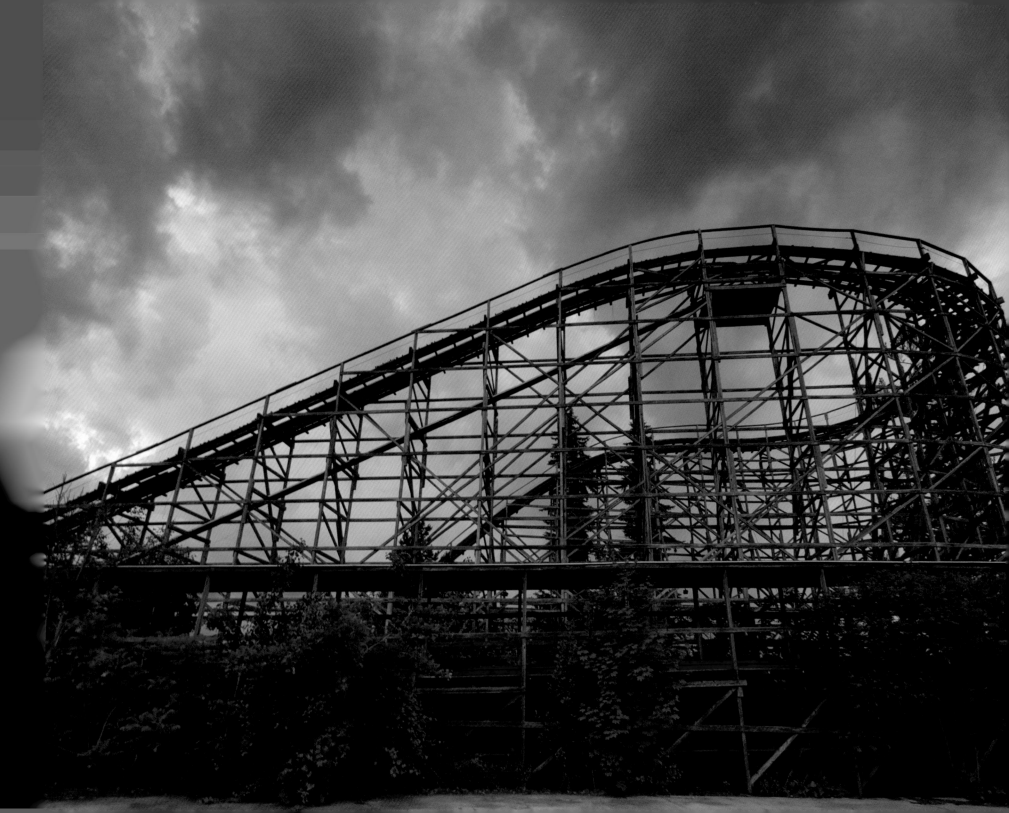

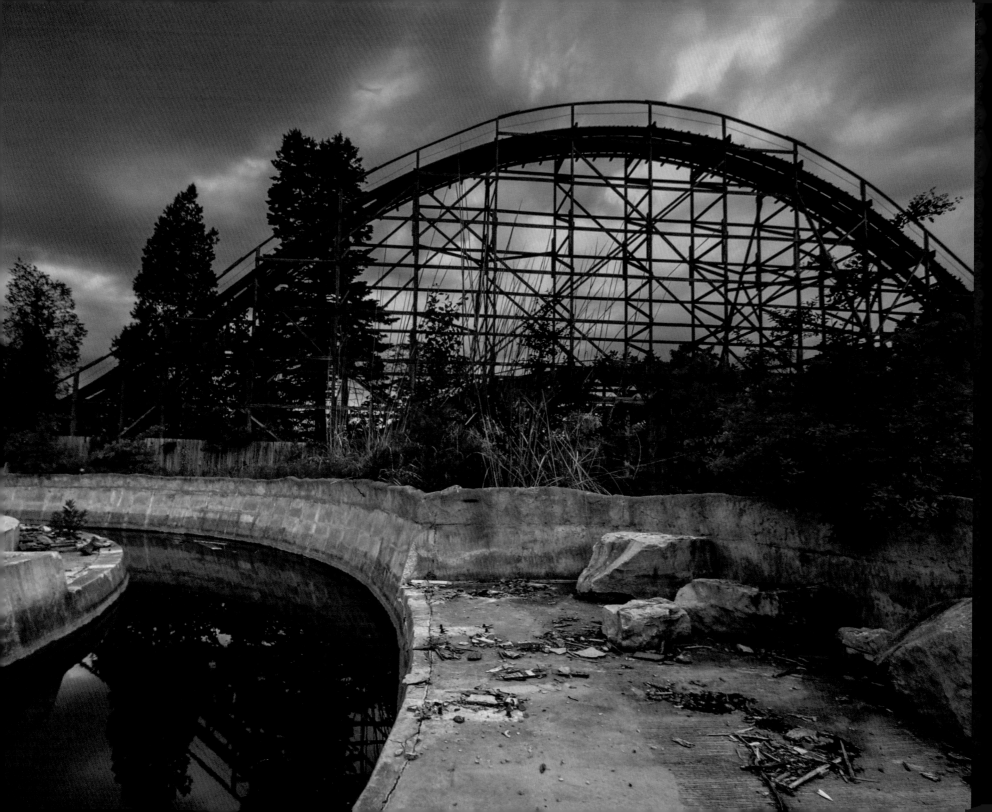

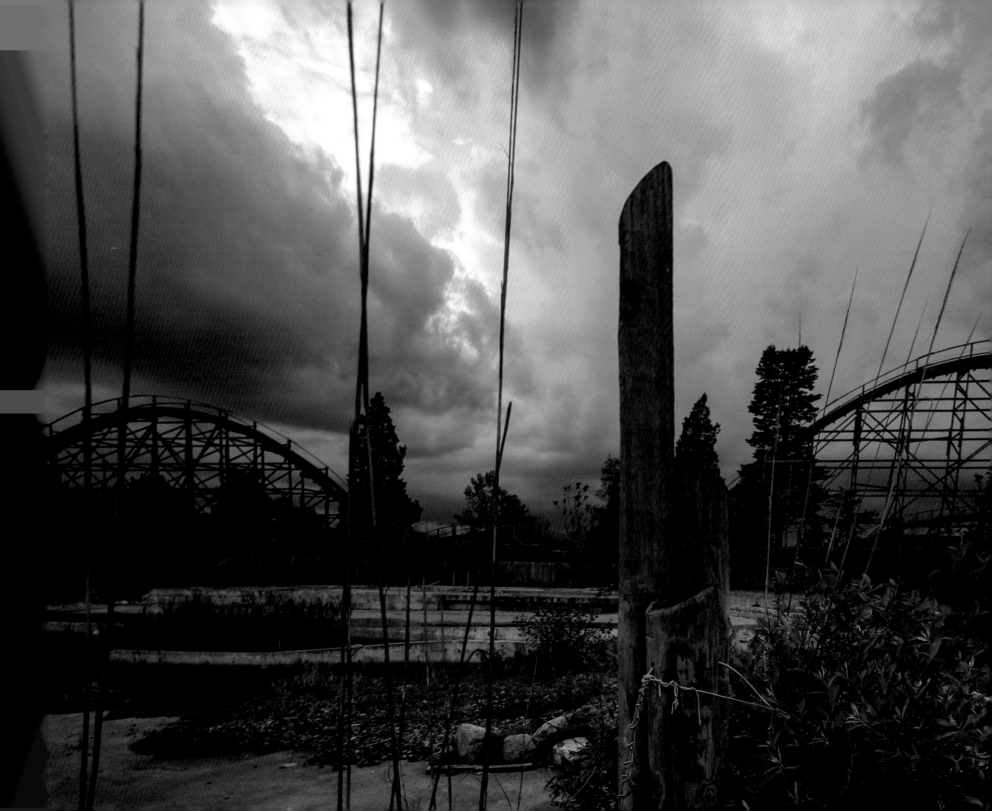

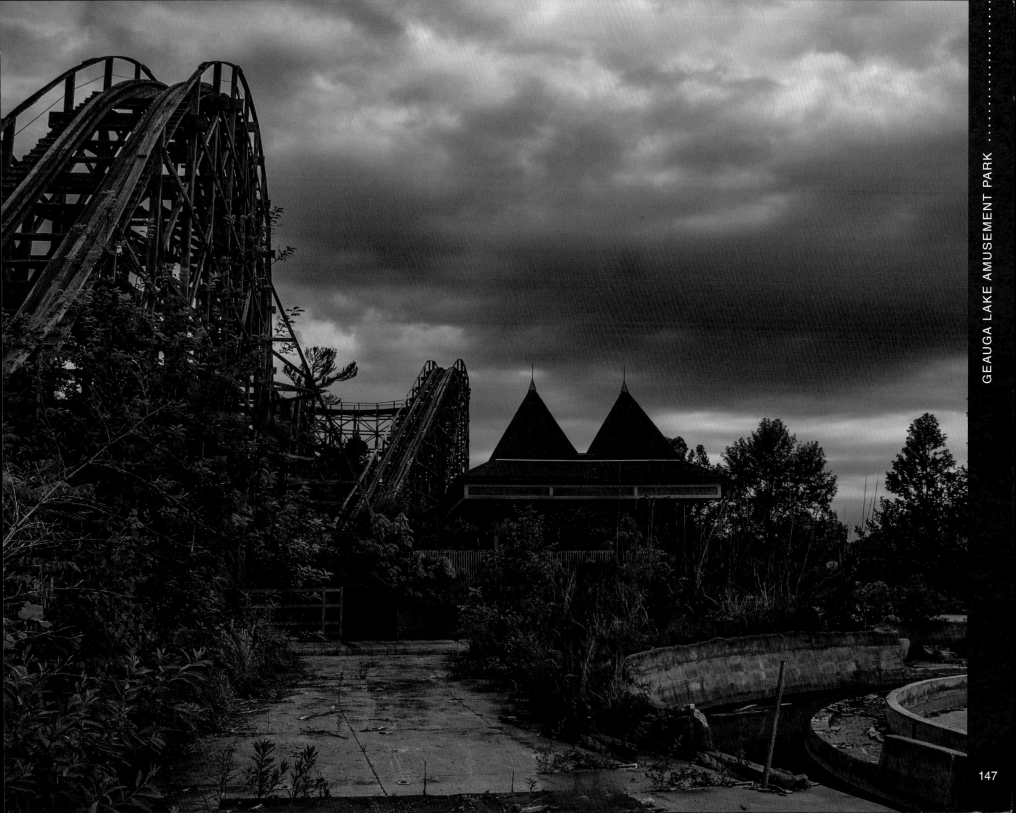

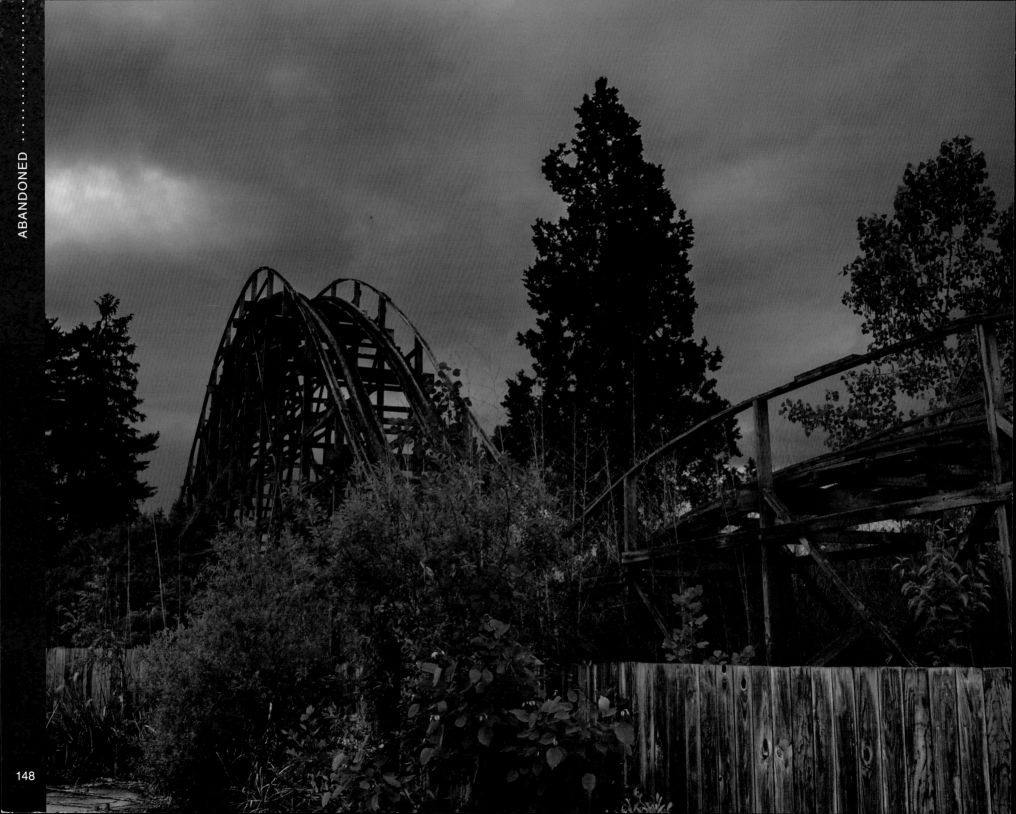

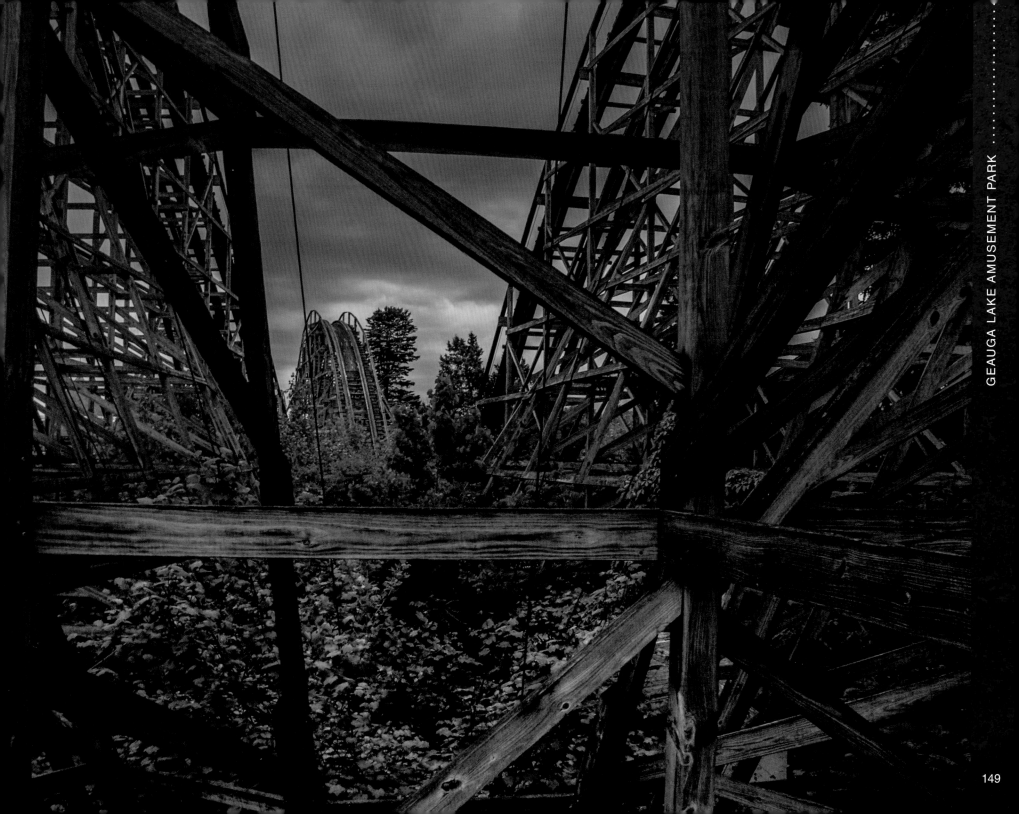

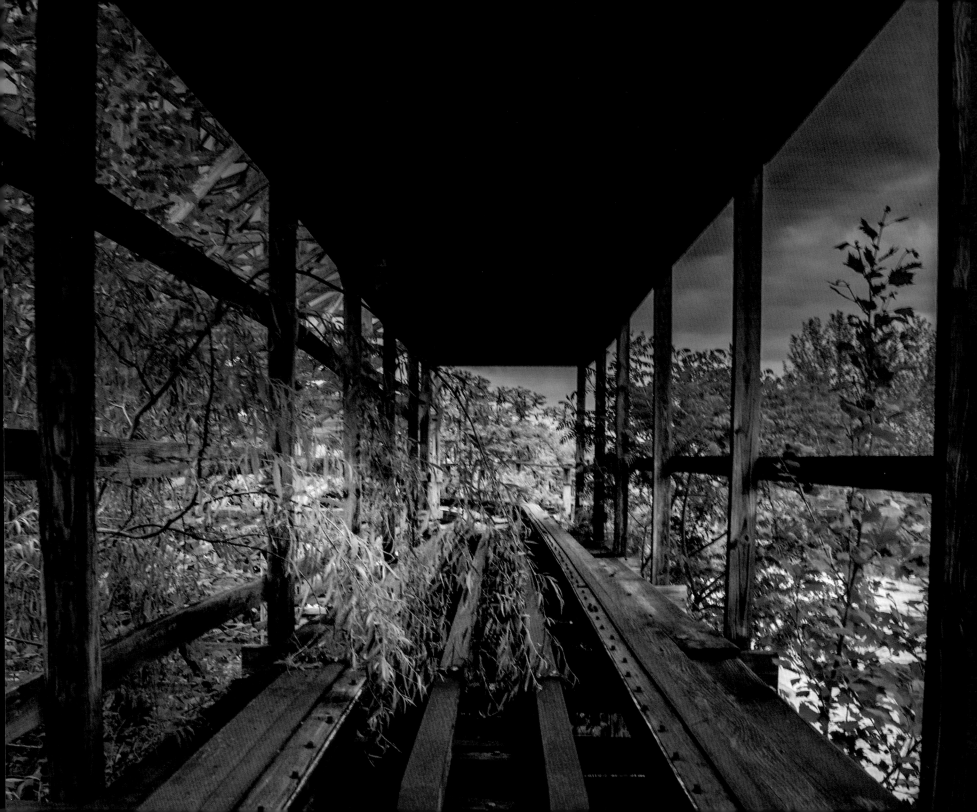

151

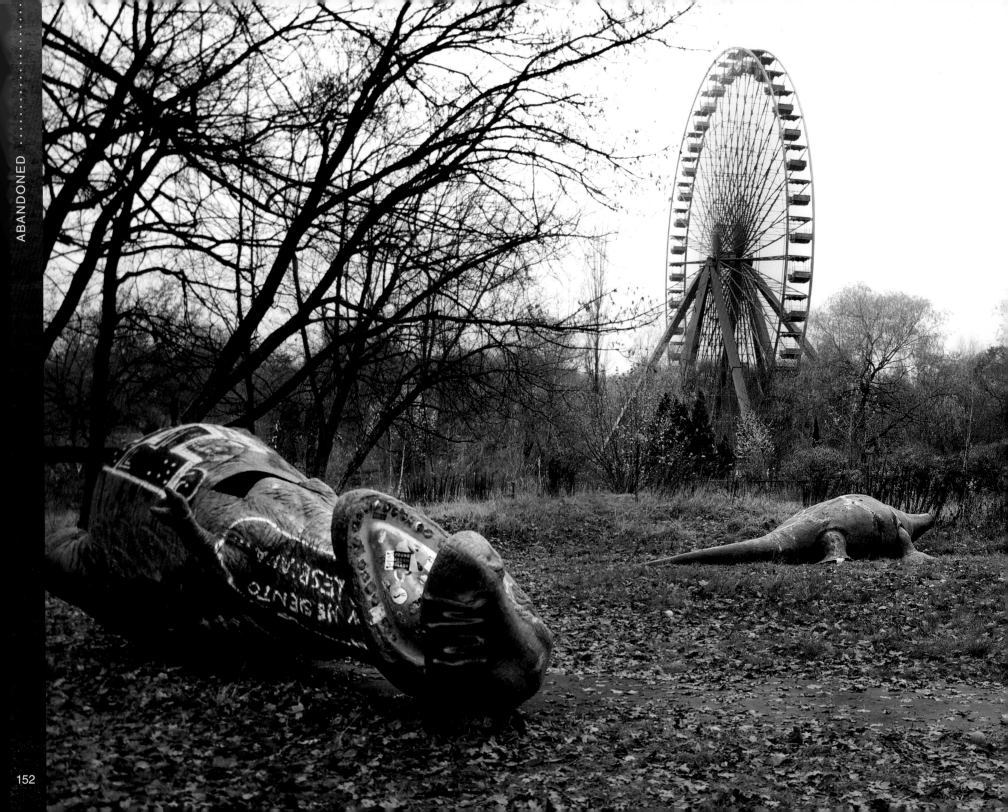

SPREEPARK

BERLIN, GERMANY
1969–2002

Located in Berlin, Germany, this abandoned amusement park was one of my favorite places to photograph. The rides were mostly intact, but accompanied by overgrown weeds that offered stirring, beautiful visuals throughout the forgotten park.

After I had successfully photographed the entire park, I heard German police say, "Sir, hand over your passport," which is always unnerving. Luckily for me, they were familiar with my work and just escorted me out of the park, warning me not to take any more photographs. As I left, I was able to sneak one last photograph of the rather cryptic, crumbling dinosaur statues resting against a forbidding foreground of the ominous Ferris wheel in the distance. It was a poignant shot I just had to take, and to this day, it's one of my favorite photographs I've ever captured.

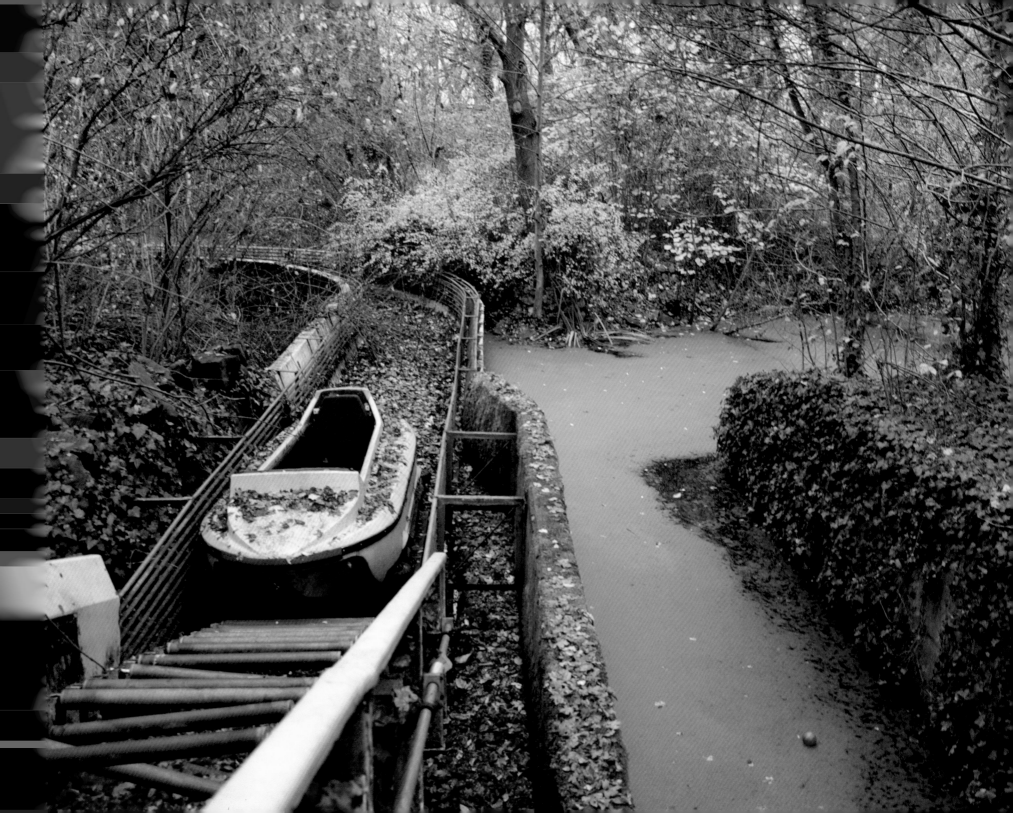

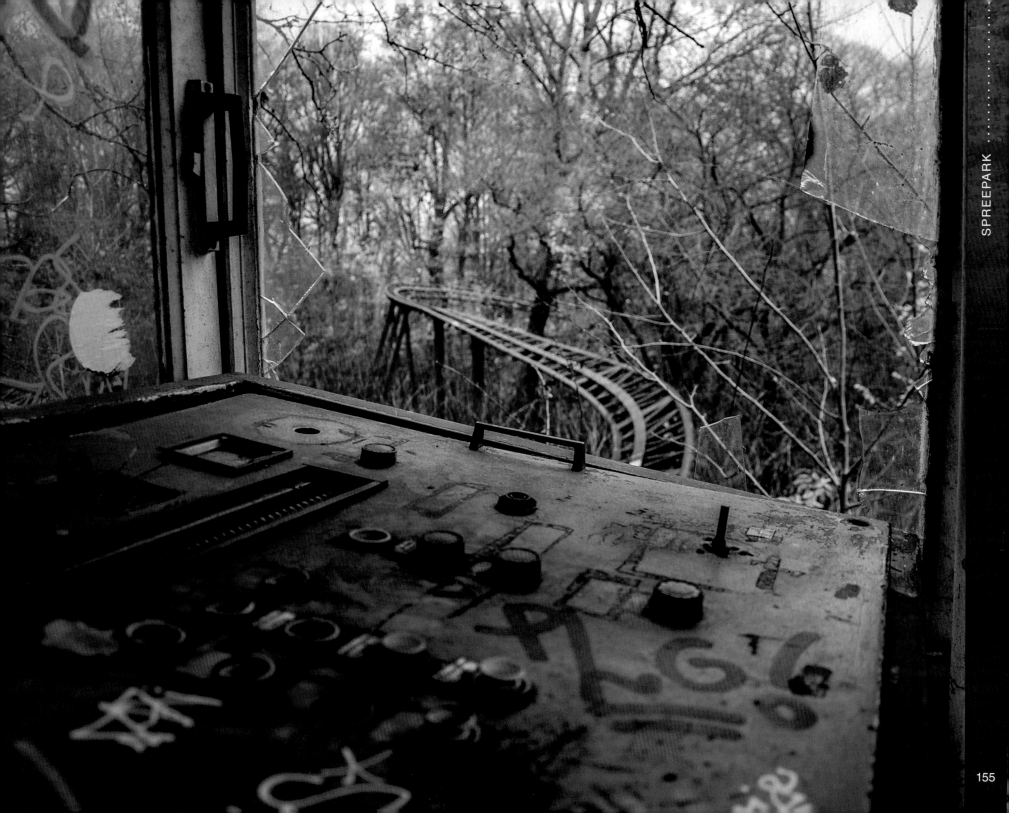

155

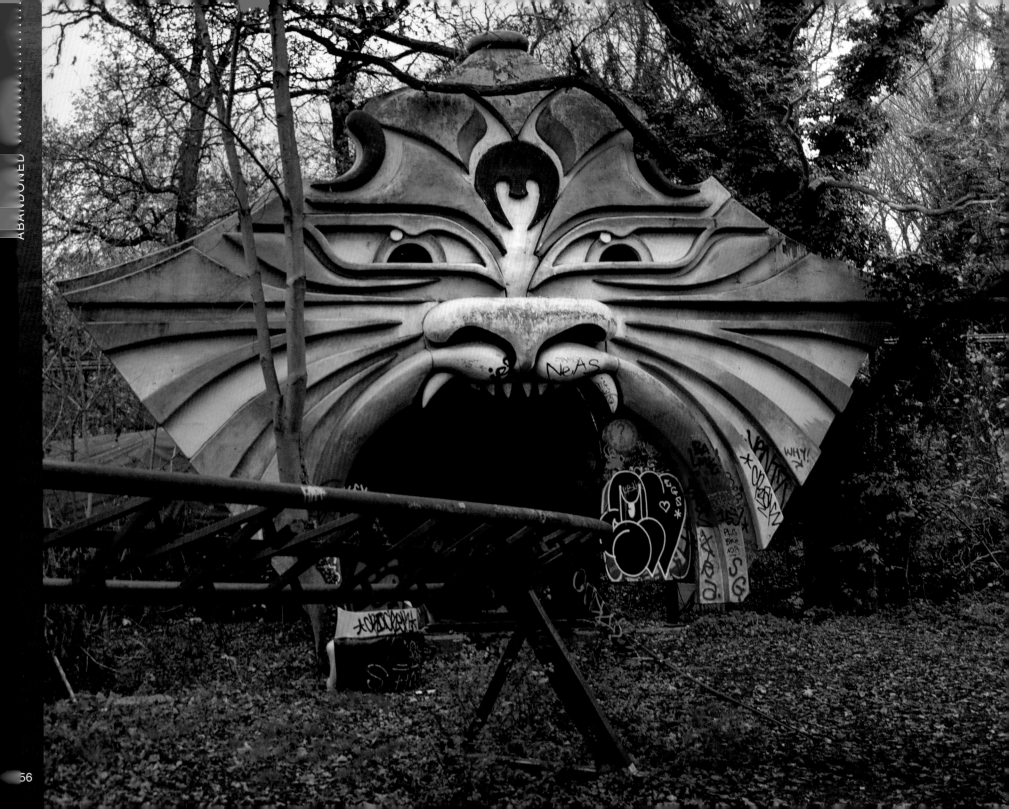

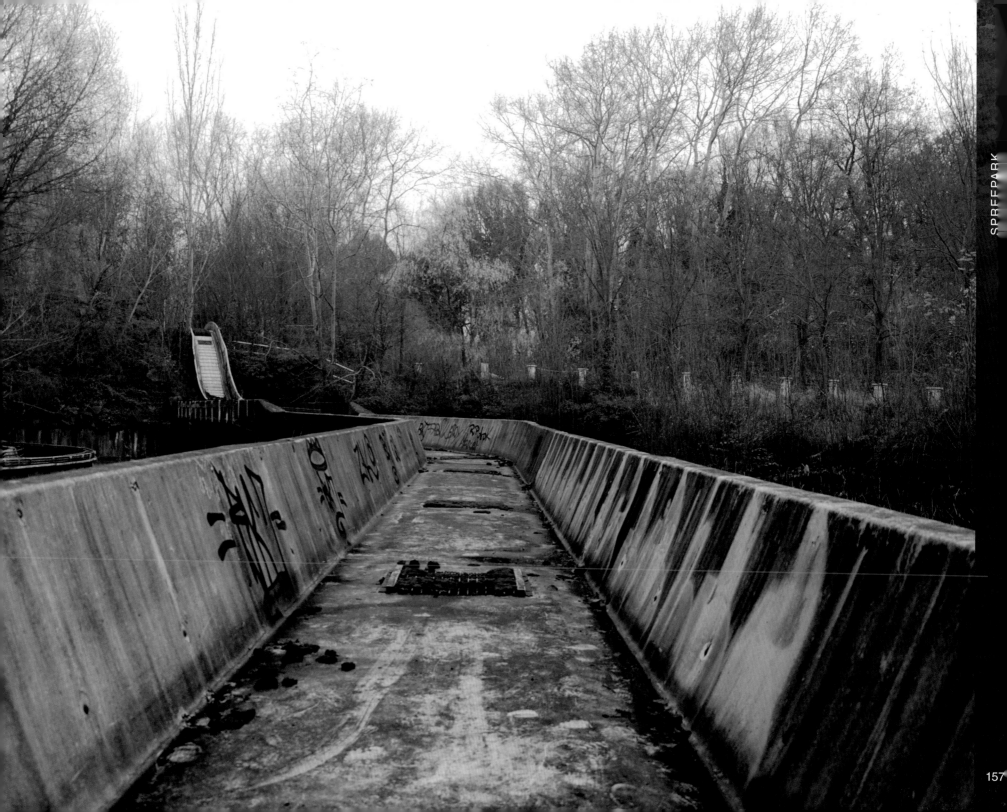

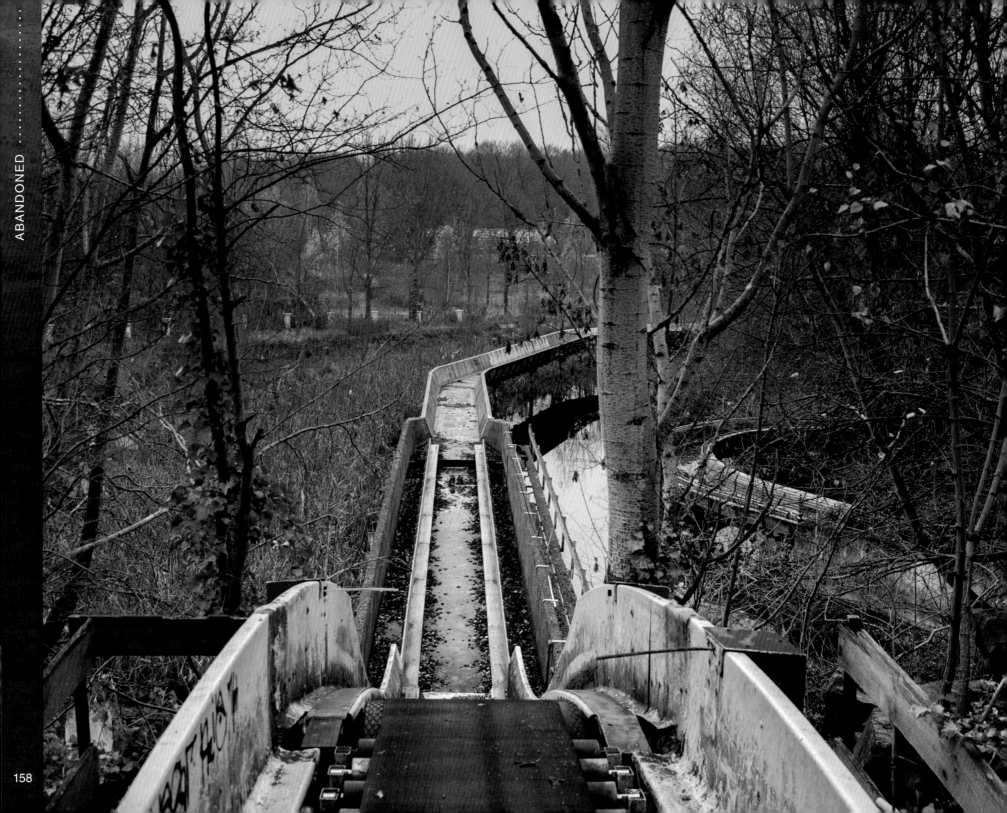

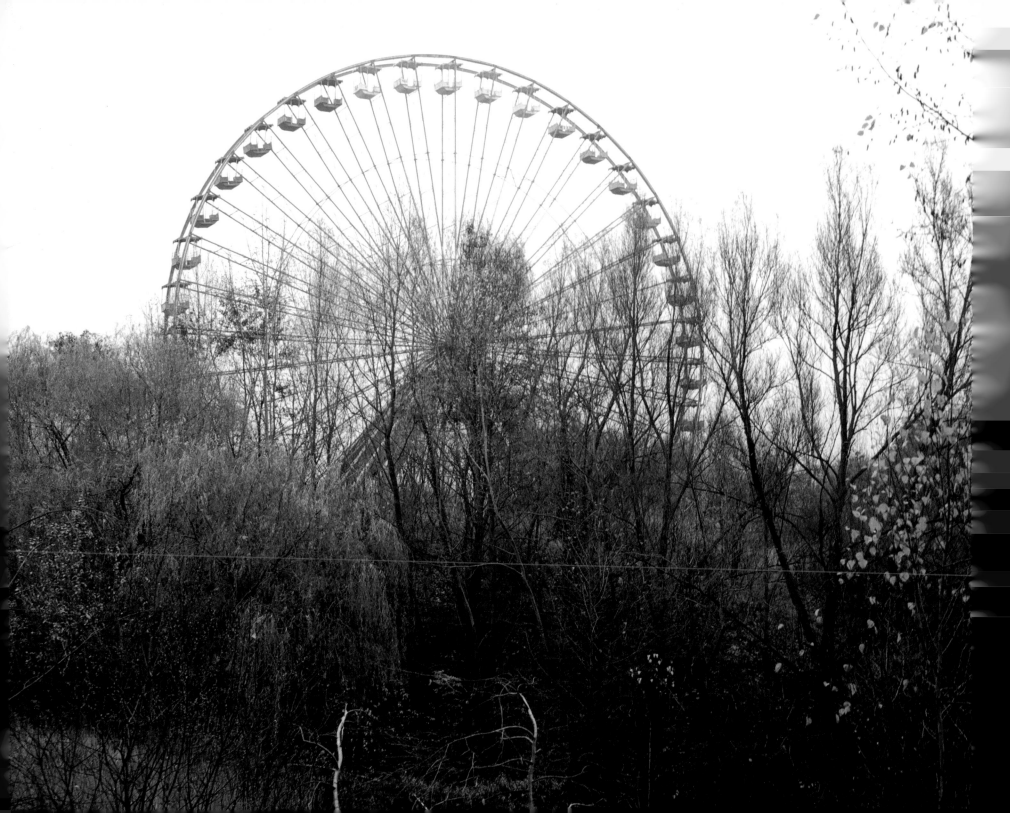

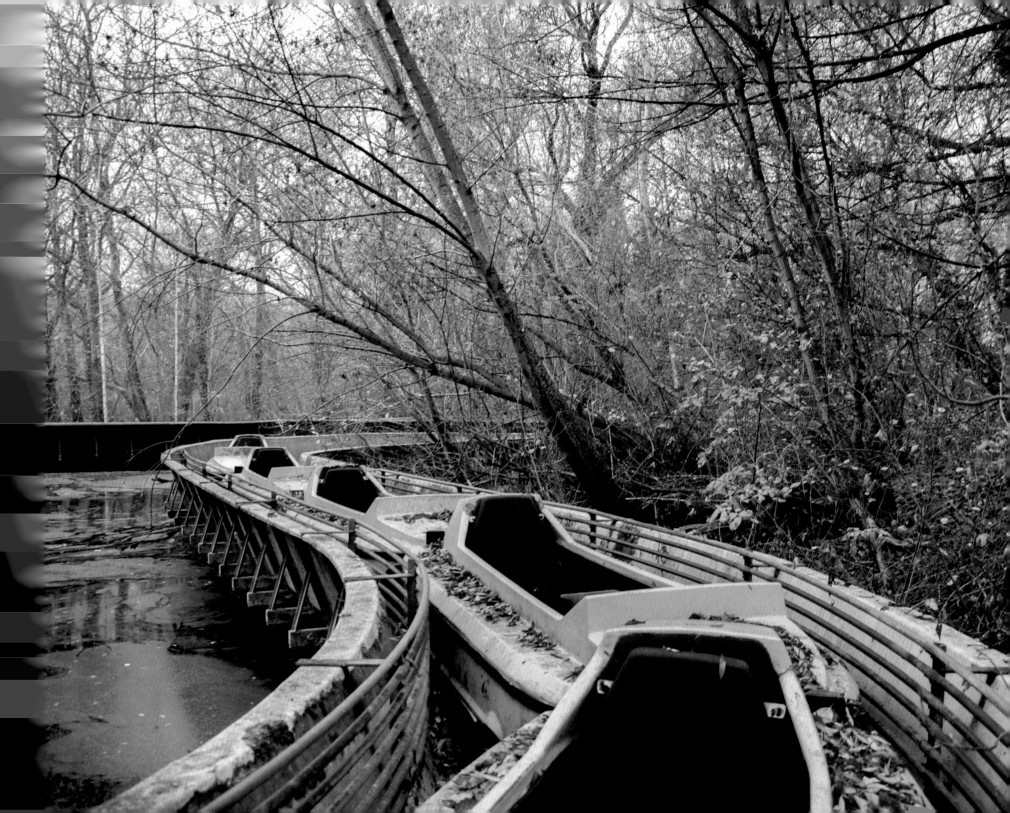

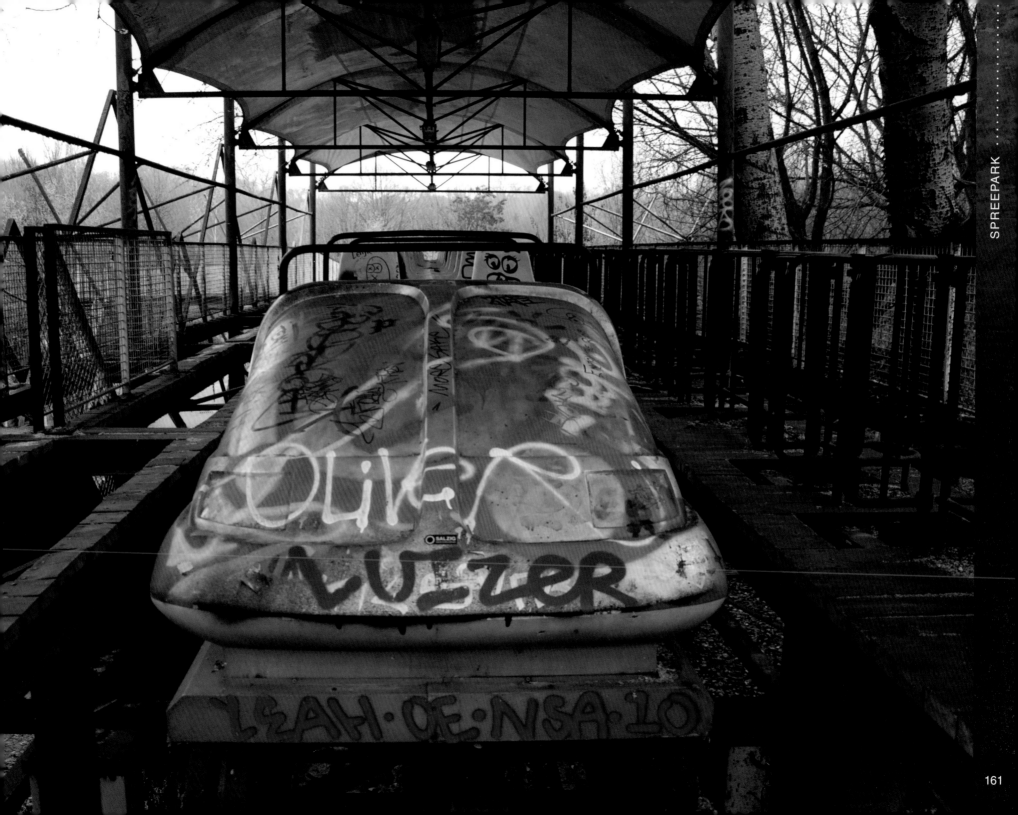

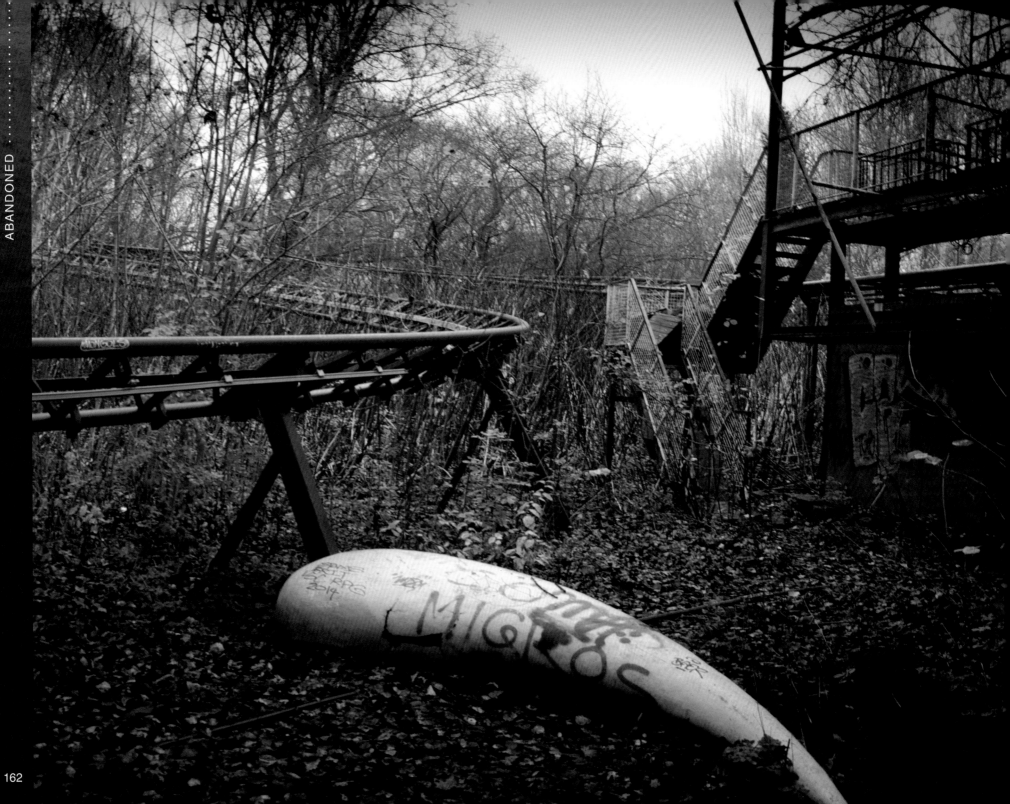

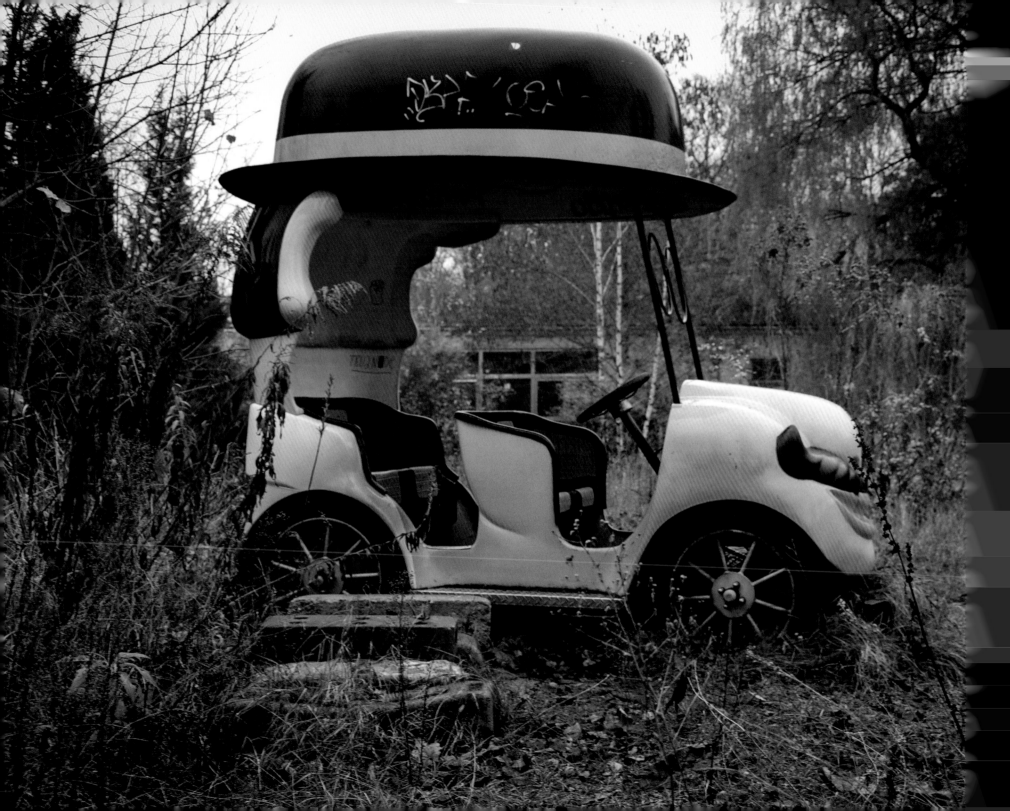

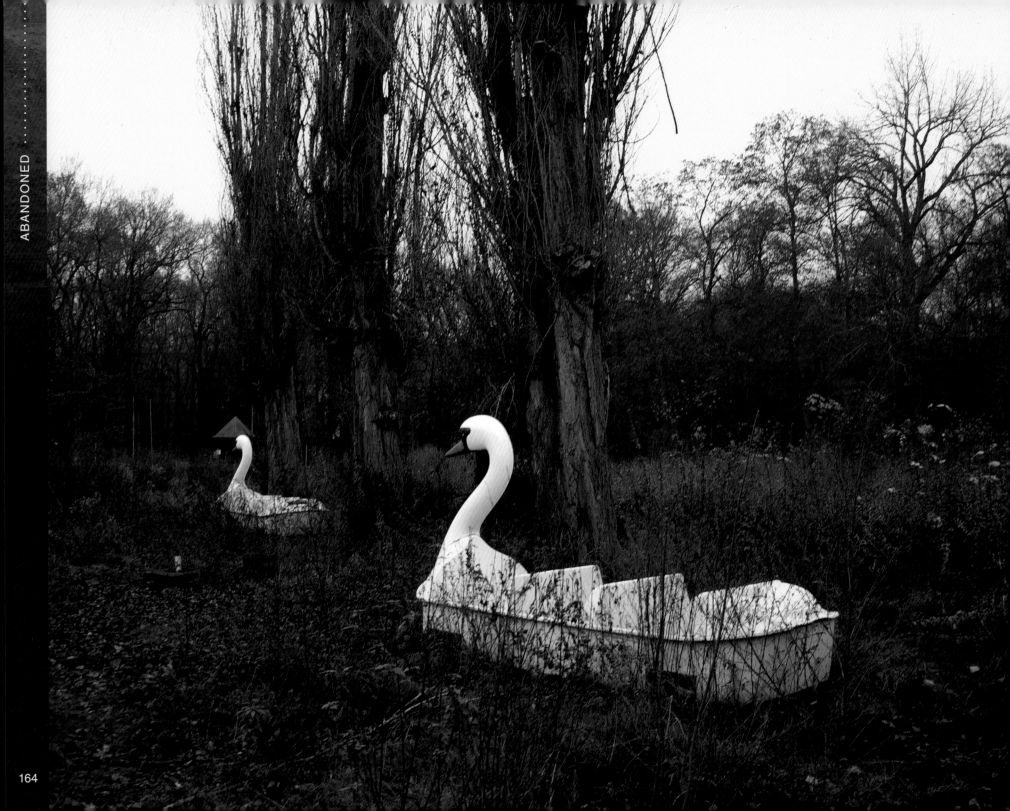

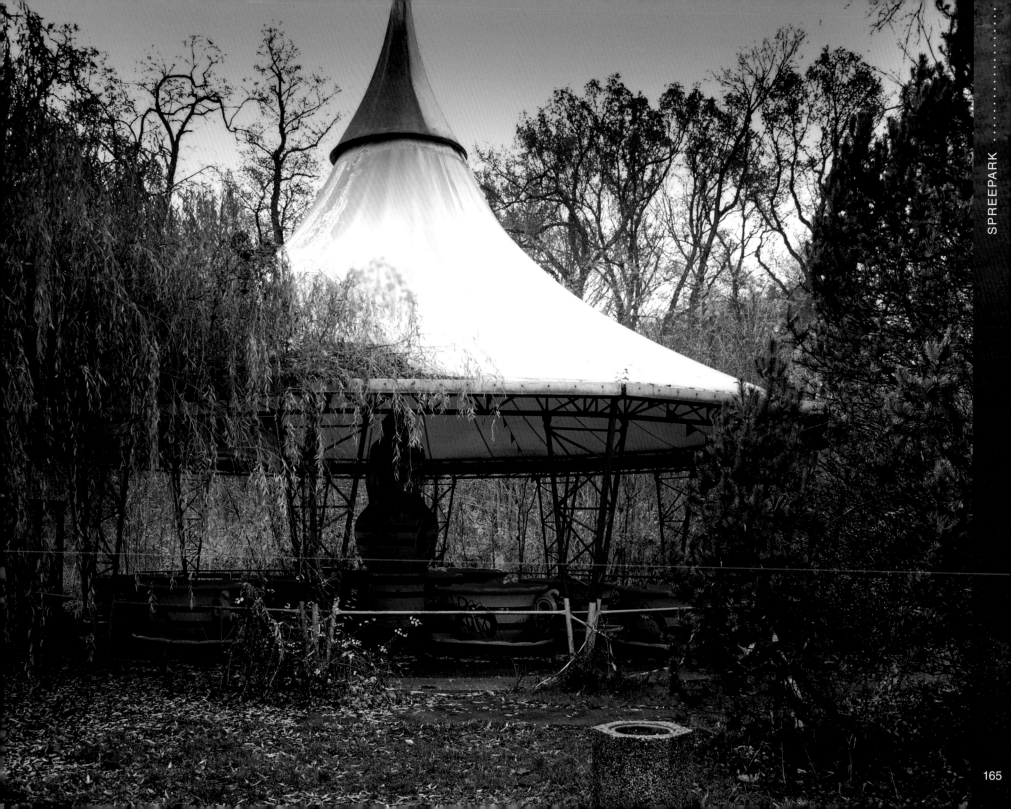

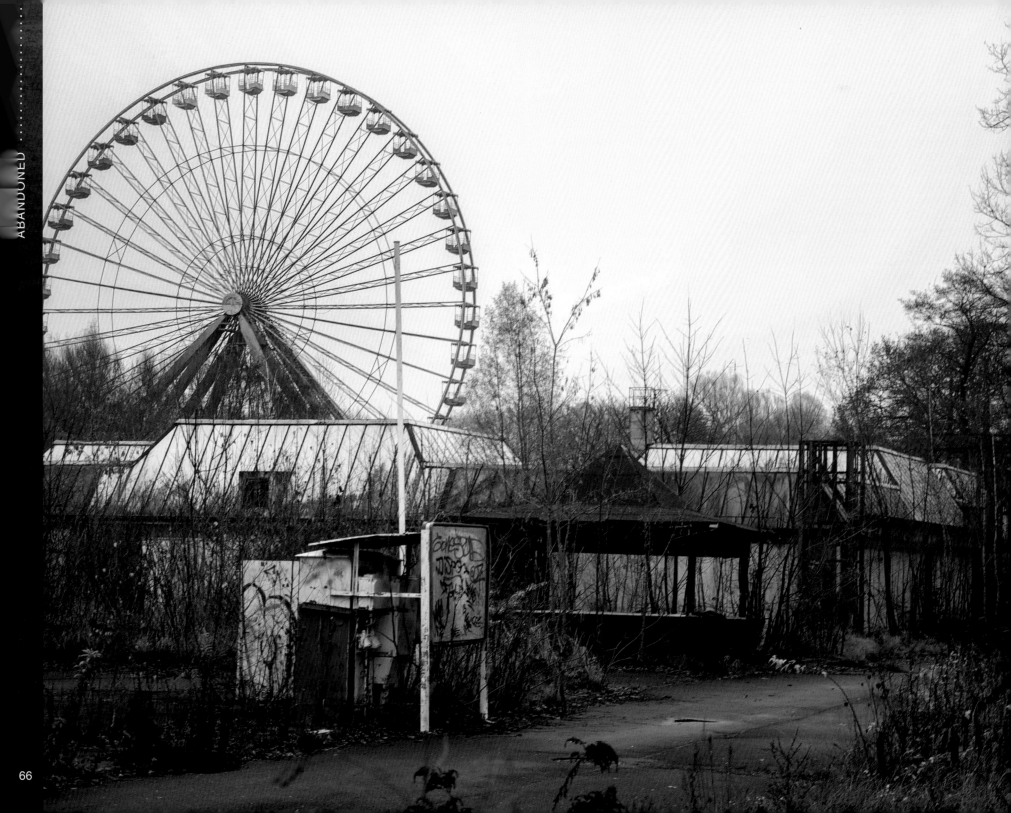

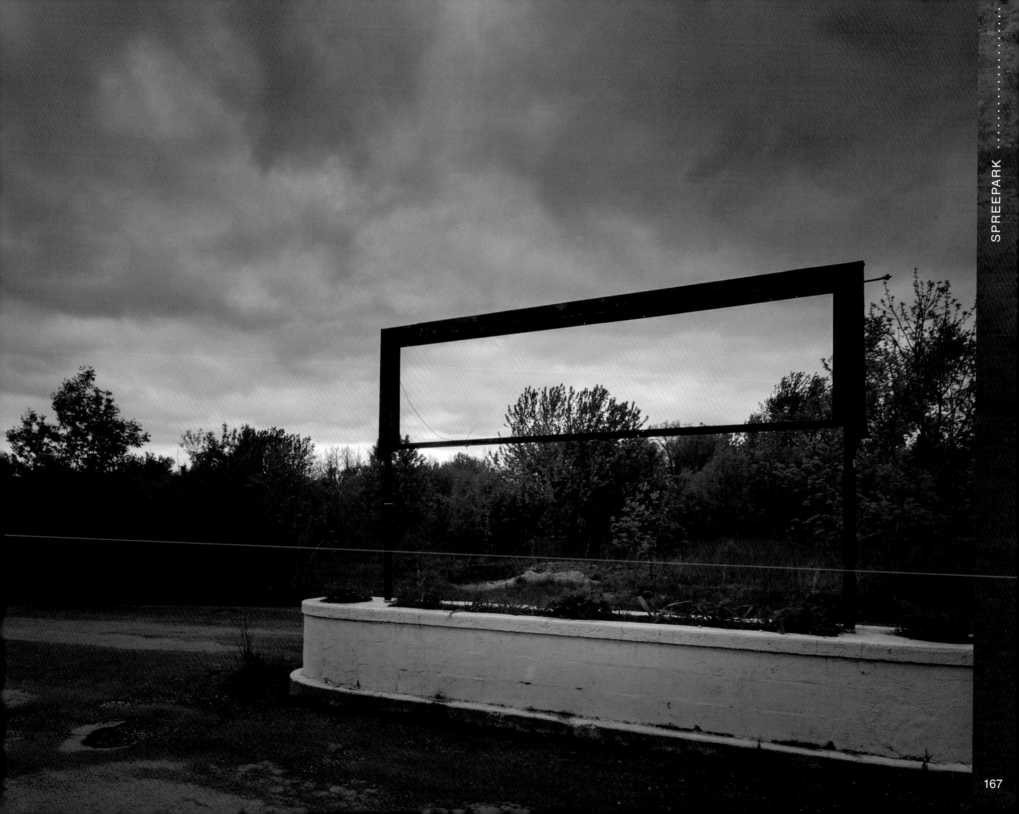

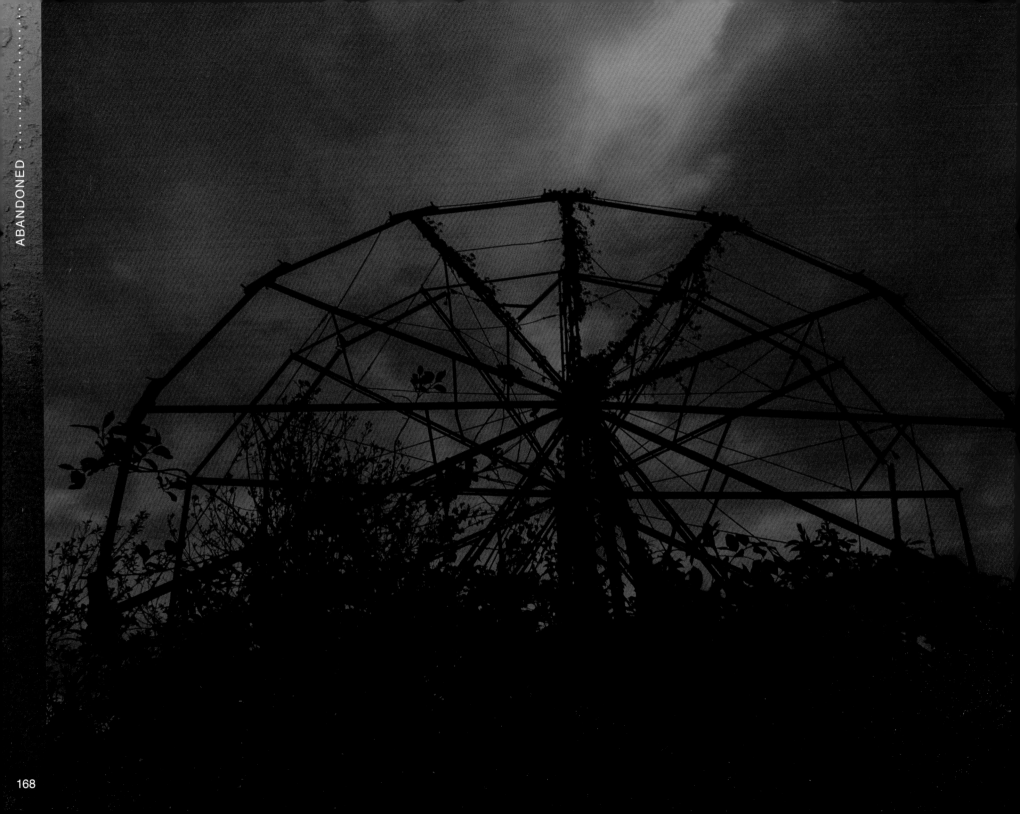

CHIPPEWA LAKE AMUSEMENT PARK

CHIPPEWA LAKE, OHIO
1898–1969

This is one of the oldest abandoned theme parks I have ever visited. It operated for precisely a century—albeit under a different name for a portion of the duration—before its untimely demise. It used to be a very popular theme park, with more people sharing with me their yearning memories over the years than any other abandoned theme park.

It was a place my parents spent their childhoods. I remember hearing them reminisce about the good memories they had at the park. They even brought me here several times as a child in my early years, but I was too young to have any real nostalgic memories other than the old film photographs in my family scrapbooks. The old photographs, some even in black and white, are now covered in thick dust and show only a glimpse into what this park once looked like—and it was glorious.

I visited here several times since the park became abandoned. Each time, it felt as though I was almost searching for a cause of death. At times, I even brought with me old film photographs of the park, trying to find the area in which an old photograph was taken, but sadly, it became unrecognizable.

There is a spooky, Scooby Doo kind of atmosphere here, with the skeletal remains of the wooden rides resting against the stillness of the lake at dusk.

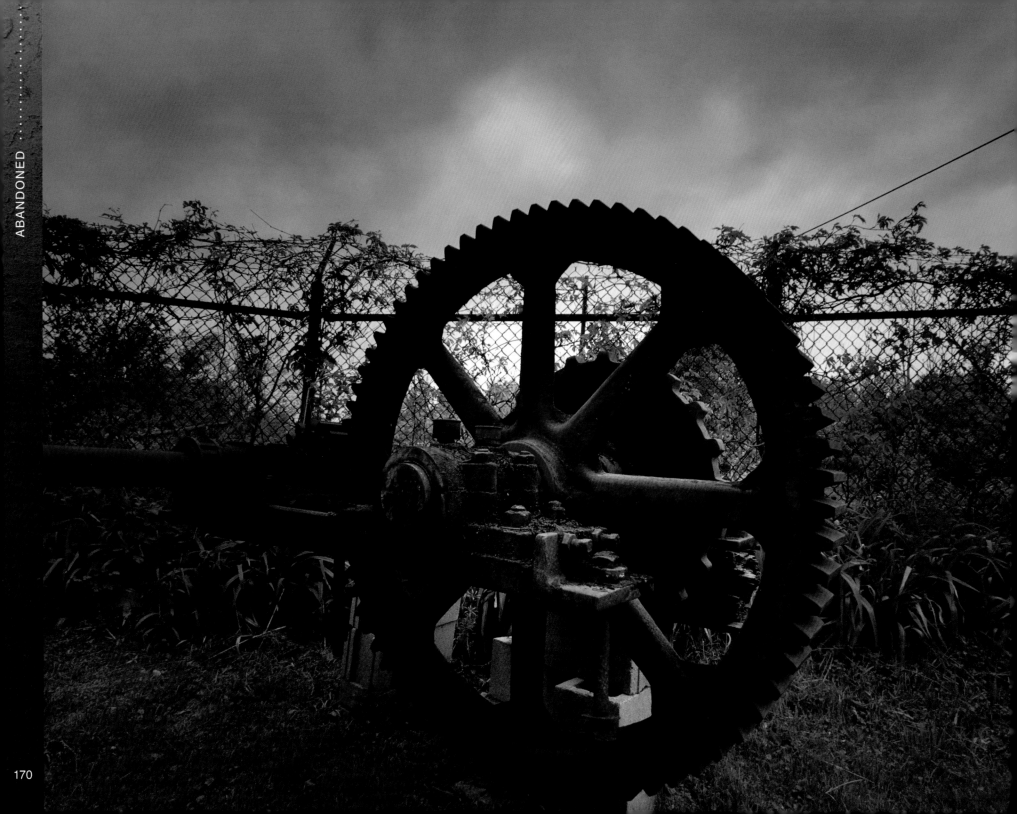

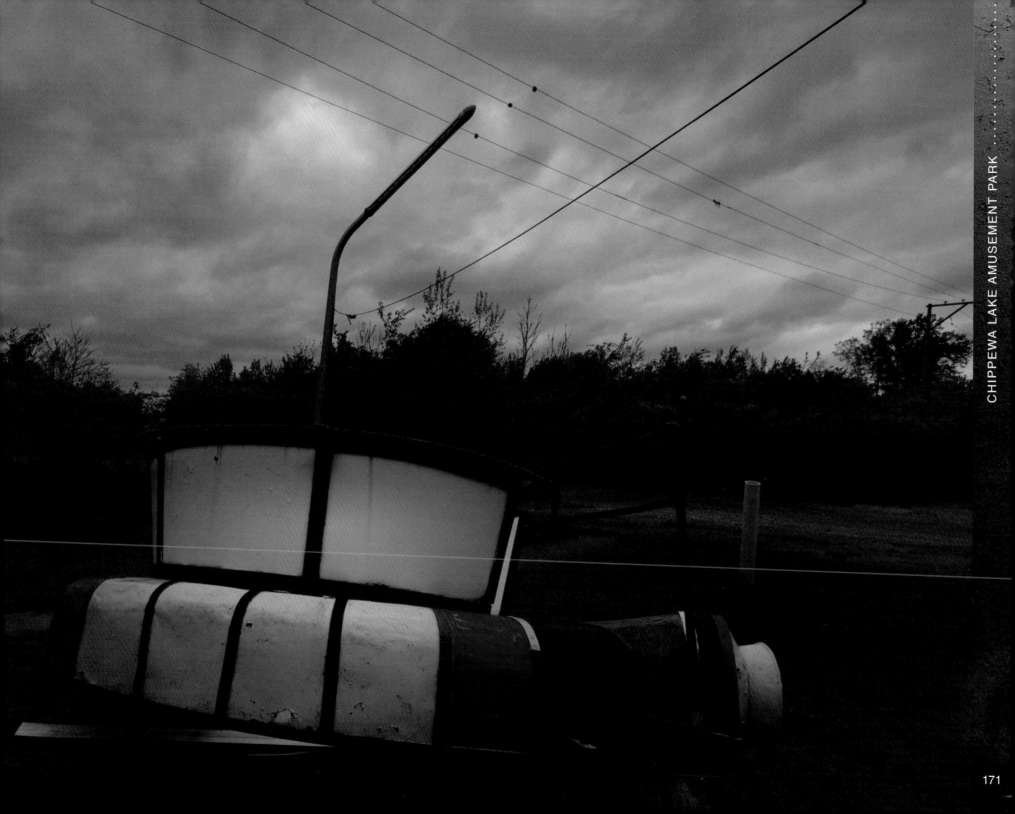

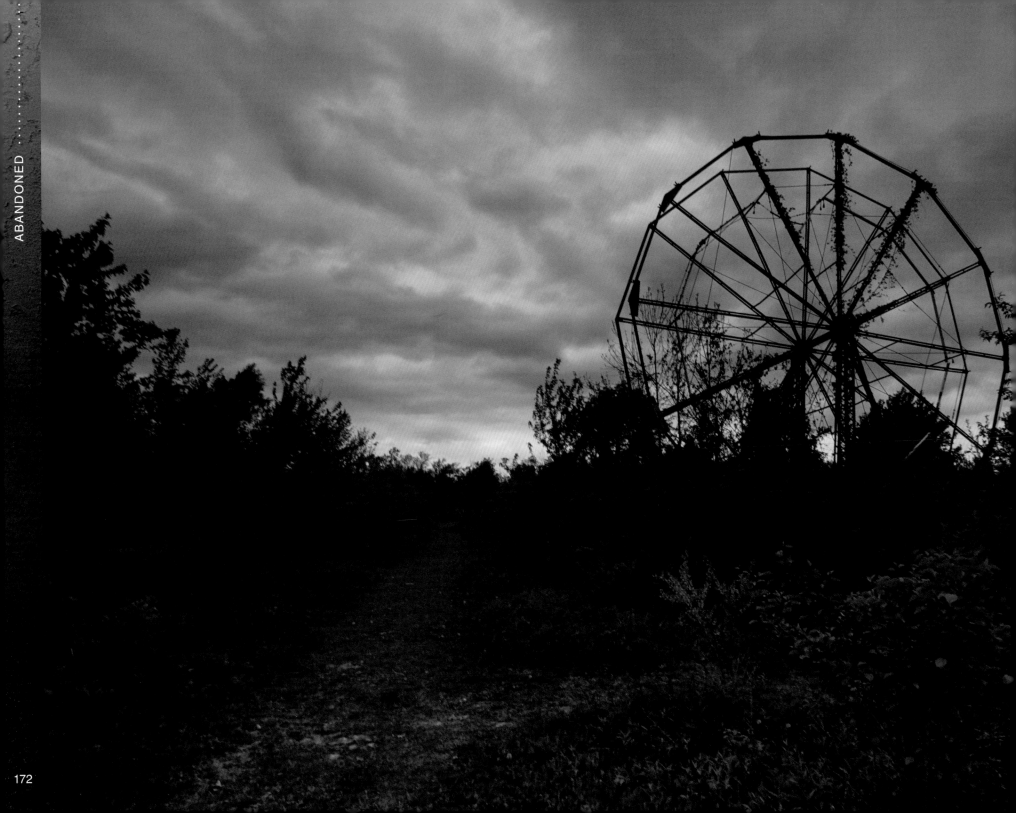

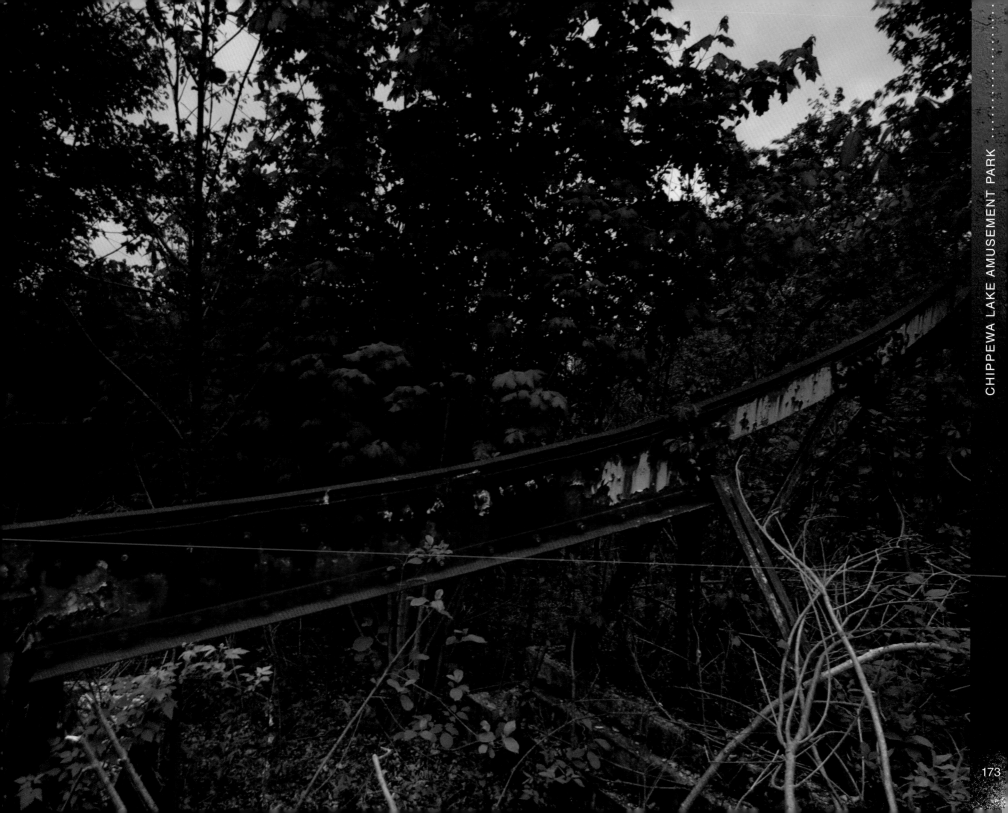

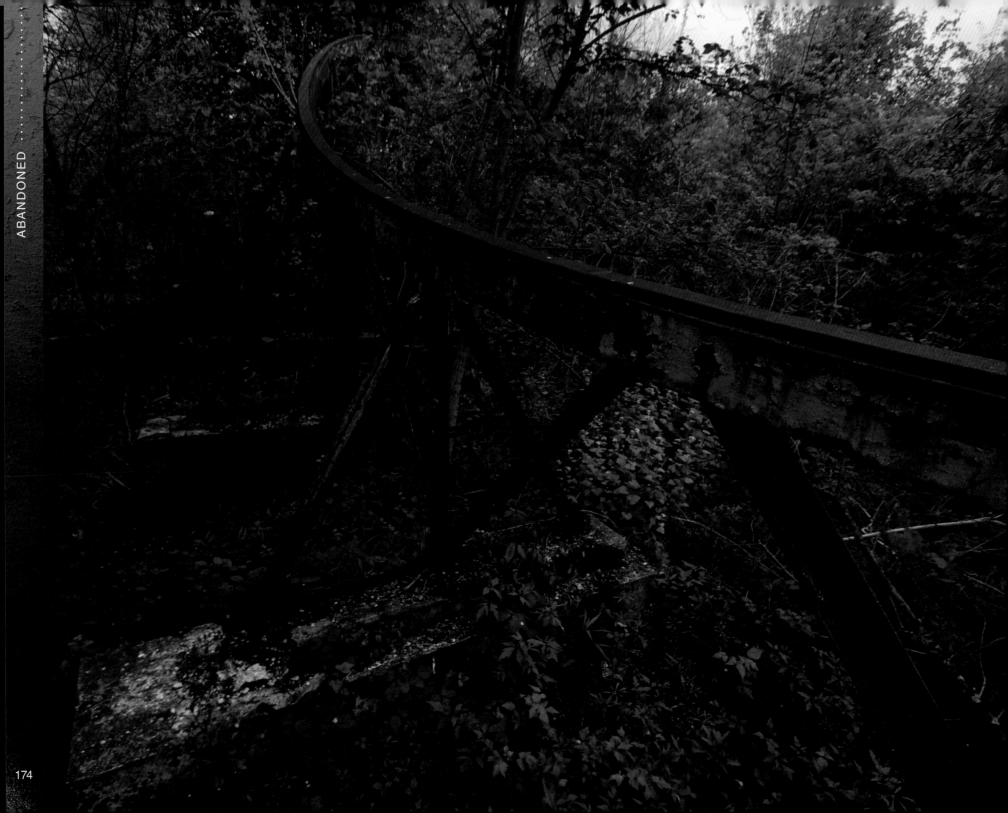

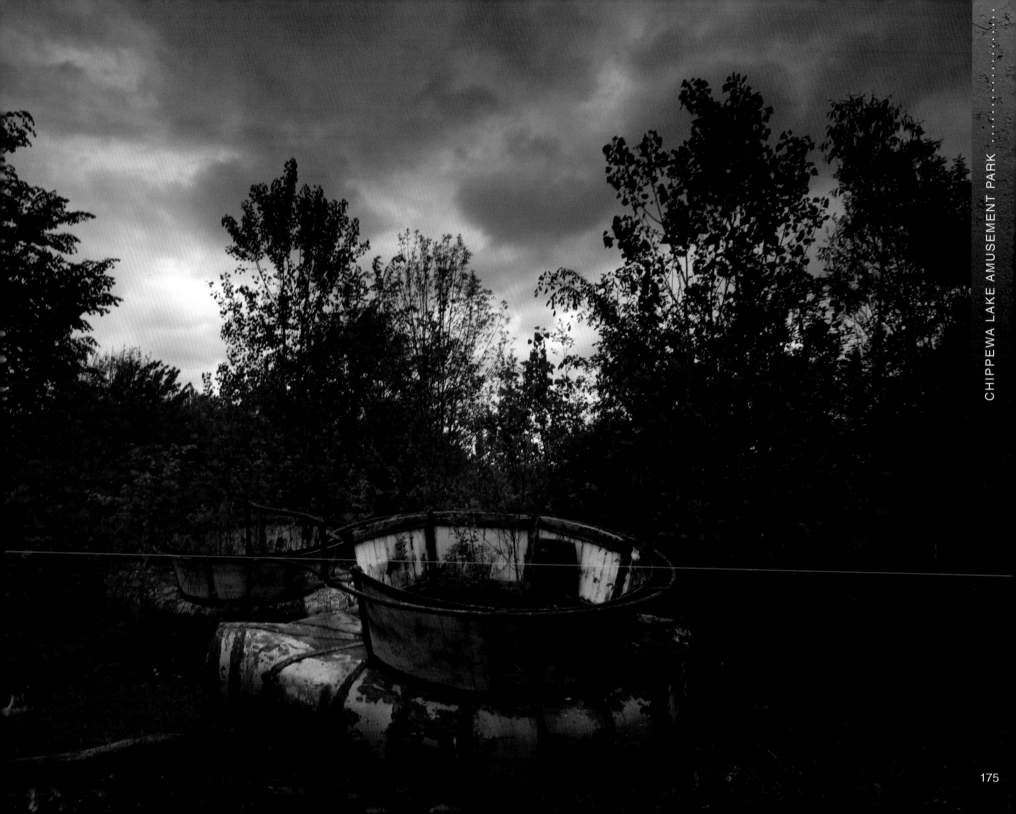

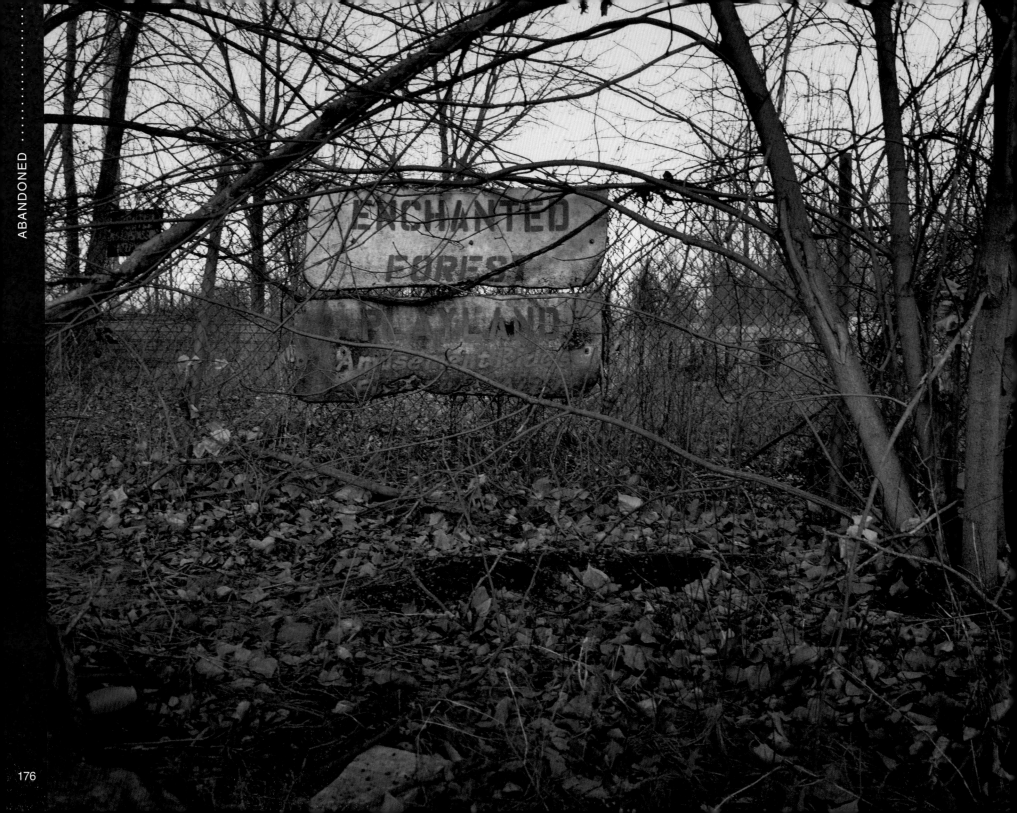

ENCHANTED FOREST PLAYLAND

TOLEDO, OHIO
2000–2005

I remember it like it was yesterday. I remember going up that first incline on the roller coaster. I can still hear the clink, clink, clink of the chains pulling the cars upward. As soon as you reached the top, there would be an almost deafening silence, immediately followed by screams and laughter. In those few moments, it was pure bliss.

Years later, I'm here inside the broken remnants of this abandoned amusement park, and I gaze over to where the big roller coaster used to be. I remember riding all these rides and then, later at night, sitting on a blanket by the lake under the stars watching fireworks. I miss it all.

I can't remember what I did yesterday, but I can remember everything I did here.

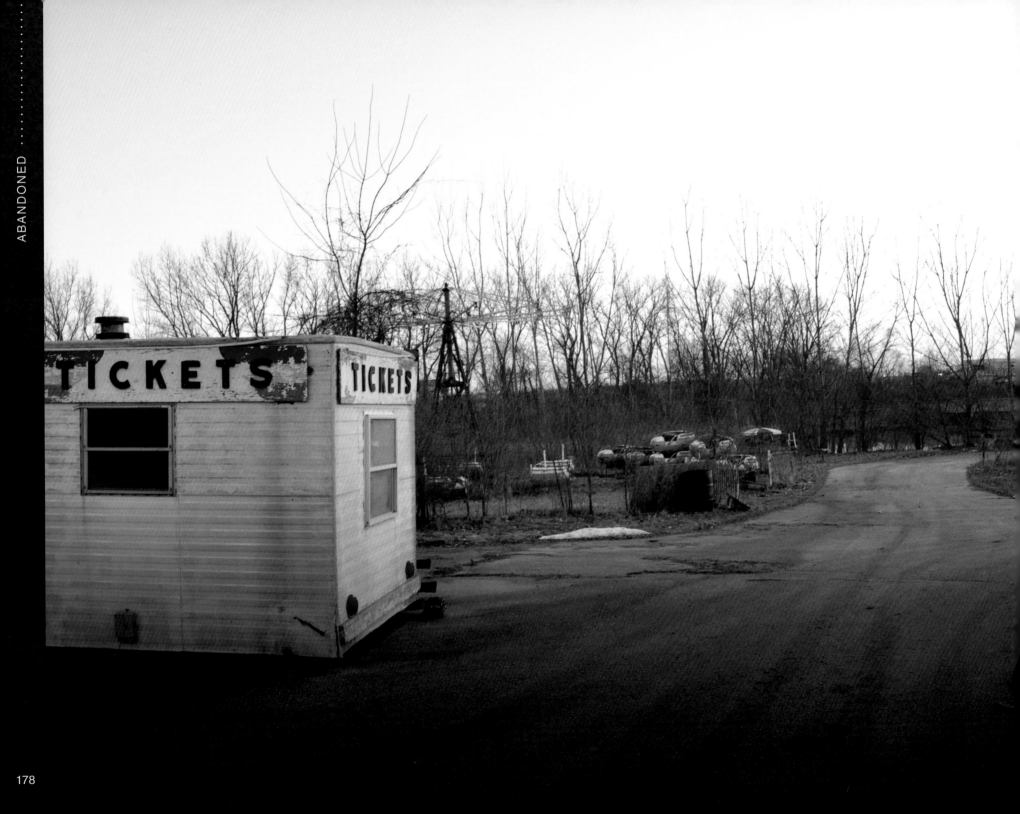

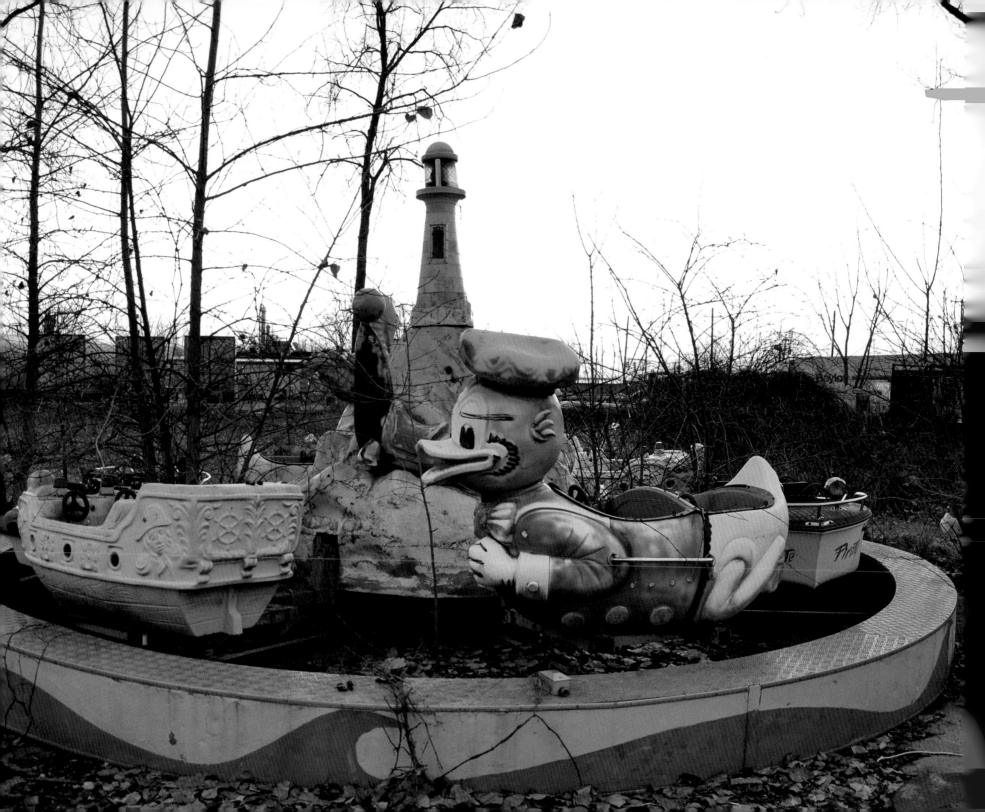

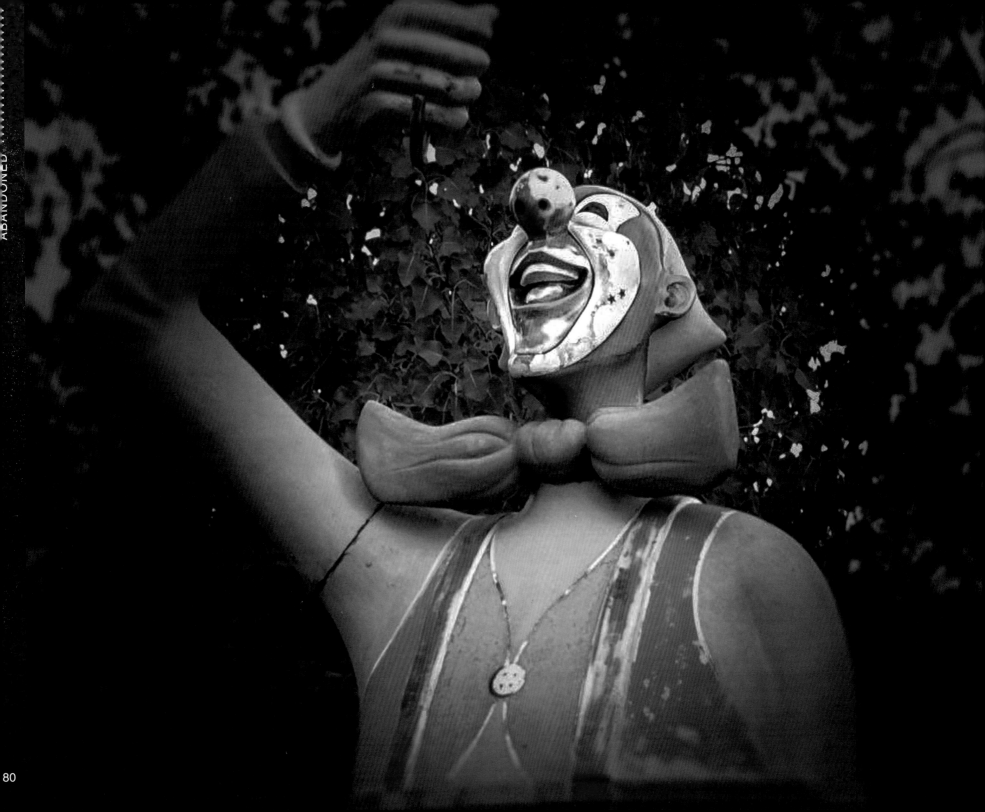

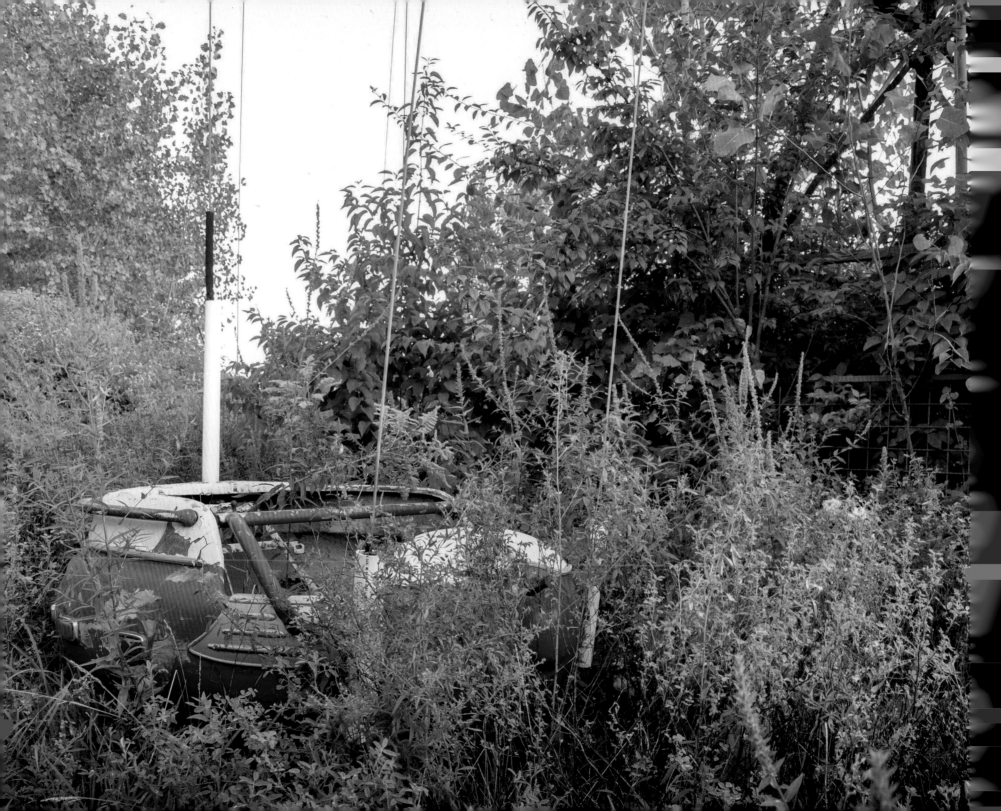

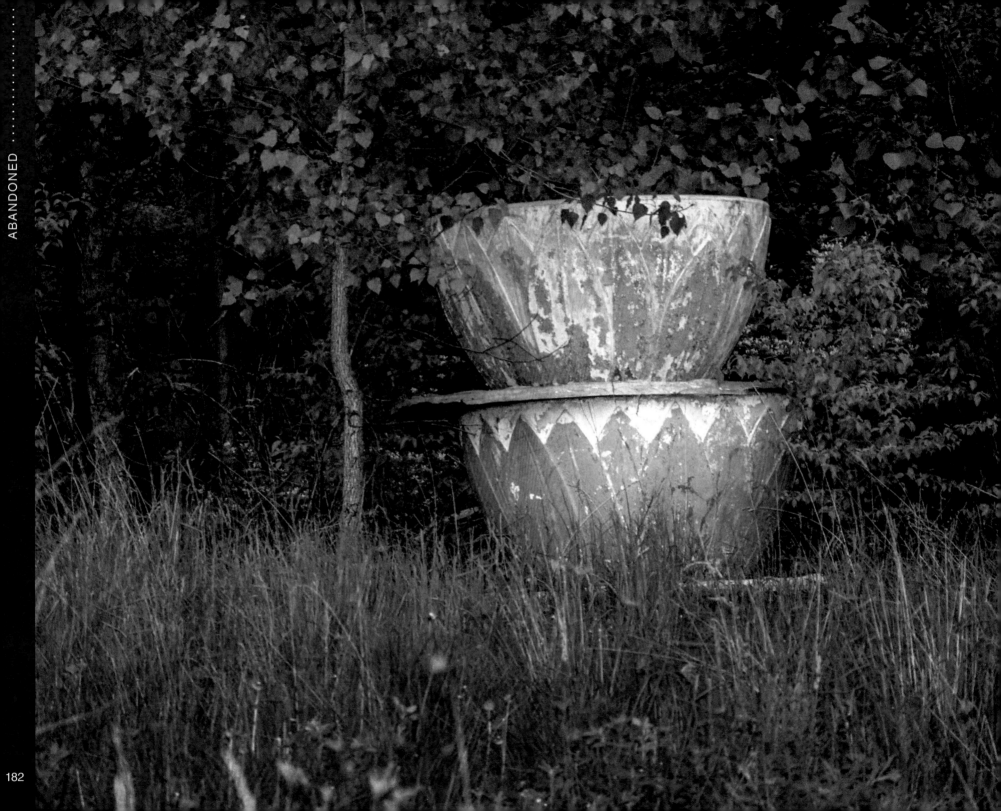

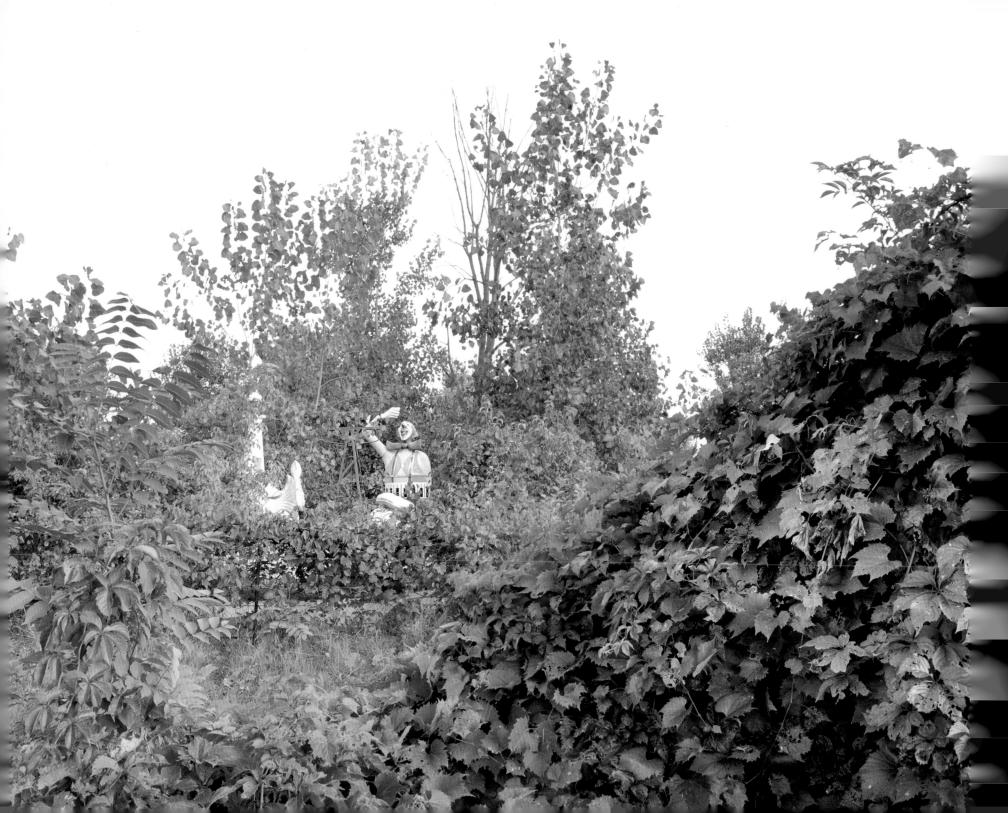

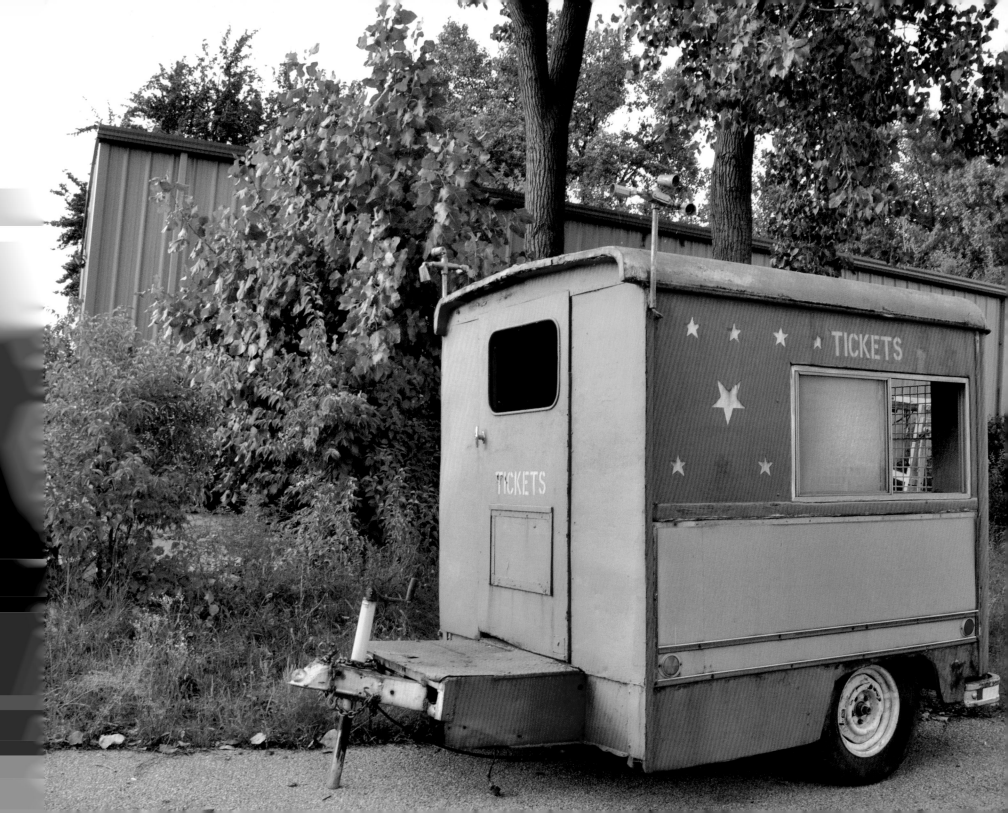

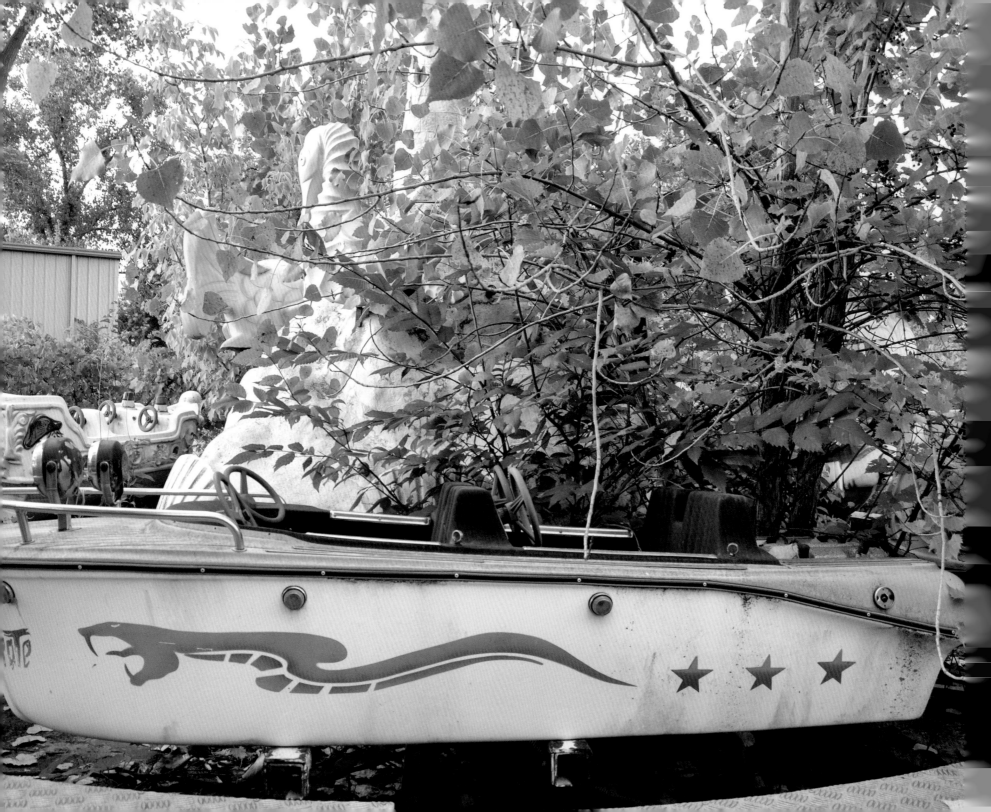

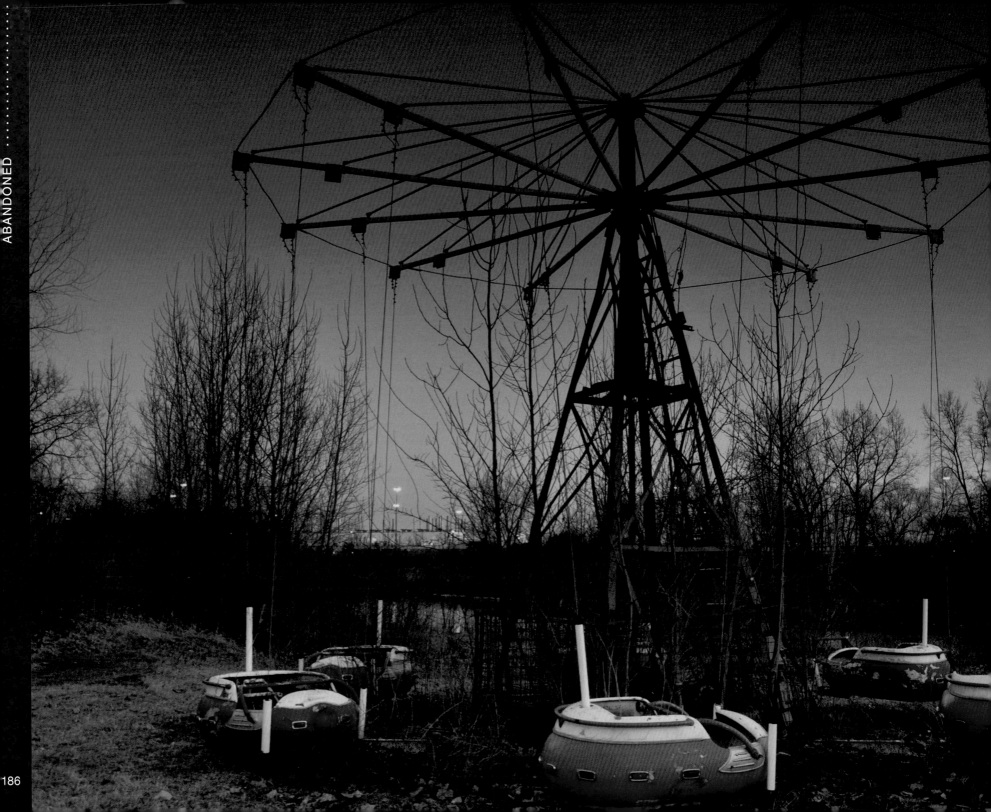

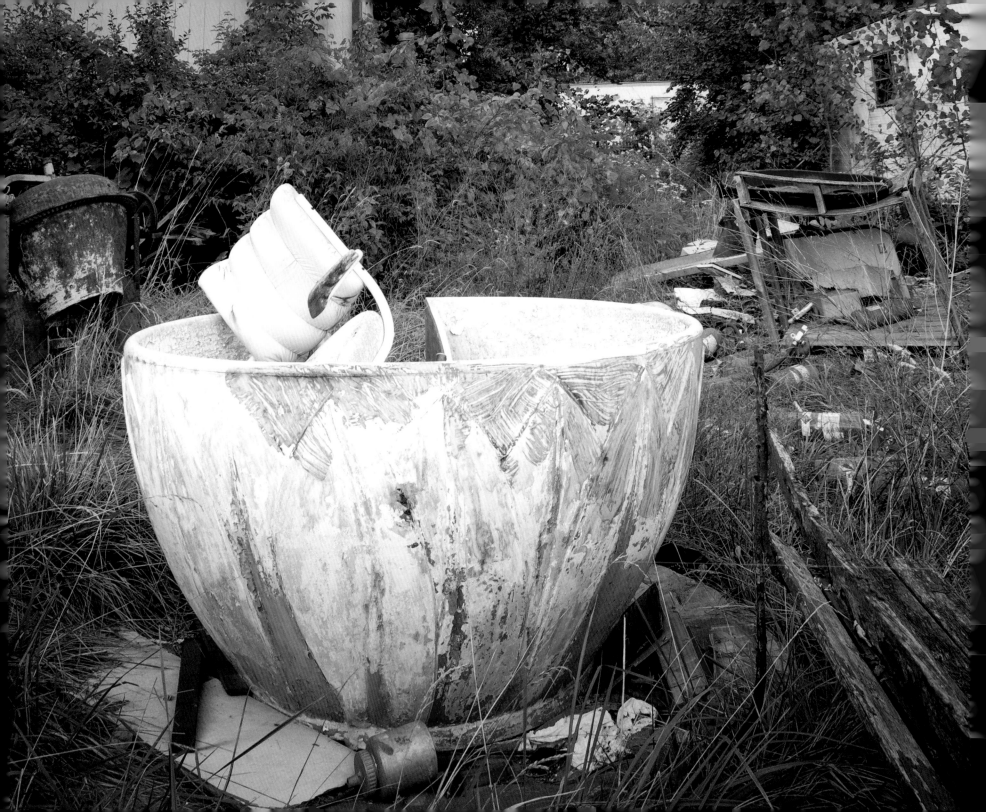

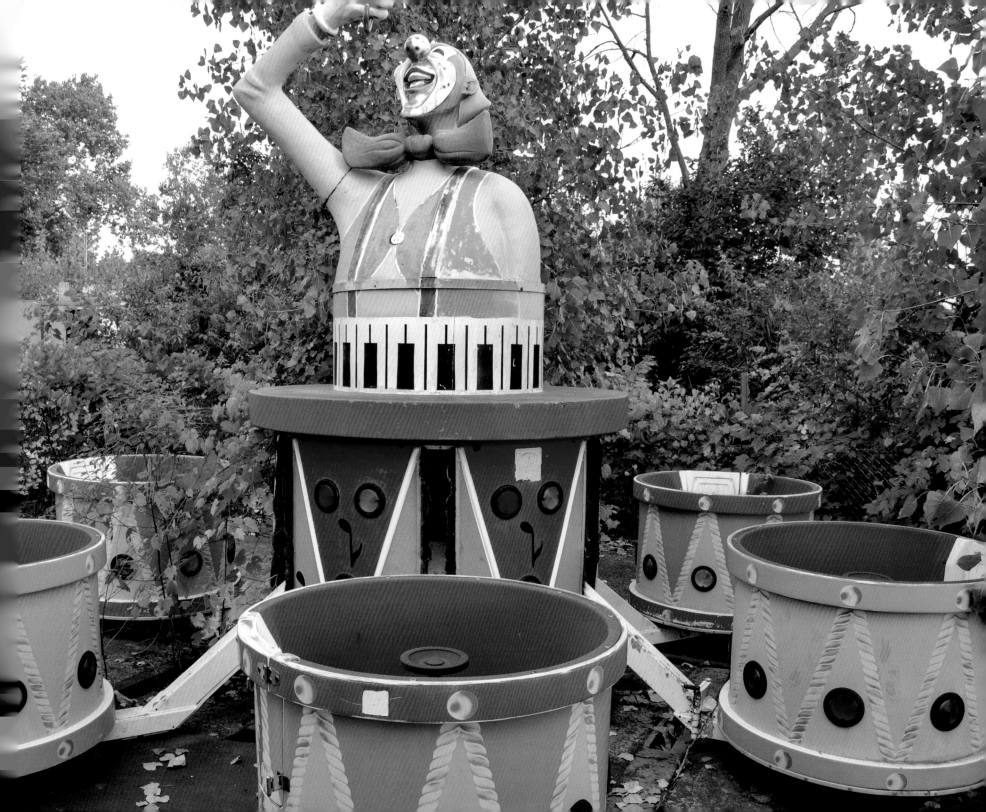

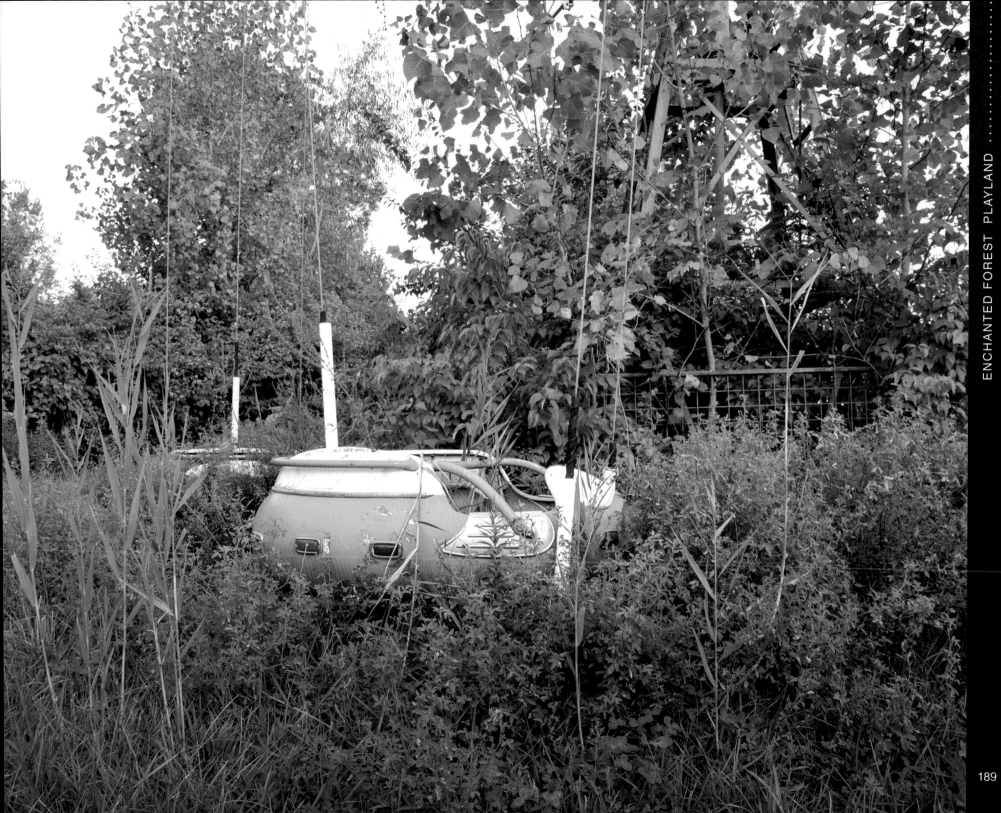

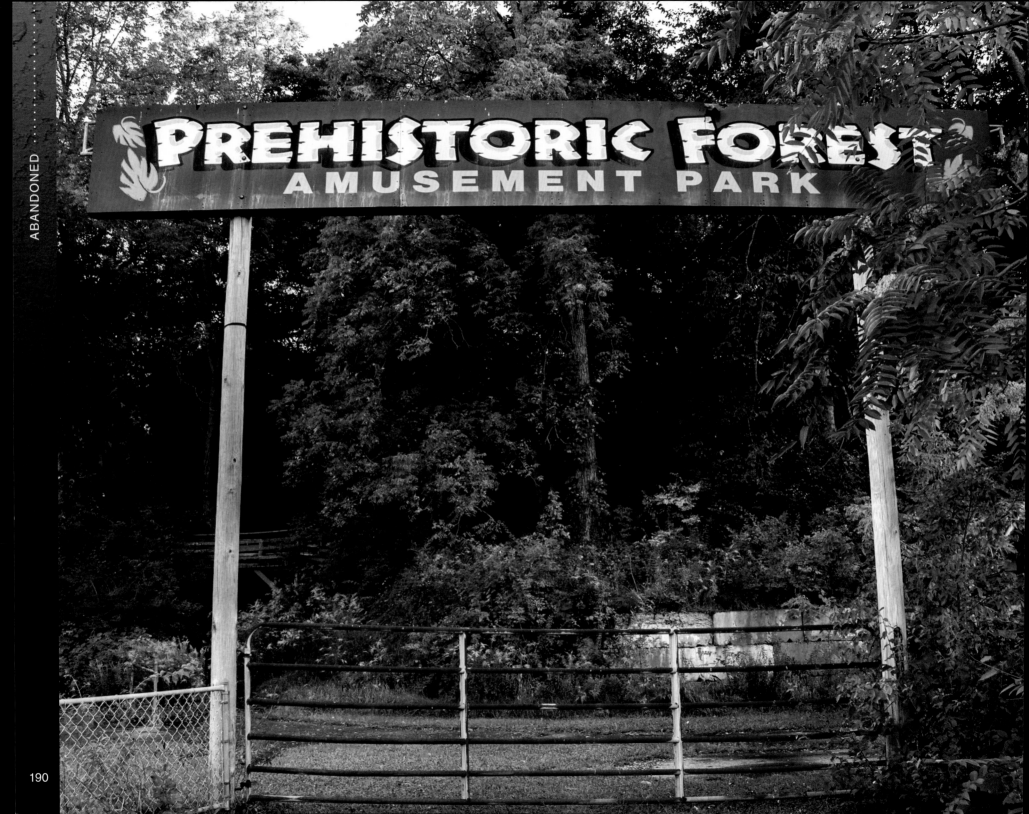

PREHISTORIC FOREST

ONSTEAD, MICHIGAN
1963—C. 2002

Prehistoric Forest is an abandoned theme park that was built in 1963 in the Irish Hills of Michigan. A safari train would take visitors through an exciting tour of a lost world that existed millions of years ago. Prehistoric Forest included a thirty-seven-foot-high waterfall and later a gigantic four-hundred-foot waterslide called Jungle Rapids Water Slide. It closed in at the end of the millennium, leaving behind a world seemingly frozen in time.

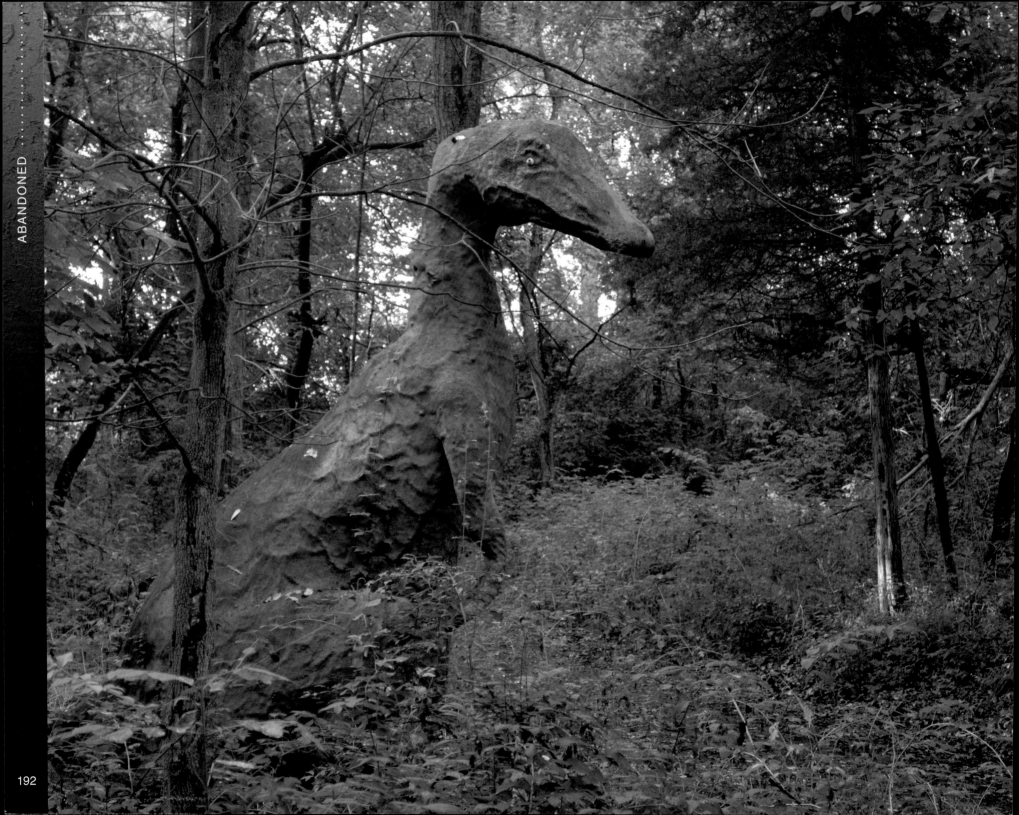

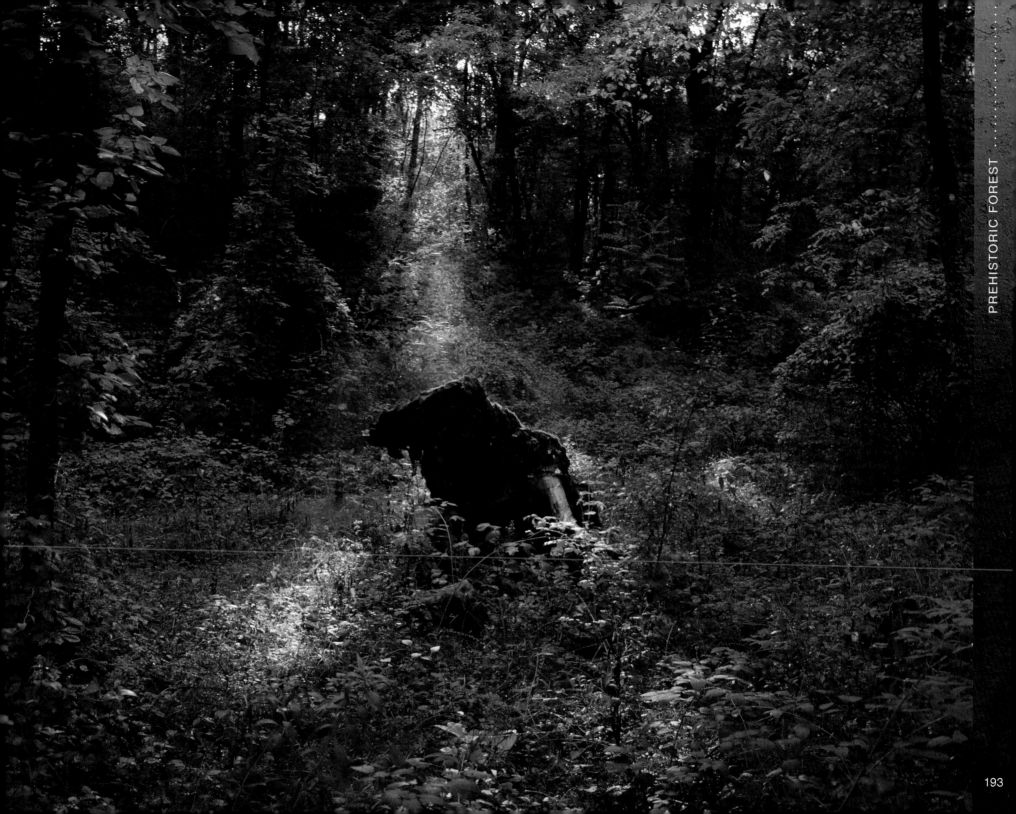

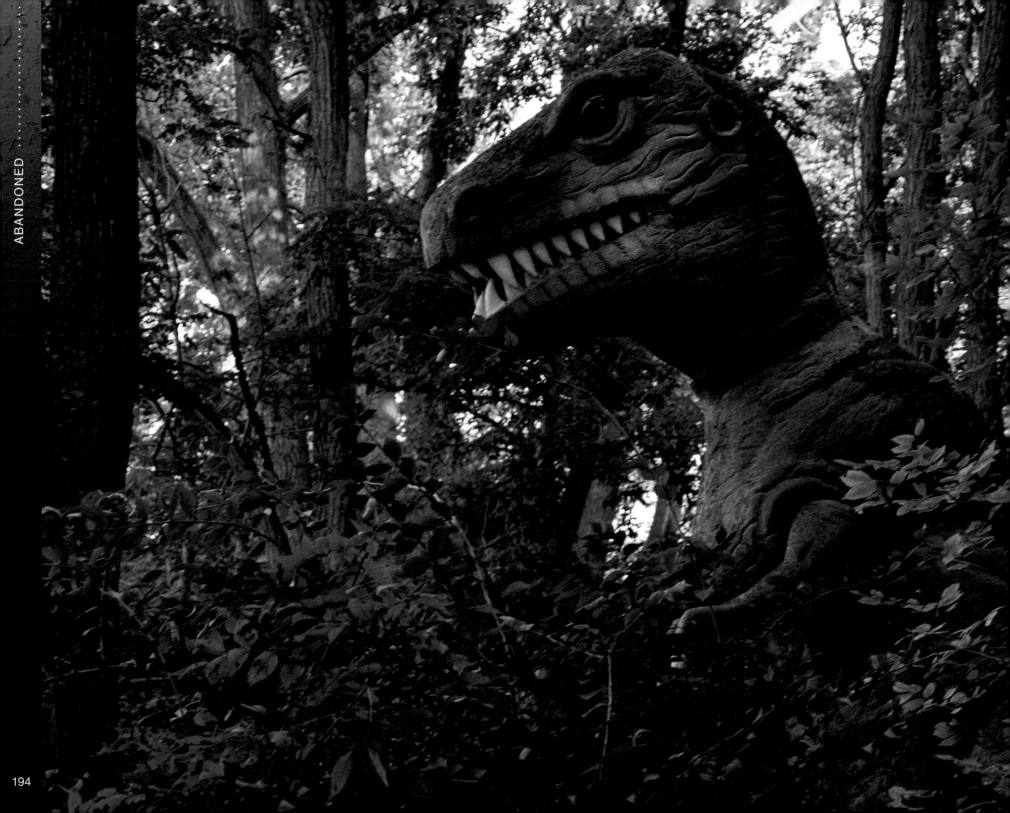

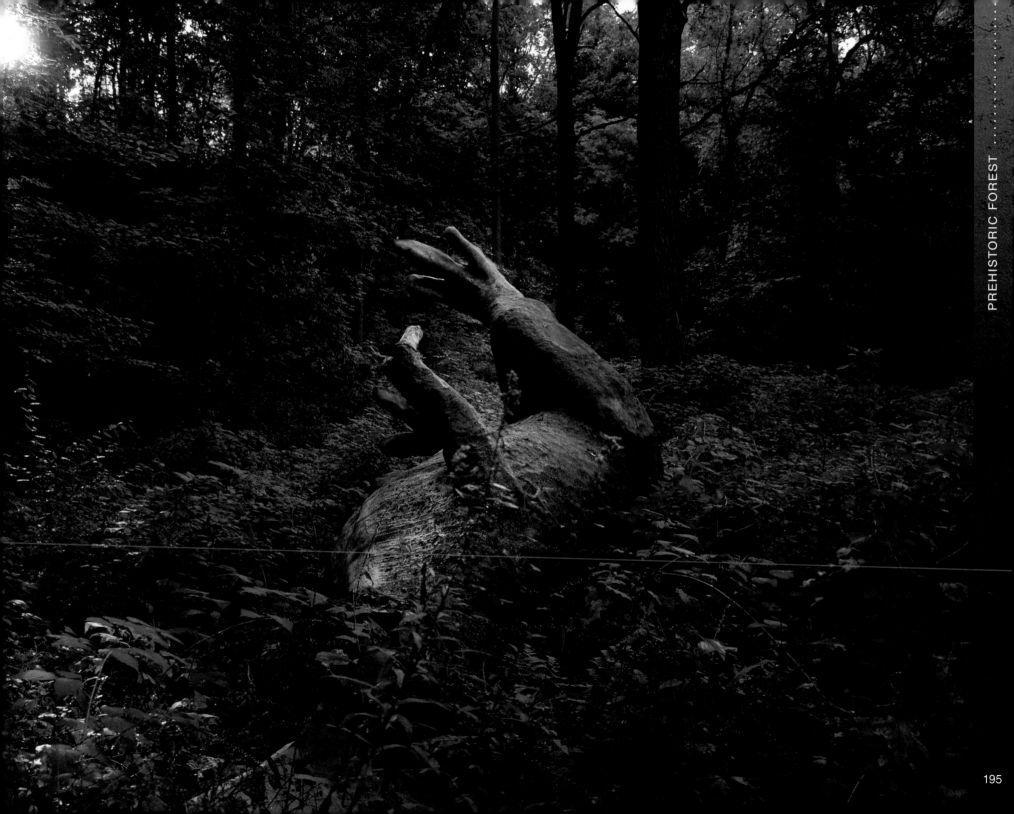

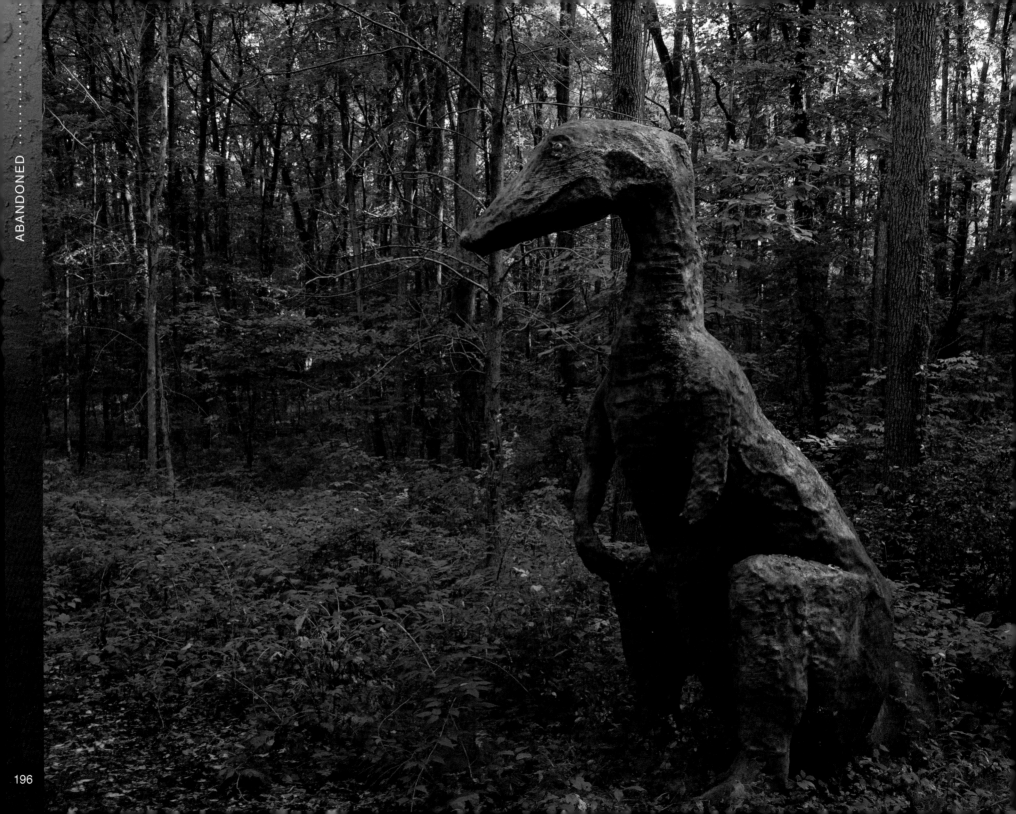

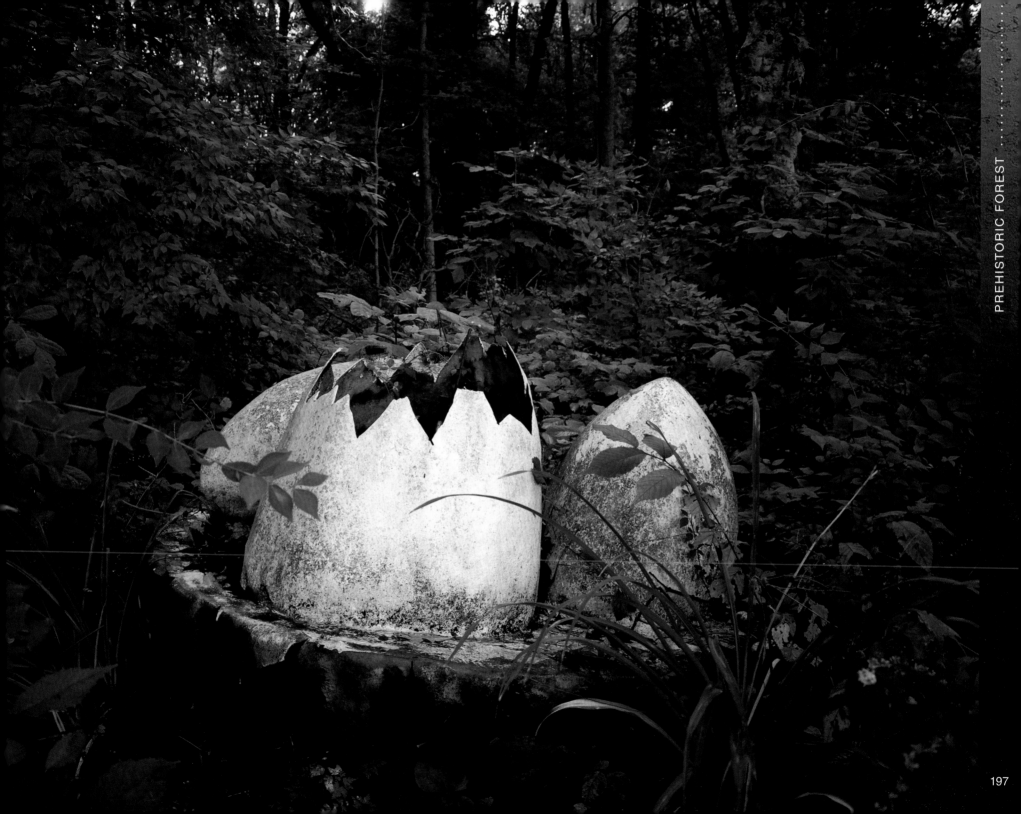

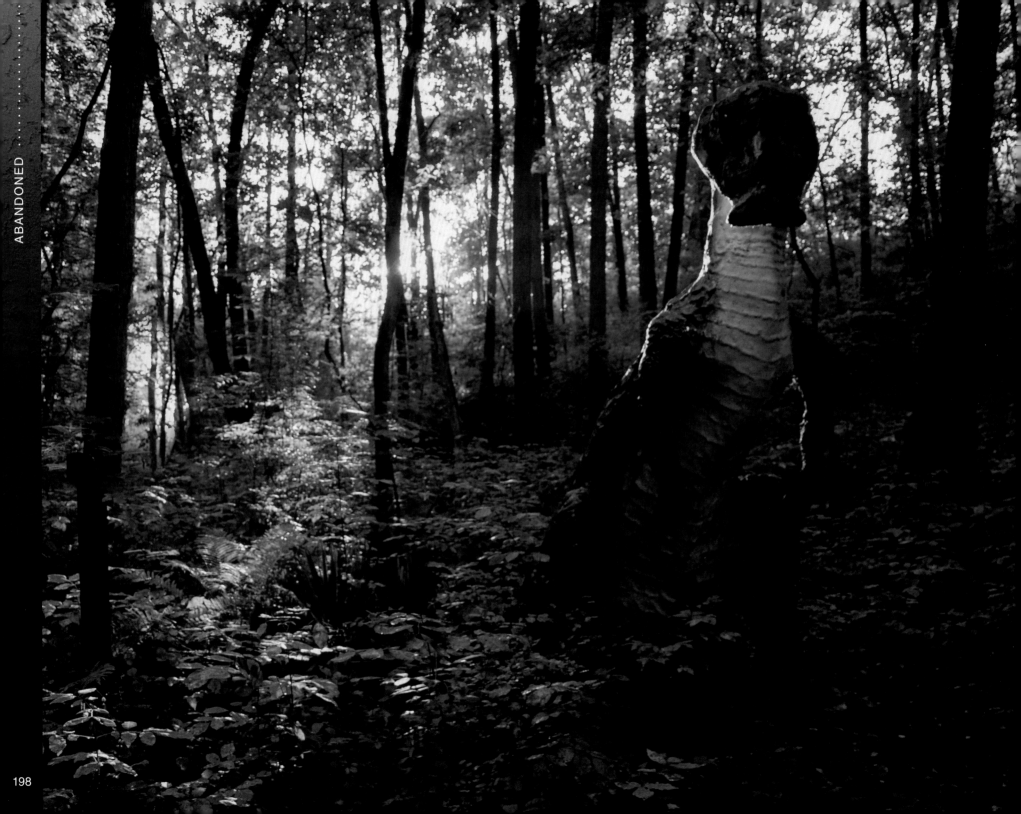

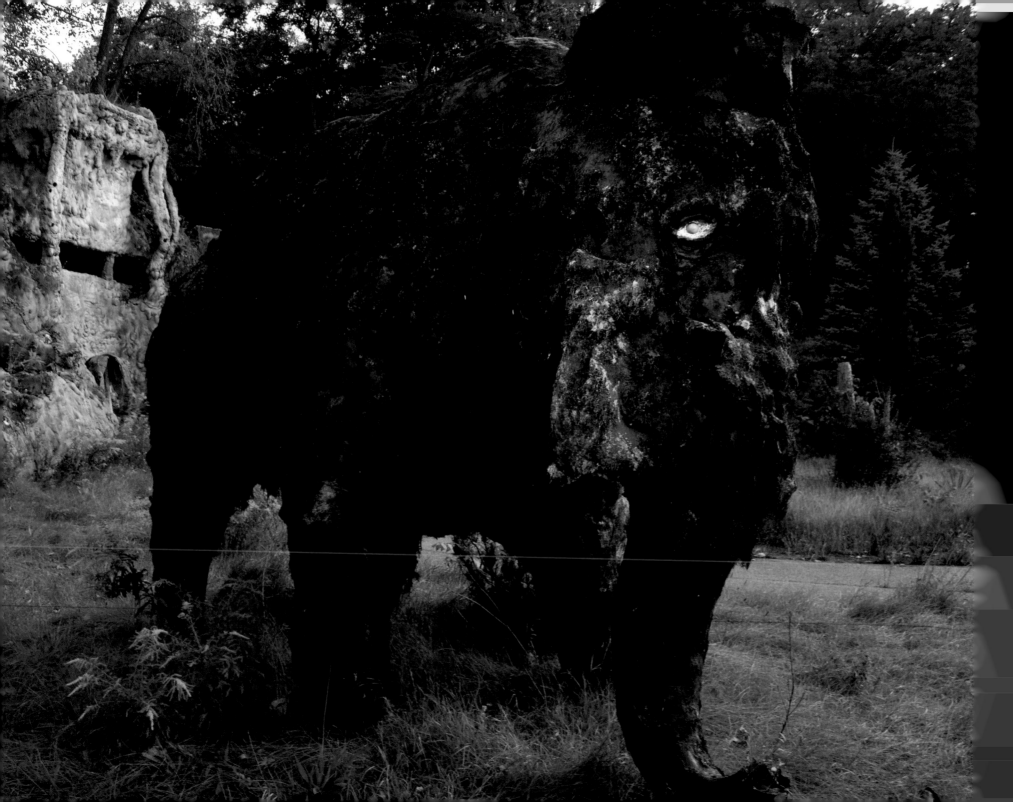

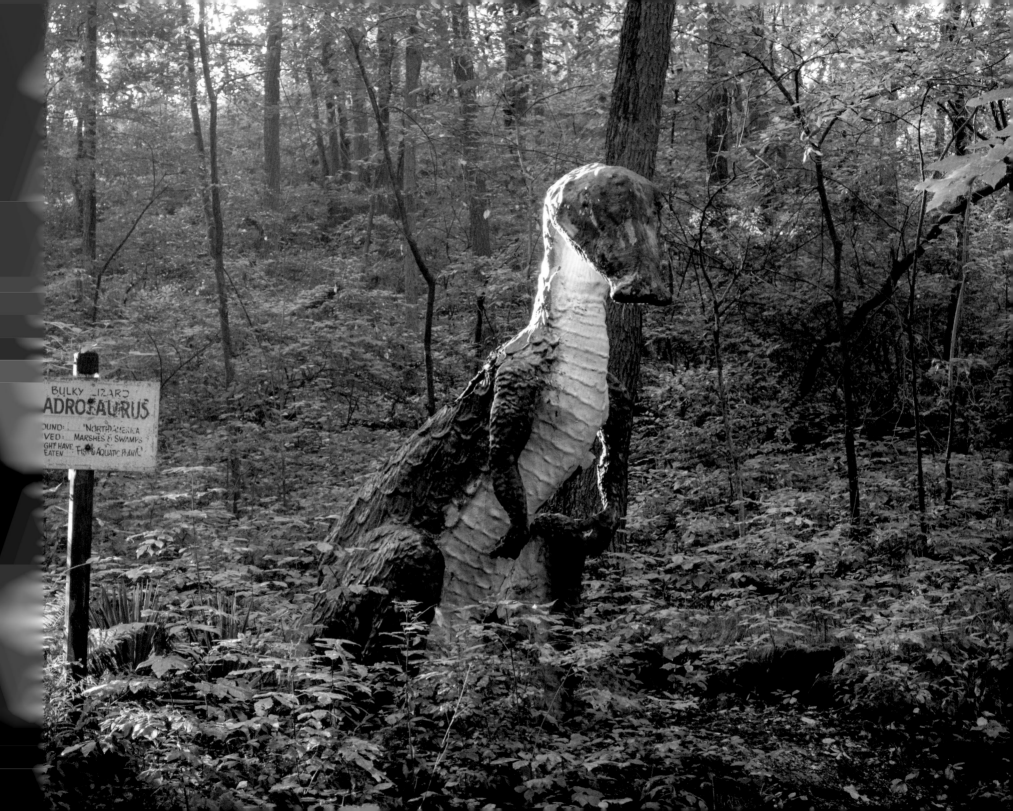

BULKY LIZARD
ADROSAURUS
OUND: NORTH AMERICA
VED: MARSHES & SWAMPS
GHT HAVE
EATEN: FISH & AQUATIC PLANTS

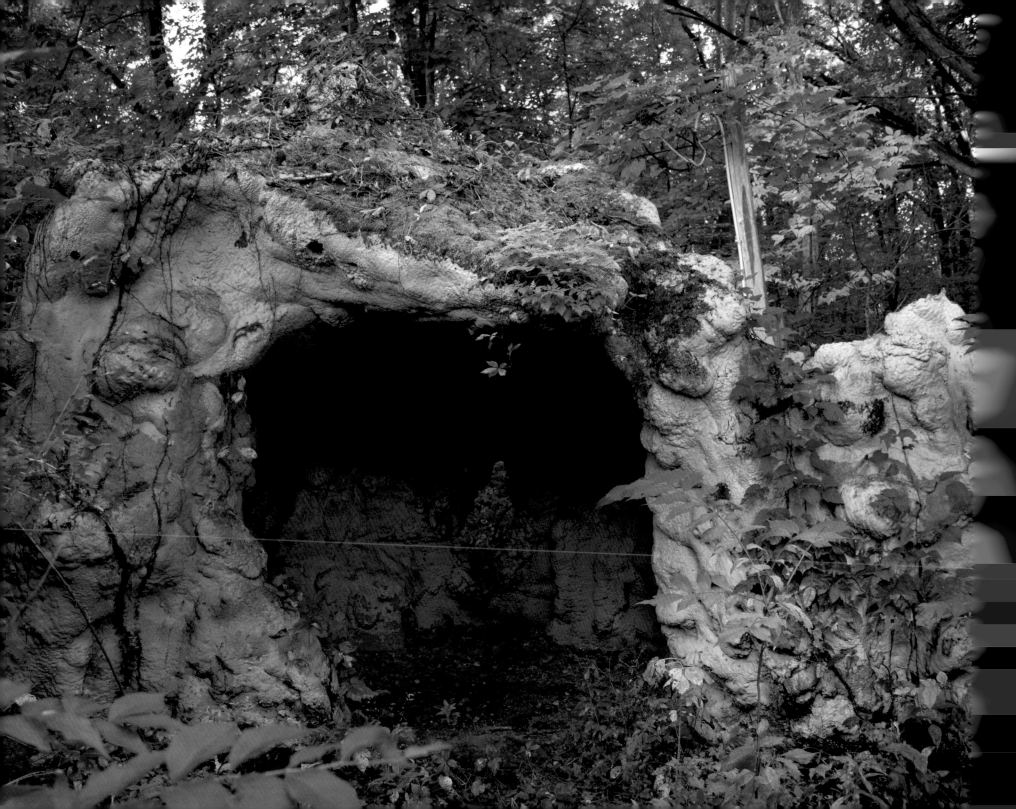

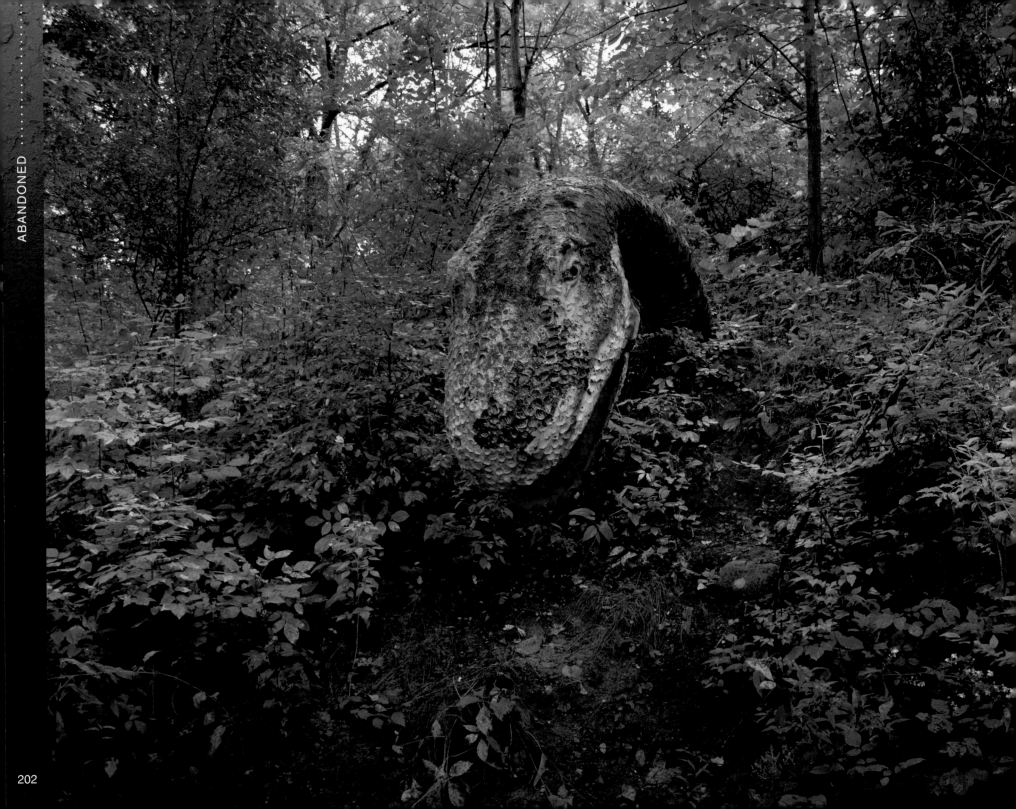

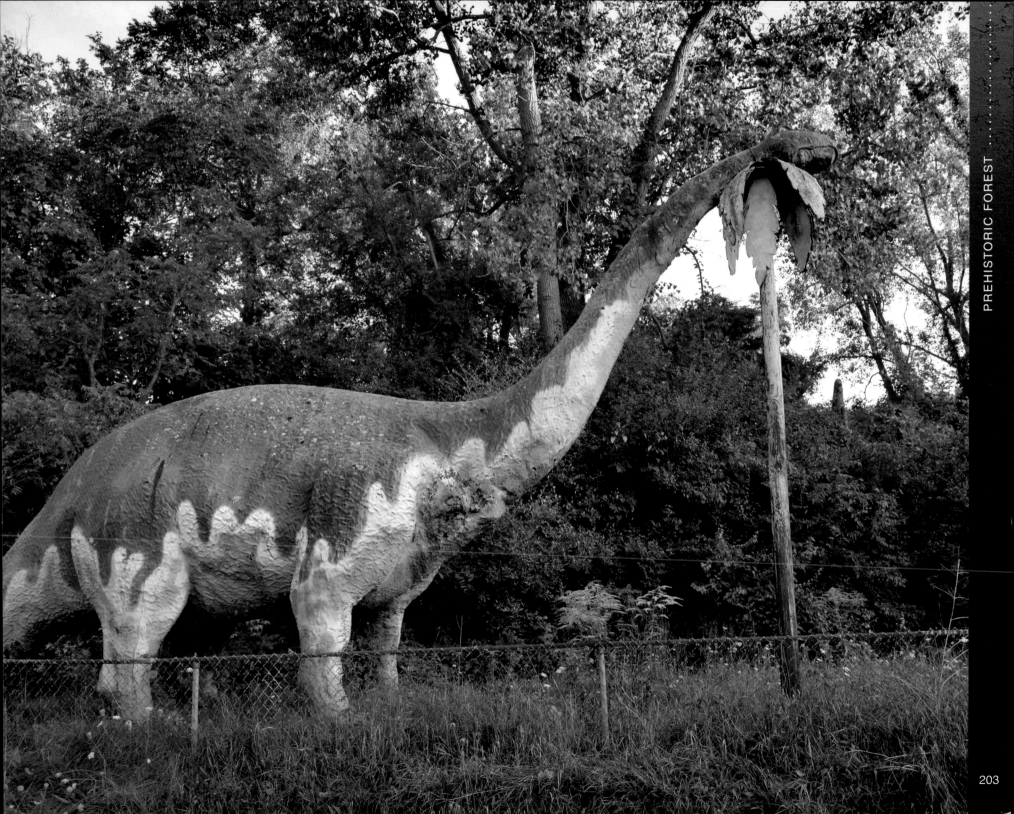